D1278474

G ®
GEORGIA AQUARIUM

at Pemberton Place®

Bringing the Ocean to Atlanta
The Creation of the Georgia Aquarium

The Mission of the Georgia Aquarium

"The Georgia Aquarium is to be an entertaining, educational, and scientific institution featuring exhibitions and programs of the highest standards, offering engaging visitor experiences, and promoting the conservation of aquatic biodiversity throughout the world."

GEORGIA AQUARIUM

at Pemberton Place™

Bringing the Ocean to Atlanta

The Creation of the Georgia Aquarium

By

Bruce A. Carlson, Ph.D.

Steve M. Shindell, Ph.D.

Foreword by:

Sylvia A. Earle, Ph.D.

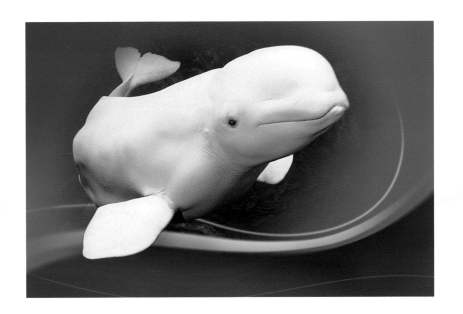

© 2007 by the Georgia Aquarium, Inc.

All rights reserved. No part of this publication may be reproduced or transmitted in any form or by any means, electronic or mechanical, including photocopy, recording or any other information storage and retrieval system, without prior permission in writing from the publisher.

ISBN 0-9799688-0-1

First Edition, 2007.

Designed by Finished Art, Inc.
Printed by Geographics, Inc.
Printed in USA.

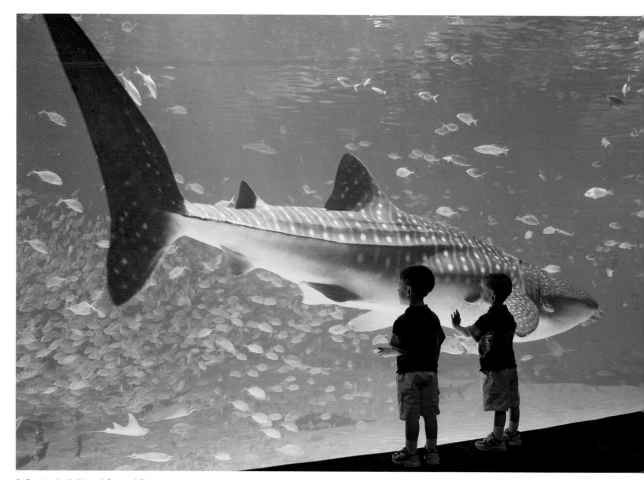

2. Benjamin (left) and Samuel Schwenker meet a whale shark (May 19, 2006)

Acknowledgements

The Georgia Aquarium is the culmination of the labor of thousands of construction workers and contractors; the total dedication of hundreds of employees and volunteers; the cooperation of civic and community leaders; the support of the media; the sharing of ideas by professional colleagues and consultants, and most importantly, the foresight and generosity of Bernie and Billi Marcus. Thanking everyone individually would take all the pages of this book, but everyone who participated in opening the Georgia Aquarium should feel a great sense of pride in knowing they helped bring forth one of the most successful aquariums ever created.

Many of the organizations and individuals who helped develop the Georgia Aquarium are mentioned in this book, but it was impossible to include everyone. We hope that all who participated, and everyone who visits the Georgia Aquarium as a guest, will enjoy this book and the recollection of the long and hectic days and nights of construction and the excitement of opening day.

To complete this book, the authors wish to thank many people who helped us get our facts and recollections correct and who contributed their advice, comments, and assistance. Our thanks go to Dr. Sylvia Earle for graciously offering to write the foreword for this book; to Jeff Swanagan, the President and Executive Director of the Georgia Aquarium who provided enthusiastic support and encouragement to get this book into production and offered editorial comments on the manuscript; to Ray Davis, the Senior Vice President of Zoological Operations, who allowed us to share his experiences (and photographs) on these pages, and to tap into his encyclopedic knowledge of the Georgia Aquarium; to Anthony Godfrey, the Senior Vice President of Finance, who helped us work through contractual agreements and documents; to Karen Deaton, Director of Exhibits and Graphics, who offered creative direction on the design and layout of this book; to Donna Fleishman for her thorough and critical review of the manuscript; to Meghann Gibbons and Ashley Payne for helping to secure permission to use certain photographs; to Deb Parsons, Kacey Danley, Laura Griesser, and Allison Floyd for the lists of volunteers and employees; to Mike Hurst for providing facts and figures about the life support systems; to Beach Clark for his input on the information technology systems; to Dr. John E. Randall for help with fish identification; to Amanda Chinberg for illustrations; and to all those who reviewed or helped with the manuscript in sections or in its entirety: Marj Awai, Tim Binder, Evonne Blythers, Stephanie Brown, Dennis Christen, Kristie Cobb, Chris Coco, Ray Davis, Alex Desiderio, Brenda Fairbanks, Donna Fleishman, Eric Gaglione, Albert George, Jahmar Hannans, Jeff Krenner, Kim Morris-Zarneke, Angela Peterson, David Santucci, Margi Shindell, Zachary Shindell, and Jomal Vailes. We also wish to thank the Paradies Gift Shop ("Beyond the Reef Giftshop") for covering the publication costs of this book.

Finally, the authors wish to thank our wives: Margi Shindell for providing the inspiration for this book, and Marj Awai for allowing us to use underwater photographs from her personal collection.

Photo Credits

Our thanks to everyone who contributed photographs for this book.

Marj Awai: front cover, 13, 35, 36, 82 - 85, 106 -108, 110 - 115, 117 -126, 128 -131, 133, 135, 138, 143 -146, 153, 155, 162, 167-172, 174, 175, 179, 183, 185-187, 189, 191, 196, 198, 204, 208-210, 215, 217, 219, 232-234, 236, 237, 239, 243, 244, 248, 251, 256, 268, 275, 276, 279, 280, 291, 295, 296, 303, 314, 316, 319, inside cover jacket.

Greg Berman: 317, 318

Bruce Carlson: 2-5, 7, 8, 15, 16, 20-26, 28-34, 69, 70, 72, 76, 87, 88, 89, 91, 94-96, 116, 127, 132, 134, 136, 137, 140, 141, 147-152, 156, 158-161, 163-166, 173, 176, 177, 178, 180-182, 184, 190, 192-195, 197, 199, 200-203, 205-207, 211-214, 216, 218, 220-222, 223-225, 227-230, 213, 235, 238, 240-242, 245-247, 250, 252, 253, 257, 258-261, 263-267, 269, 272-274, 277, 278, 281-287, 290, 292-294, 297, 299-301, 304, 307, 309-313, 315,

Paul Clarkson: 71,

Kristie Cobb: 77,

Ray Davis: 19, 67, 68, 73-75, 86, 90, 92, 93, 100, 102,288, back cover

Karen Deaton: 27, 249, 262, 302

Al Dove: 226, 270, 271

Eric Gaglione: 254

George Lainhart: 14, 35, 37,

Nancy Marcus: 6

Oscar Reyes: 142

David Santucci: 97-99, 101, 103, 139

Steve Shindell: 188

Jeff Swanagan: 17, 18, 38-42, 44-49, 57-66, 154,

Georgia Aquarium: 43, 50-56, 78-81, 104, 105, 109, 255, 305, 306, 308

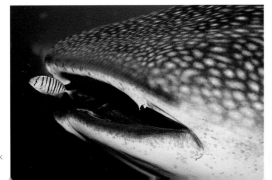

This book is dedicated to Bernie and Billi Marcus. Their many philanthropic gifts have brought joy to millions of children and adults. It was their vision and generosity that made the Georgia Aquarium a reality and enabled it to achieve a level of success that no one (other than Bernie himself) ever imagined.

5. Billi and Bernie Marcus with Patti and Bob Fousch and their son, Colin (May 19, 2006)

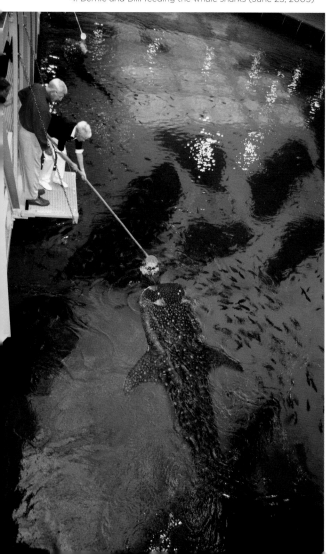

4. Bernie and Billi feeding the whale sharks (June 23, 2005)

6. The Marcus grandchildren (left to right): Chana, Jacqueline, Shira, Alexandra, Lydia, Joey

The story of the Georgia Aquarium began when Bernie Marcus co-founded The Home Depot in Atlanta on June 22, 1979. From its modest beginnings, The Home Depot became one of the top performers on Wall Street and eventually one of the largest companies in the world. Today, The Home Depot employs about 350,000 people worldwide.

Since retiring from the company, Bernie has been active in philanthropic causes, and he has been especially attentive to the Jewish tradition of 'Tikkun Olam' or "bettering the world." This commandment means that each person has a responsibility to reflect the values of justice, compassion, and peace through actions and deeds. Bernie and his wife Billi have indeed made the world a better place for many people. Among their many charitable causes, The Marcus Institute in Atlanta provides treatment and services for children with special needs, and the Marcus Foundation provides grants for a variety of causes and civic activities.

Eleven years after founding The Home Depot, Bernie spent his 60th birthday at the Monterey Bay Aquarium. It was on that occasion that the idea of an aquarium for Atlanta began to germinate. On November 19, 2001, after years of contemplation and research, Bernie announced his plans to create the Georgia Aquarium. Throughout the next four years, Bernie remained intimately involved with the design and construction of the new Aquarium, the acquisition of the animals for the exhibits, and the selection of the staff. In the end, he succeeded in creating one of the most successful aquariums in the world. By the end of its first year, attendance exceeded 3.6 million people, and the Aquarium has set off an economic revival in downtown Atlanta.

While success can be measured in many ways, for Bernie and Billi the success of the Georgia Aquarium is measured by millions and millions of smiling faces.

7. Bernie Marcus (November 16, 2005)

Message From Bernie

" *I am a lucky man.*

A first generation American who started life in a tenement apartment in New Jersey, I am living the American dream with my wonderful wife and family. The business goals I set have been achieved and, every day, I wake up looking forward to what life will bring.

Early in my career in retailing, I had a vision of a massive store unlike anything in the world at that time—the home improvement store of the future. With the help of my partners, and all the other wonderful people who were there at the start, The Home Depot has become one of retail's most compelling success stories, with more than 2,000 stores and 350,000 associates.

Now retired from The Home Depot, with a new life in philanthropy, I certainly have all I will ever need, so Billi and I spend our money helping other people live their lives better.

One of our key desires was to give the people of Atlanta and Georgia a thank you for their early support of The Home Depot. It was here we literally broke ground on the company; here we found our first associates, our first shareholders, our first customers and our lifelong friends.

We were approached by people with suggestions to enhance or enlarge things that already existed, but I was already envisioning something different, bigger, better and about as unique as The Home Depot was in 1979. It was the vision of an aquarium unlike any attraction in the world. Why an aquarium? Whether you're young or old, rich or poor, black or white, it seems to be the one place you can spend a few hours, relax—and smile. However, I didn't want it to be like any other aquarium, envisioning something that combined education and entertainment; taught conservation to landlocked Atlanta children and adults; had a major economic impact on Atlanta and the state of Georgia; and, ultimately, be a lot of fun and spread joy to all who visit.

A great facility needs a great location, and the land for the Aquarium was donated—right in the heart of the city's downtown—in a magnanimous gesture by The Coca-Cola Company. The Georgia Aquarium will always be grateful to them for their foresight and generosity, and the Aquarium could not have a better neighbor at Pemberton Place.

When the design and construction team came together to create this thing that I envisioned, it was not totally made up of people or companies that had built

aquariums before and might have been influenced by previous concepts. This prevented the words, "but... this is the way aquariums have always been built, or "this just can't be done."

On the other hand, when it came to the professional Aquarium team, we looked for "the best of the best," those who had years of experience in caring for fish and animals. These professionals, along with the goodness, generosity and marketing savvy of our sponsors, helped me achieve my dream and continue to ensure that our guests have a once-in-a-lifetime experience.

There are so many to thank for making the Georgia Aquarium a reality—Rick Slagle and the Marcus Foundation, Jeff Swanagan and the dedicated Aquarium staff, sponsors, vendors, the design and construction teams, the Aquarium Board of Directors, Wolfgang Puck, UPS, the thousands of volunteers, and many, many others. A special thank you must be given to Atlanta Mayor Shirley Franklin, who, with her team, helped facilitate the incredible speed with which the Aquarium opened.

Today, the Georgia Aquarium—the world's largest—stands in the heart of a revitalized downtown Atlanta. People from all over the world come to visit, to learn and to stand in awe of the beauty and the vastness of the world that lives in the world's oceans, rivers and streams.

The Georgia Aquarium is truly what I dreamed and hoped it would be. Like I said, I am a lucky man. "

Foreword

By Dr. Sylvia A. Earle

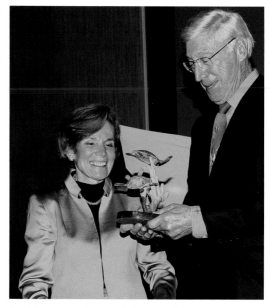

8. Sylvia Earle receiving a gift from Bernie Marcus (September 7, 2006)

Atlanta's Ocean

I was thrilled when my friend, Jeff Swanagan, invited me to see the place in downtown Atlanta where the "biggest fish house in the world" would soon be built. A few days later, with boots and hard hat, I toured the mysterious fenced-in area destined to become home for thousands of sea creatures—mostly fish raised far from the ocean, who would be given permanent residence in the grandest of grand fish spas. There is no substitute for the ocean, of course, but the vision Jeff described to me of a place in which *whale sharks* could disappear from sight swimming from one side of the enclosure to the other sounded like a splendid alternative for wild sharks that otherwise might wind up as shark filet, soup or stuffed trophies. The staff engaged to serve the residents of the aquarium was impressive too—veterinarians, nutritionists, engineers, technicians and scientists, as well as artists and educators whose focus would be to engage the public with an enhanced awareness of the importance of the world's waters and the life they contain.

After the initial tour, I had a chance to re-connect with another long-time friend, Bruce Carlson, one of the elite aquatic scientists who has the uncanny ability to think like a fish. That means he can imagine what it is like to be sheathed in sleek, shimmering skin and glide weightless through a blue three-dimensional realm with enhanced whole-body senses of touch, smell, taste, sound and balance. He recognizes fish as individuals—no two exactly alike—and understands their needs for clean water, the right food, light, space, neighbors, and for some, rocks, coral or other structures for cover.

Bruce and Jeff related how the aquarium was intended as a way for Bernie Marcus, the famous co-founder of The Home Depot, to "give back" to the people of Atlanta, of Georgia, and of the country—not just to kids or to grownups, but something that would resonate with everyone, no matter who they were. "Aquariums give people a chance to see how beautiful fish, jellies, crabs and other sea animals are," Bruce said, "and they also show how the land and water connect, and how all of it connects back to us." He described the ambitious plans for the Georgia Aquarium's program that would be accurate, entertaining, informative and *fun*.

The idea certainly resonated with *me*. As a 12 year old, I visited the aquarium in St. Augustine's Marineland. I suspect that the magical nose-to-nose, eye-to-eye encounter I had there with a large grouper helped send me on my personal path to becoming a marine biologist and ocean explorer. I have been to dozens of aquariums in various countries since then and have witnessed the beginning of several including those in Boston, Orlando, Tampa, Charleston, Monterey, Long Beach, Baltimore, New Orleans, Lisbon and Quingdao. Only in Japan had I seen an aquarium designed to accommodate the biggest fish in the sea, a whale shark. The idea of having whale sharks swimming in a giant pool in downtown Atlanta at first seemed impossible, then merely unlikely, then—after meeting Bernie Marcus—entirely reasonable and wholly desirable. I got caught up in the dream of being able to dispel the fears and myths people have about sharks and other sea creatures with representatives of the biggest of all sharks becoming Atlanta-based ambassadors.

I have for years prowled many a Home Depot for supplies needed to build one thing or another at home, or in various labs, or in support of research expeditions in several oceans. I had heard of the two men who turned modest means into everyman's dream, making a difference while doing much more than making a living. I had also heard that Bernie Marcus attributes some of his success in business and in life to his passion for listening to others. On our first meeting, I was listening to Bernie Marcus and was fascinated by his description of what he hoped the aquarium would become.

Many months later, I had a chance to stand with Bernie and the love of his life, Billi, watching five marshmallow-white beluga whales glide to the front window of their new home. Billi has taken a special interest in the aquarium's belugas—all animals that came from other aquariums with the understanding that in Atlanta, they would continue to be part of long-range captive breeding and conservation outreach programs. In the wild, belugas are suffering from high levels of pollutants in the waters where they live and from the contaminated fish they consume. Some are slaughtered for food. At the Georgia Aquarium the belugas have already touched the minds and hearts of millions of people who would otherwise never get to see a real, live whale, to watch them watching you, and to be inspired to care about their future in the wild.

The waters of the world, from mountain streams to the deep sea, are in trouble from the overload of pollutants we have added and the huge amount of wild fish and other creatures we have taken out, mostly in the past century. This is bad news for wildlife on the land and in the sea, but it is also bad news for us. Water is vital for all life; the ocean is the cornerstone of our life-support system, driving climate, weather, planetary chemistry, and holding 97% of the water and 97% of life on Earth.

The good news is the growing awareness that we can do things to protect what remains of healthy systems such as some of Georgia's lakes and rivers, and the amazingly productive place offshore from Savannah known as Gray's Reef, renowned as a gathering place for northern right whales, sea turtles and giant sponges, and now part of the National Marine Sanctuary system. We can also take heart knowing that we can help restore health to rivers and reefs, and thereby protect our own health. The key is knowing, and knowing is the key to the success of the Georgia Aquarium.

Someone asked me, "What is your favorite part of the Aquarium?" I thought about the great speckled shape of a whale shark magically emerging from the blueness beyond where I stood; the giant grouper surrounded by a hundred flickering golden attendants; the display of that improbable survivor, the robust redhorse sucker fish; and the one celebrating horseshoe crabs, creatures that preceded dinosaurs by at least 100 million years and still swimming in the coastal waters of Georgia—but my favorite thing about the Georgia Aquarium? It is the light. I saw it in the eyes of a boy transfixed by the grace of a tiny seahorse, curling its tail around a sliver of grass. It was the shine in Billi's eyes when one of the belugas paused and looked at her; the glow when Bruce describes how people pulled together to successfully bring whale sharks from the other side of the world to Atlanta; the aura that Bernie has when he talks about the way people have embraced the Aquarium as a place that they come back to time and again because they love what they find there. It is the light of a gift that ignites knowing and caring—a luminous gift that just keeps on giving.

Sylvia A. Earle is a marine biologist, Explorer-in-Residence and leader of the Sustainable Seas Expeditions at National Geographic, former chief scientist at NOAA, chairman of Deep Ocean Exploration and Research, President of Deep Search International and Chair of the Harte Research Institute's Advisory Council. Holder of several deep-diving records, she is the author of some 160 publications.

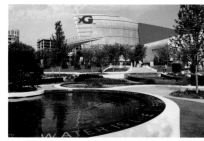

9.

10.

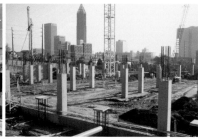

11.

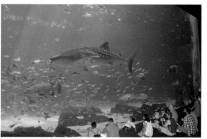

12.

Table Of Contents

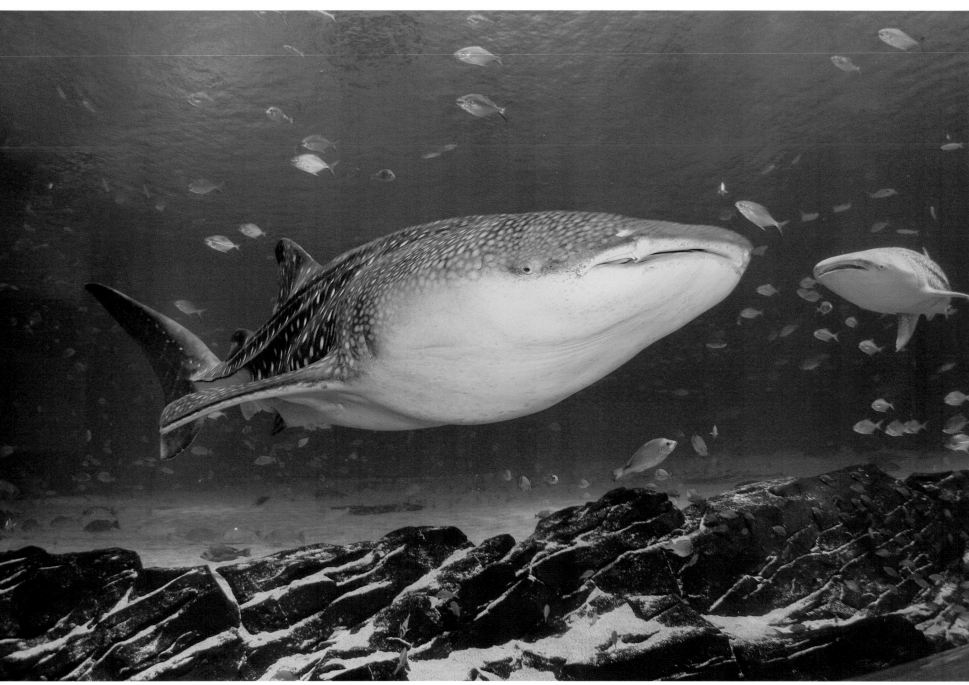

13. Whale shark "Alice", *Rhincodon typus*

Introduction

By Jeff Swanagan
President and Executive Director,
Georgia Aquarium

14.

In the spring of 2000, I was invited to meet Bernie Marcus. Given that Bernie was the co-founder of The Home Depot, I marched off to one of The Home Depot stores (where I had spent a considerable amount of money over the years making various home repairs and improvements), and found the book *Built from Scratch*. It is the story of Bernie Marcus and Arthur Blank, and their successful start of The Home Depot in Georgia in 1979. Bernie mentions in his book (and countless times has related to me) his keys to success: "be on the floor, engage the customers, and listen, listen and listen." We used this strategy, and numerous other lessons from Bernie, as a foundation when we planned the Georgia Aquarium.

The International Aquarium Conference (IAC) held in November 2000 in Monaco, afforded us the opportunity to listen to international professionals. The conference was held at Le Musée Océanographique de Monaco, where the renowned ocean explorer Jacques-Yves Cousteau once served as Director. Aquarists from around the world listened to presentations and shared their experiences and knowledge. In 2004, the IAC was held at the esteemed Monterey Bay Aquarium. In addition to the IAC, conferences held by the Association of Zoos and Aquariums (AZA), Regional Aquatics Workshops (RAW), Elasmobranch conferences, Aquatic Veterinary Medicine meetings, as well as many others, provided a great way for the Georgia Aquarium team to listen to professionals and collaborate with peers.

During an AZA conference in St. Louis, I approached Dr. Bruce Carlson about the possibility of joining the Georgia Aquarium team. At that moment it consisted of myself and members of

The Marcus Foundation staff, led by Rick Slagle. The date was September 10, 2001 and I knew that Bruce's scientific credentials and years of experience at the Waikiki Aquarium would be crucial to the project. The next day, September 11, 2001 would change the world. I expected to get a phone call from The Marcus Foundation telling me the project of a lifetime was on hold due to world events and uncertainty, but Bernie said he was even more committed.

On November 19, 2001, under the State Capitol of Georgia, and with Governor Roy Barnes present, Bernie announced his pledge of $200 million (later this would grow to $250 million) to create the Georgia Aquarium. This gift was, and remains, the largest single philanthropic gift in the State of Georgia! Bernie did this to say thank you to the citizens of Georgia for helping him start The Home Depot and to honor the associates of the company. Bernie and his wife, Billi, wanted their gift to be one that could be enjoyed by all ages, one that could ignite economic development, and be a gift that continued giving well into the future.

Shortly after the grand announcement, Bernie embarked on a "listening" tour that would take him and his small team to 55 aquariums in 13 countries in three months. Bernie would ask every director he met, "What would you do differently if time and money were not an issue?" The replies from Ted Beattie (Shedd Aquarium), Frank Murru (SeaWorld), Julie Packard (Monterey Bay Aquarium), Dr. Paul Boyle (WCS-New York Aquarium), Yoshitaka Abe (Fukushima Aquamarine), Dr. Senzo Uchida (Okinawa Churaumi Aquarium) and Dr. Itaru Uchida (Nagoya Aquarium) provided crucial advice and contributed greatly to the success of the Georgia Aquarium.

One scientific advisor who provided significant input into the design and inspiration of the Georgia Aquarium was Dr. Robert Hueter, Director of the Center for Shark Research at the Mote Marine Laboratory in Sarasota, Florida. Dr. Hueter, along with Steve Kaiser (one of the first four employees of the Aquarium) created the original design of the huge Ocean Voyager exhibit, and later collaborated with us on developing a whale shark research program, which included Mote Marine Laboratory, the Georgia Aquarium and biologists from Mexico.

Designing the exhibit was just the start; getting the 15-foot whale sharks to Atlanta was yet another problem. To achieve this, we created a peer review system comprised of experts from other aquariums and challenged them to dream their wildest dreams. One person in the group seemed to know exactly what to do: Ray Davis. In 2003, we invited him to join our team. He not only guided us on how to move whale sharks, but he now leads the entire zoological team as a Senior Vice President. His team has since grown to include experts from every major aquarium in the United States.

During one of our trips to the New York Aquarium, we saw the bathysphere used by Otis Barton and William Beebe in which the duo made their historic dive to 3,028' (923 m) in 1934. We just had to touch it and reminisce about its story. In 1979, inspired by the bathysphere, Dr. Sylvia Earle dove solo in a *JIM suit* (a special suit allowing divers to walk on the sea floor at great depths, it resembles suits worn by Astronauts), and she became the first person to stand un-tethered at the bottom of the ocean at 1,250' (381 m). Sylvia has become an ardent supporter and advisor to the Georgia Aquarium, and I am pleased that she has written

the Foreword for this book. While she has spent most of her life on the ocean, I was surprised to hear that the first time she saw a whale shark was not in the ocean, it was at the Osaka Aquarium. Later, in 2005, she traveled with Dr. Bruce Carlson, his wife Marj Awai, and Dr. Robert Hueter to see her first whale sharks in the ocean off the coast of the Yucatan Peninsula.

Following Bernie's strategy of listening, we sought advice from government agencies, related organizations and universities. We received input from the Georgia Department of Natural Resources, the National Oceanographic and Atmospheric Administration (NOAA), the U.S. Fish and Wildlife Service, and the Georgia Environmental Protection Department. Related organizations were well represented by The Ocean Project, River Keepers, Georgia Wildlife Federation, The Nature Conservancy, The Oceans Conservancy and the Fernbank Science Center. The University of Georgia, Georgia Institute of Technology, Georgia State University, Morehouse College and Savannah State University also provided advice and support in developing the Aquarium, especially from those who served on the Aquarium's conservation and education advisory committees

During the early design phases, Dr. Paul Boyle presented our team with findings of the nationwide research conducted by The Ocean Project (www.theoceanproject.org) where we learned how to create "connecting messages" about the ocean and embrace entertainment as a means to provide guests with engaging experiences that teach the heart as well as the mind. *Deepo's Undersea 3D Wondershow* produced by Gary Goddard is a wonderful manifestation of this strategy.

With the support of the community and sponsorships, the Georgia Aquarium was built at a cost of approximately $320 million, of which Bernie and Billi Marcus provided $250 million. The land was donated by The Coca-Cola Company at a value of $24 million and the Aquarium now shares Pemberton Place with the new World of Coca-Cola. Several philanthropic companies enabled the Aquarium to open debt-free by participating as presenting sponsors for the five galleries and *Deepo's Undersea 3D Wondershow*: The Ocean Voyager gallery was built by The Home Depot; Tropical Diver presented by AirTran Airways; Georgia Explorer presented by SunTrust; River Scout presented by The Southern Company; Coldwater Quest presented by Georgia-Pacific; and *Deepo's Undersea 3D Wondershow* presented by AT&T. Turner Broadcasting System, Inc. sponsored the Education Loop, and Publix Super Market Charities sponsored Kid's Cove. Other major gifts were given by firms that were contracted to build or assist with the startup operation: Accenture; Brasfield & Gorrie; ChoicePoint; Clear Channel; Comcast; Environmental Protection Agency; FF&E; Heery International; Kenwood; Lithonia Lighting and Zep, Acuity Brands Companies; McKenny's; Microsoft; Mountainview Group / Lab 601; Piedmont Hospitals; Radiant Systems; Thompson, Ventulett, Stainback & Associates; Unisys; UPS; and, WXIA-TV 11 ALIVE. Numerous individuals provided funds for sponsored admissions to ensure children could enjoy this amazing gift, and for the 4R Program for Rescue, Research, Rehabilitation and Relocation. Two outstanding individuals, Pete and Ada Lee Correll, both graduates of the University of Georgia, funded the Correll Center for Aquatic Animal Health, a joint collaboration between the University of Georgia College of Veterinary Medicine and the Georgia Aquarium.

Bernie's vision for the Aquarium was not only for it to inspire, but to be successful as a non-profit business organization. Mike Leven, one of Bernie's closest friends and former CEO of several large hotel chains, recommended that we create a large ballroom. The team conducted another series of "listening" adventures with local hotels, especially the Hyatt Regency Atlanta, Cobb Galleria and the Atlanta Convention and Visitors Bureau, who introduced us to the top event planners. The result is a 16,400 square foot ballroom, divisible into three sections with views into the beluga whale habitat and Ocean Voyager featuring whale sharks. The response to this venue has been overwhelming with 800 events in the first twelve months. By the end of the first year, the Aquarium began a multi-million dollar expansion of the ballroom and family support restrooms, as well as additional storage and life support systems.

This book is just one way that you, the reader, can begin to understand the immense task undertaken to fulfill Bernie's dream. Visiting the aquarium and our website (www.GeorgiaAquarium.org) will help you understand even more. I also recommend that you visit the Beyond the Reef Gift Shop and purchase "Window to WOW," and "Two + Two = WOW!" developed in partnership with WXIA-TV 11 ALIVE. Thanks to Bob Walker and Phil Humes at WXIA, we were provided with a great duo to help tell our story: reporter Marc Pickard and cameraman Willis Boyd.

To all the dedicated staff, volunteers, supporters, consultants, contractors, designers and advisors, thank you for helping us fulfill Bernie and Billi's dream and making the Georgia Aquarium "the world's most engaging aquarium experience."

"To all the dedicated staff, volunteers, supporters, consultants, contractors, designers and advisors, thank you for helping us fulfill Bernie and Billi's dream and making the Georgia Aquarium 'the world's most engaging aquarium experience.'"

— Jeff Swanagan

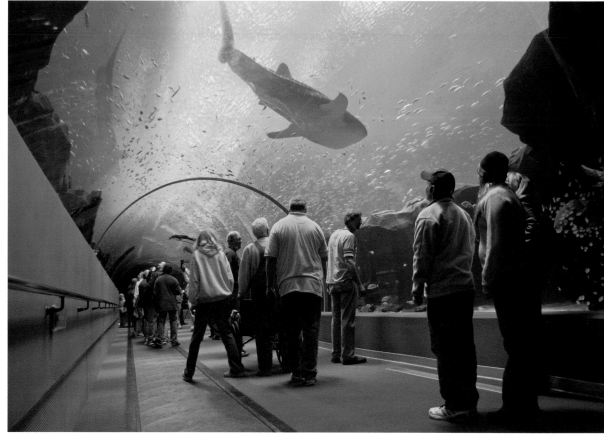

15.

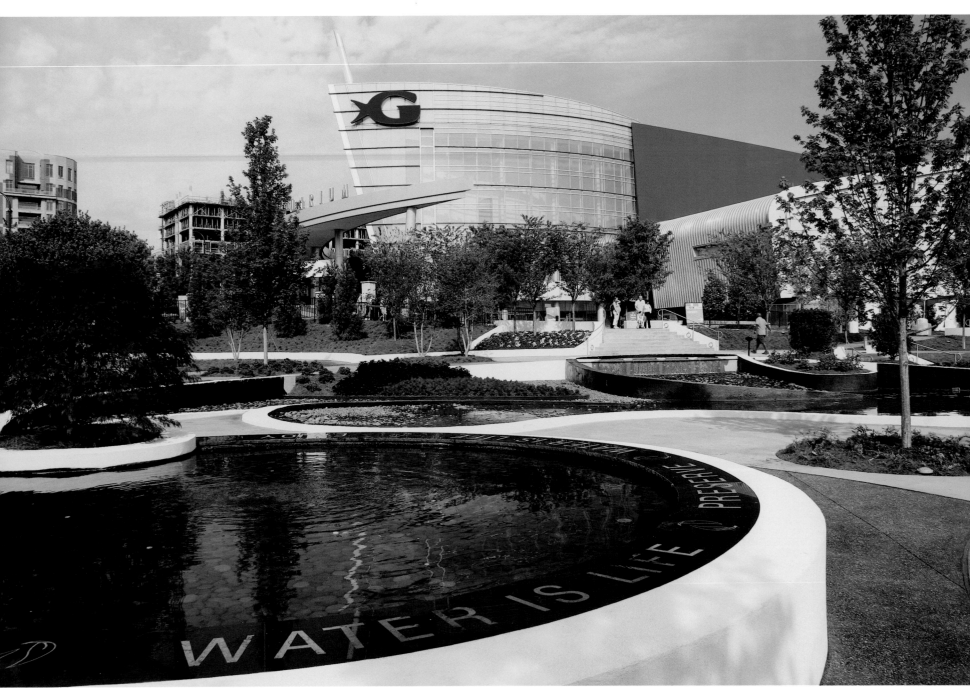

CHAPTER ONE:

Learning From the World's Great Aquariums

A Brief History of Aquariums

It was just over 150 years from the opening of the first public aquarium in Regents Park at the London Zoo to opening day at the Georgia Aquarium. Throughout this 150-year history, tremendous technological advances have resulted in larger and better exhibits, and have allowed the public to see glimpses of this ocean planet that most people will never be able to see first-hand. The Georgia Aquarium stands at the pinnacle of this long evolution in aquarium design.

Gardens, parks, game reserves, fishponds, and animal collections have existed for five thousand years, from the Mesopotamians on through the Renaissance. Explorers and fishermen would tell stories of exotic and dangerous aquatic creatures that often were partly true, and partly fabrication. Countries would spend considerable resources on multi-year expeditions to uncover the secrets of distant lands. Many creatures from the sea were dried or pickled, and placed in personal collections. Most often, the ability to collect a menagerie of animals said more about the collector's status than anything about the animals themselves. There was no true rationale regarding the collections, and the live land animals that survived often were poorly cared for. Most of the animals from the sea remained a mystery.

All this changed in the middle half of the 19th century when glass-making technology allowed large clear plates of glass to be constructed. People started collecting land plants and keeping them in glass boxes, and eventually water was added to these containers to house animals from the sea. By May 1853, this fad expanded to the opening of the first public aquarium at the London Zoo. The Fish House, as it was called, had many "firsts" including the first fish ever to appear in a photograph.[1]

The term *aquarium* was coined by Philip Henry Gosse in 1854. Several books rapidly appeared and exposed the public to this new hobby, including *The Aquarium* (1854), *Handbook to the Marine Aquarium* (1855), and *Life Beneath the Waters or the Aquarium in America* (1858). The public had an insatiable desire for more aquariums.

P. T. Barnum established the first aquarium in the United States at his American Museum in New York in 1856. Within the next fifty years roughly twenty aquariums sprang up in Europe and the United States, with the first ones in the United States opening in Boston (1859); Woods Hole, Massachusetts (1873); San Francisco (1894); New York (1896) and Honolulu (1904). Of these, the National Aquarium in Washington, D.C. (originally at Woods Hole), the New York Aquarium, and the Waikiki Aquarium in Honolulu continue to operate to this day. The public has had a long fascination with public aquariums, but the expense and the expertise to maintain them have always been challenging to provide.

The modern era of aquarium building is often said to have started in 1969 with the opening of the New England Aquarium in Boston. This new aquarium pioneered many innovative exhibit designs and equally important it became a focal point for the renewal of the downtown area. This concept of combining a great aquarium with urban revitalization continued with the creation of the Seattle Aquarium (1977); the National Aquarium in Baltimore (1981); the Monterey Bay Aquarium (1984); the Aquarium of the Americas, New Orleans (1990); the Texas State Aquarium (1990); the Tennessee Aquarium, Chattanooga (1992); The Florida Aquarium, Tampa (1995); the Aquarium of the Pacific, Long Beach (1998); and the South Carolina Aquarium, Charleston (2000) to name a few. Older aquariums such as the John G. Shedd Aquarium in Chicago, and the Steinhart Aquarium in San Francisco, which were built in the 1920–30's, have embarked upon major renovations, expansions and completely new facilities to provide new exhibits for their visitors and state-of-the-art environments for their animal collections.

One of the most important technological advancements that allowed aquariums to create grand new exhibits with large viewing windows was the use of acrylic panels. Glass was the original standard for all aquariums, but beginning in 1960 a few small acrylic panels were used in an exhibit at Marineland of Florida. Today, nearly all exhibit windows are made of this relatively lightweight material, which has superior optical properties compared to glass.

Another significant change in aquariums and zoos over the last century has been the shift away from menageries toward a greater emphasis on conservation and wildlife management. In 1924, the American Association of Zoological Parks and Aquariums was founded as a professional forum for zoo and aquarium professionals to discuss animal husbandry issues. In 1993 the name of the organization was changed to the Association of Zoos and Aquariums (AZA) and the mission today focuses on wildlife conservation, education and science in addition to animal care. The change in AZA is a reflection of the fact that zoos and aquariums have advanced from

[1] For a more complete history of aquariums, read *"Aquariums, Windows to Nature"* by Leighton R. Taylor, 1993, Prentice Hall General Reference, New York.

being displays of curiosities and oddities, into significant educational, research and conservation institutions. The animals in these facilities now serve as "ambassadors" for their counterparts in the wild, engendering an awareness and concern among the public for the perils facing these animals and their natural habitats. Modern aquariums now play a significant role in channeling public concern for wildlife into effective research and conservation programs, and they bridge the gap between the general public and the scientific community through interpretive graphics, television productions, education programs, field conservation projects, and much more.

The Georgia Aquarium, currently the world's largest aquarium, has truly been built on the shoulders of giants, capitalizing on the best features of modern aquariums, and learning from the mistakes of the past. To cite a few examples: the acrylic window at the Ocean Voyager exhibit is the largest window on the North American continent; a living coral reef now flourishes in downtown Atlanta in the Aquarium's Tropical Diver Gallery; the Education Loop is a major acknowledgement of the importance of education in public aquariums; the Correll Center for Aquatic Animal Health is a great example of public philanthropy and a partnership with a research university (the University of Georgia). Using its financial resources, the Georgia Aquarium has begun to "give back to nature" by sponsoring conservation projects in Georgia and other areas of the world.

The Georgia Aquarium is the culmination of 150 years of inspired design. As we proceed in this book to describe how the Georgia Aquarium was created and how it is operates today, we hope that it will serve as a historical document and also as

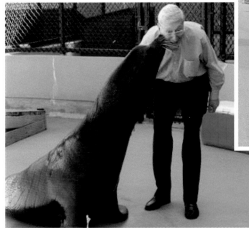

17. Bernie and a sea lion at the New York Aquarium

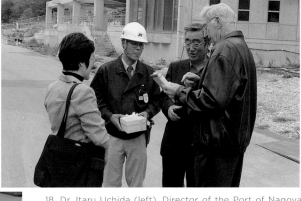

18. Dr. Itaru Uchida (left), Director of the Port of Nagoya Aquarium; and Dr. Senzo Uchida, Director of the Churaumi Aquarium, Okinawa; with Bernie Marcus (February 10, 2002)

a guidebook for those who will create the next generation of grand aquariums.

The World Tour of Aquariums

Before any architects were hired, and before any planning had begun, Bernie embarked on a tour to meet the leaders of the world's greatest aquariums and to tap into their collective wisdom on how to create a great aquarium. Accompanying Bernie was his wife, Billi; the newly hired Executive Director for the Georgia Aquarium, Jeff Swanagan; and the President of The Marcus Foundation, Rick Slagle. Aquarium designer Jim Peterson also joined the group and later was instrumental in helping to formulate its early concepts.

Starting in the fall of 2001 and continuing through the spring of 2002, the entourage traveled 109,000 miles (175,000 km), and visited 56 aquariums in 13 countries. They listened to the best minds and most experienced aquarium professionals in the world, and they had the opportunity to see state-of-the-art exhibits and technology. The collective wisdom of these experts was ultimately summarized in ten invaluable lessons:

Lesson #1: THE AQUARIUM MUST BE DEBT-FREE Aquariums are expensive to build and their annual operating costs run in the tens of millions of dollars. Some very good aquariums have been built on borrowed money and later have run into serious difficulty meeting their financial obligations. To ensure that the Georgia Aquarium would not have this problem, Bernie contributed $250 million, and additional contributions from major sponsors, founders, and thousands of individual donors raised another $70 million.

Developing a conservative business plan was crucial. Too often aquarium developers have underestimated operating costs while over-estimating revenues. The Georgia Aquarium avoided that trap by using energy efficient equipment, maintaining a lean but effective workforce, and maximizing revenues by capitalizing on the convention and leisure markets. This lesson was very clear: unless an aquarium can meet its financial obligations, it cannot begin to achieve its primary mission to provide enjoyable experiences, education, conservation and research.

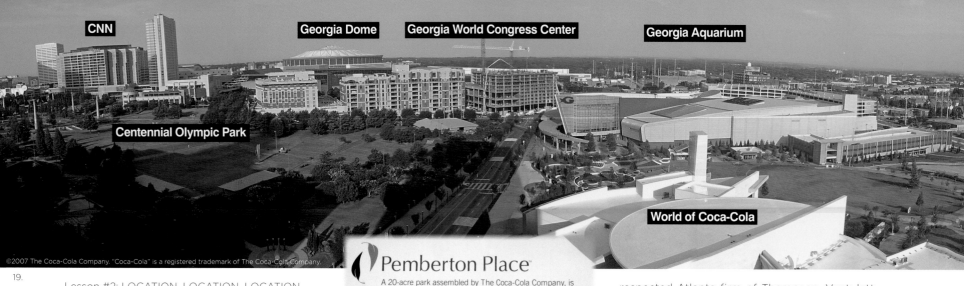

©2007 The Coca-Cola Company. "Coca-Cola" is a registered trademark of The Coca-Cola Company.

19.

Lesson #2: LOCATION, LOCATION, LOCATION

The most successful aquariums have maximized attendance through site synergy, by selecting locations near other quality attractions and destinations. Amazingly, Atlanta had nearly 20 acres of undeveloped real estate in a prime downtown location that had "synergy" written all over it. The location selected for the Georgia Aquarium is a block away from the fourth largest convention center in the United States; it is adjacent to Centennial Olympic Park; CNN world headquarters is located on the opposite side of the park; three professional sports arenas are nearby as well as three central rapid transit hubs; one block to the east is a major interstate highway (I-75/I-85); and nearly 40,000 hotel rooms are within walking distance.

Who owned this incredible property? The Coca-Cola Company owned it, and they were contemplating building a new "World of Coke" attraction there. Bernie met with then-President of The Coca-Cola Company, Doug Daft, and a deal was struck. The new Aquarium would be given the west half of the property for the Georgia Aquarium, while The Coca-Cola Company

Pemberton Place™

A 20-acre park assembled by The Coca-Cola Company, is home to The World of Coca-Cola and The Georgia Aquarium. It is named for John S. Pemberton, who invented the formula for Coca-Cola in 1886. The Coca-Cola Company dedicates Pemberton Place to the people of Atlanta.

would build its new attraction on the remaining half. The entire site would be re-named "Pemberton Place" in honor of Dr. John Pemberton who invented Coca-Cola in 1886.

Lesson #3: DESIGN THE AQUARIUM FROM THE INSIDE-OUT

One way to build an aquarium is start with a concept for a building and then figure out how to make the exhibits fit inside. To Bernie, and everyone with whom he met, this was backwards. Understanding the requirements for the animals must be the first priority, and then the building should be planned around them. Bernie embraced this principle so strongly that he didn't even consider hiring an architectural firm until he was certain he knew exactly which animals and exhibits he wanted inside the building. When the architectural firm was finally selected—the highly

Coca-Cola®

respected Atlanta firm of Thompson, Ventulett, Stainback & Associates (TVS)—they were given their orders: "Don't get carried away designing an extravagant building." The Georgia Aquarium would be about the fish, not architecture. In the end, Bernie got the best of both worlds: exciting interior spaces to showcase aquatic life from around the world, and a magnificent new building for downtown Atlanta.

Lesson #4: DESIGN FOR OPERATIONAL EFFICIENCIES

For over a century, increasingly larger and more sophisticated aquariums have been built around the world, and each of them has pioneered new designs, technologies, and innovative new exhibits. The success of the Georgia Aquarium owes much to the people and the great aquariums that have preceded it, and to those who have so generously offered advice based on their years of experience. Often during the world tour, people would tell Bernie "if we could design this again, here is how we would do it." The design of the Georgia Aquarium was guided by this collective wisdom, and many efficiencies and innovative new ideas became part of the final plan. Three examples are highlighted here and discussed in more detail later in this book.

Dedicated Animal Health Center

Early in the design phase, veterinarians from other aquariums and from the University of Georgia's College of Veterinary Medicine came to Atlanta to help plan a state-of-the-art veterinary clinic and laboratory for the Georgia Aquarium. After nearly two days of intensive work, the team came up with a design that has set new standards for aquariums. The Correll Center for Aquatic Animal Health includes lockers, scrub rooms, a large room for surgical procedures, radiology equipment, intensive care facilities, plus a laboratory, pharmacy, meeting rooms and records rooms. This comprehensive center is connected to all of the exhibit areas via large corridors to allow rapid access in the event of an emergency.

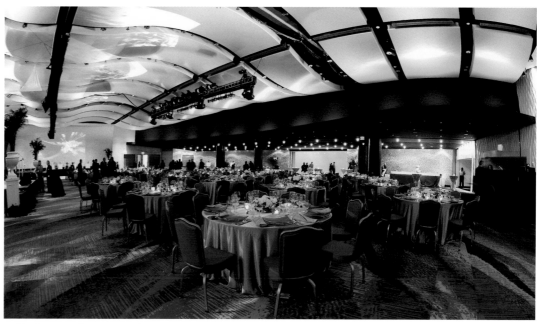

21. The Oceans Ballroom during the grand opening week (November 19, 2005)

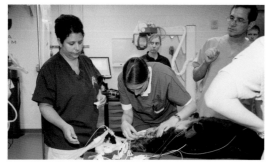

20. A sea otter undergoes a checkup in the Aquatic Animal Health Clinic.

22.

23. Guests in the Oceans Ballroom have their own private views of whale sharks and beluga whales.

Oceans Ballroom

No aquarium in the United States has anything like the Oceans Ballroom at the Georgia Aquarium. This 16,400 square foot ballroom can be divided into three separate banquet rooms and is complete with views into the Ocean Voyager exhibit and the Beluga Whale exhibit.

The Education Loop

Bernie correctly understood from his visits to other aquariums that the exhibits have to be exciting and enjoyable, and he also recognized the importance of education to make the new Georgia Aquarium a valuable asset to the community. While all aquariums provide education programs, the amount of space devoted to classrooms and educational activities often seems like an afterthought, but not at the Georgia Aquarium. The second floor, which covers nearly 25% of the public space, has been dedicated to education. The Education Loop wraps around the entire building, taking advantage of the space above each exhibit to allow students an exclusive view into the exhibits. Adjacent classrooms allow students uninterrupted learning opportunities

The Correll Center for Aquatic Animal Health, the Oceans Ballroom and the Education Loop are three of many unique design features of the Georgia Aquarium that were inspired by the world tour.

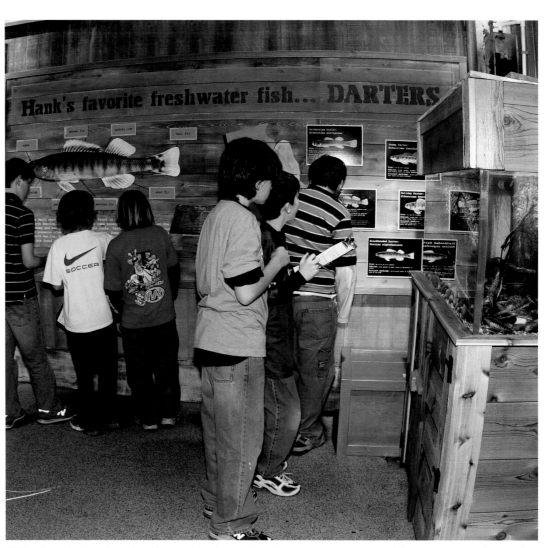

24. The Education Loop is a unique feature of the Georgia Aquarium and gives students an uninterrupted opportunity to explore the galleries and learn about aquatic animals.

25. The west side of the Aquarium has 1.5 acres of land in reserve for possible future expansion.

Lesson #5: NEVER CONSIDER THE AQUARIUM "FINISHED"

All of the aquariums on the world tour had undergone expansion, or major remodeling, or they were contemplating plans to do so. Aquariums are constantly reinventing themselves and offering new exhibits and new programs for their guests, ensuring that every visit will feel like a new experience.

With this lesson in mind, planning for the Georgia Aquarium included a 6,000 square foot area for changing exhibits, a multi-use theater, life support systems stubbed out for increased capacity, and 1.5 acres of land kept in reserve on the west side of the building for future expansion.

Lesson #6: A.D.R.O.I.T.

Jim Peterson, a veteran of aquarium design and an early consultant to the Georgia Aquarium, offered up the acronym "ADROIT" for six design criteria considered critical for a successful guest experience:

A = Arrival. Guests must know they've reached their destination by seeing a sign, sculpture, logo or the significant architecture of the building.

D = Decompression. After making the journey to the Aquarium, help visitors decompress by creating a pleasant transition from the hectic city to the enjoyable experience inside the Aquarium.

R = Reception. Welcome guests with open arms and smiling faces!

O = Orientation. Once inside the building, help guests find out where to go next by presenting a map or other means of orientation.

I = Investigation. This is the part where guests explore the galleries and exhibits.

T = Termination. Planning an interesting point of departure and transition back to the city is the final element of the visitor experience.

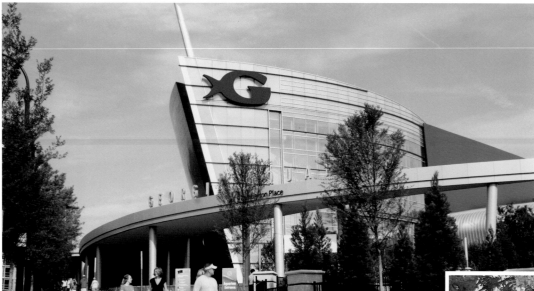

26. The distinctive logo is an unmistakable sign to guests that they have arrived at the Georgia Aquarium.

27. The plaza leading to the ticketing windows is accented with flower gardens.

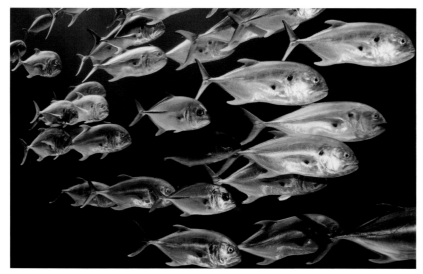

28. Once inside, a "wall of fishes" (jacks) guides visitors to the spacious interior atrium.

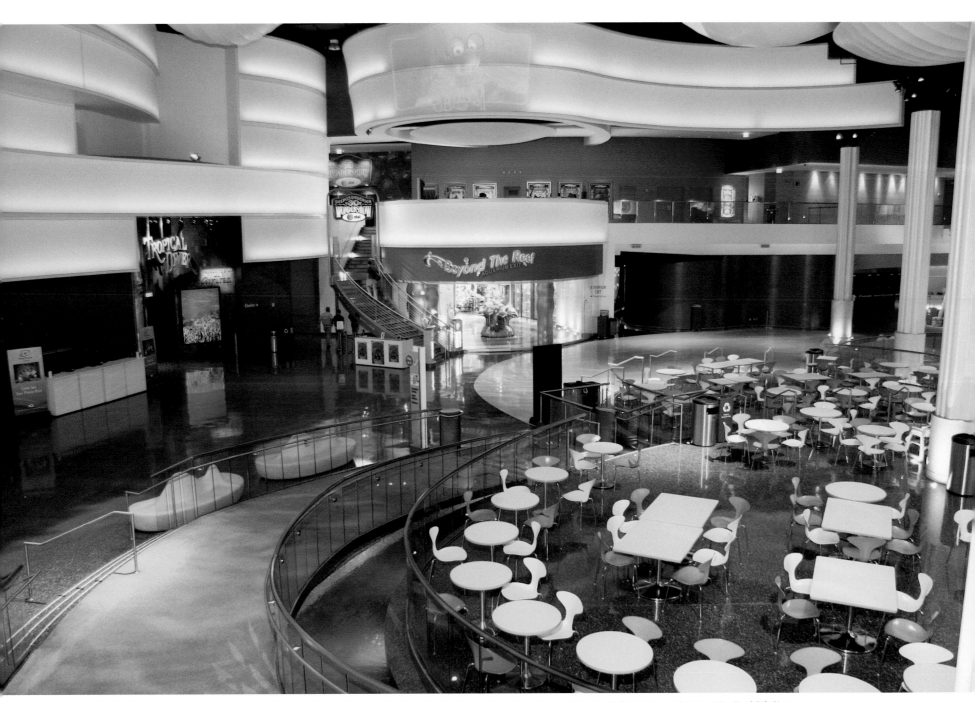

29. The huge central atrium is a gathering place and the starting point for investigating the exhibit galleries, the 4-D Theater, Café Aquaria, and Beyond the Reef Gift Shop.

Lesson #7: CONNECT WITH THE COMMUNITY

The most successful aquariums in the United States and elsewhere in the world have developed strong ties with their communities. Businesses, civic groups, conservation organizations, educational institutions, government agencies, hobbyists, families and individuals have become intimately involved in their local aquariums and take great pride in their association. Taking this lesson to heart, early in its development, the Georgia Aquarium reached out to people throughout the state and received an outpouring of support. Some groups helped develop concept ideas for exhibits; others were involved in developing education and conservation programs; while others helped design facilities such as the animal health clinic. Thousands more became volunteers or made monetary or in-kind donations.

32.

30.

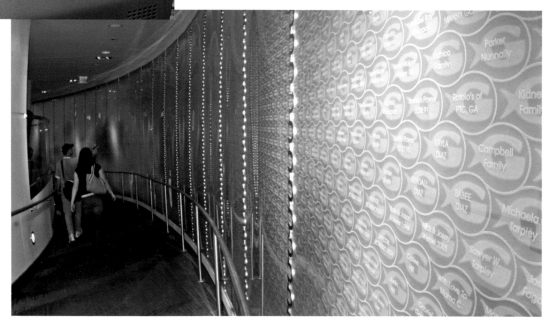

31. Over 35,000 people added their names to the "Fish Scale" donor wall by making a contribution to the Georgia Aquarium. Individual scales can be located by typing a name on the nearby computer kiosk.

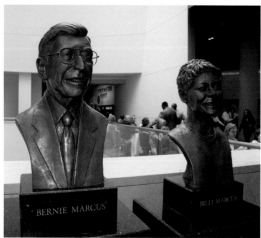

33. Busts of Bernie and Billi Marcus are a focal point in the beautiful Recognition Rotunda.

Lesson #8: REACH THE HEARTS AND MINDS OF VISITORS

One of the great lessons to emerge from the world tour was the importance of creating an appropriate balance between entertainment and education. Certainly, people visit aquariums to have an enjoyable experience, but if the exhibits are created simply for amusement the experience may be perceived as trivial. Conversely, an aquarium risks losing its audience to boredom if it is too academic. Bernie was keenly aware that an aquarium that generates excitement and wonder could also affect people's hearts and minds, and this could change their attitudes and behaviors towards the environment and aquatic life. Creating a truly enjoyable, engaging and enriching experience ultimately became the overarching goal of the Georgia Aquarium.

One organization that played an early role in helping the Georgia Aquarium formulate this exhibit philosophy was The Ocean Project. Surveys conducted by The Ocean Project clearly indicated that most people have little understanding about the ocean or how it affects their lives. The Ocean Project's mission is to increase the public's awareness and concern for the oceans by enlisting the support of aquariums, zoos, science centers, museums and other educational centers, and collaborating to create "a lasting, measurable awareness of the importance, value and sensitivity of the ocean." Positive messages and experiences are far more effective at achieving this goal than encyclopedic listings of names and facts. The Georgia Aquarium has become an enthusiastic partner in this important effort and will continually improve the way it engages visitors through one-on-one contacts between guests and aquarium staff, and through innovative graphics, video presentations, audio tours, and education programs for students and the general public.

Lesson #9: PRACTICE WHAT YOU PREACH: CONSERVATION

The most important lesson guests should learn during a visit to an aquarium is that their actions can affect the oceans and aquatic animals, and that by making the correct choices their impact on the environment can be minimized. The Aquarium must also lead by example and demonstrate that it too is making decisions that are directed toward conservation, by reducing consumption of resources, recycling, sponsoring programs and research to help protect wildlife and habitats, and by providing incentives for employees to become more conservation-minded in their daily activities.

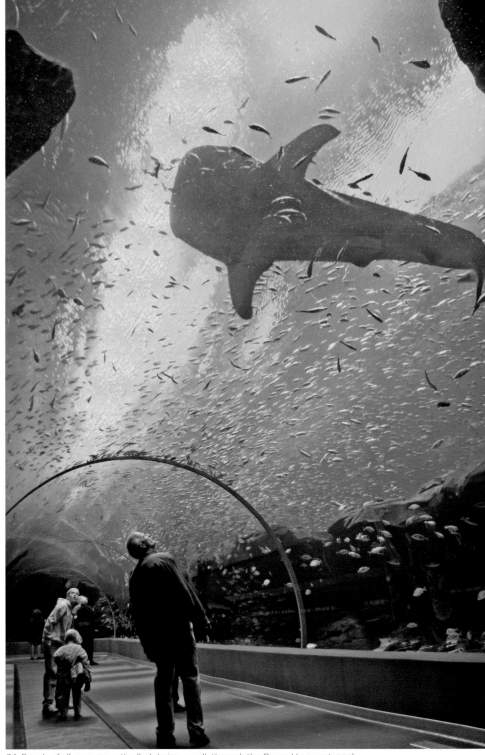

34. People of all ages are enthralled during a walk through the Ocean Voyager tunnel.

The Georgia Aquarium determined it would preferentially acquire animals that needed rescue or rehabilitation, or to obtain animals bred in other aquariums or on aquaculture farms. As an example, of the thousands of fishes in the Ocean Voyager exhibit, the majority was obtained from aquaculture sources. Other fishes, notably the whale sharks, were obtained from fishermen before they could be sold on the market as food.

Within six months of opening, the Georgia Aquarium had established an extensive internal recycling program, had became a partner in the national Seafood Watch program, offered employees subsidies for riding public transportation (MARTA), and had sponsored conservation-related research projects in several locations around the world. This commitment to conservation will continue to grow as the Georgia Aquarium matures.

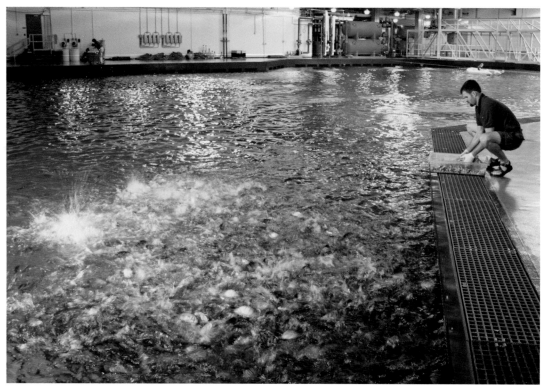

35. Many of the fishes in Ocean Voyager, such as these golden trevally, were obtained from fish farms.

36. The majority of living corals in the Pacific Barrier Reef exhibit was obtained from cultures maintained at other public aquariums.

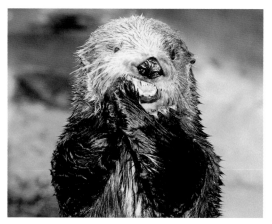

37. The Georgia Aquarium has two sea otters. One of them was born at the Oregon Zoo, while the other was a rescued animal that could not be returned to the wild.

38. Bernie Marcus presents his thoughts to the planning team (May 12, 2002).

Lesson #10: BERNIE'S WORDS OF WISDOM

When his world tour was finished, Bernie knew what he wanted to do and was ready to assemble his team to create the Georgia Aquarium. He had absorbed all the collective wisdom from the world leaders in aquarium management, husbandry and technology, and to this he added his own words of wisdom as guidance for his new design team:

"Think outside the box"—Bernie despised hearing anyone say, "it can't be done." He constantly pushed the team to the edge of the envelope—and beyond. He said he wanted an "aquarium like no other."

"There is no place for tradition at the Georgia Aquarium"—Whenever the design team began to revert to traditional solutions and planning methods, he insisted that the team go back to the drawing board and come up with fresh new concepts.

"The Georgia Aquarium must be a WOW experience"—Bernie wanted exhibits that would be so well done and so compelling that everyone would say "WOW" when they saw them. If any exhibit didn't pass this test, it never made it off the drawing board.

The design team's attentiveness to the lessons from the world tour, and to Bernie's personal directives paid off handsomely after the Aquarium opened. One million people passed through its doors every 100 days during its first year setting new attendance records for aquariums in North America—and probably no one visited without saying "WOW!"

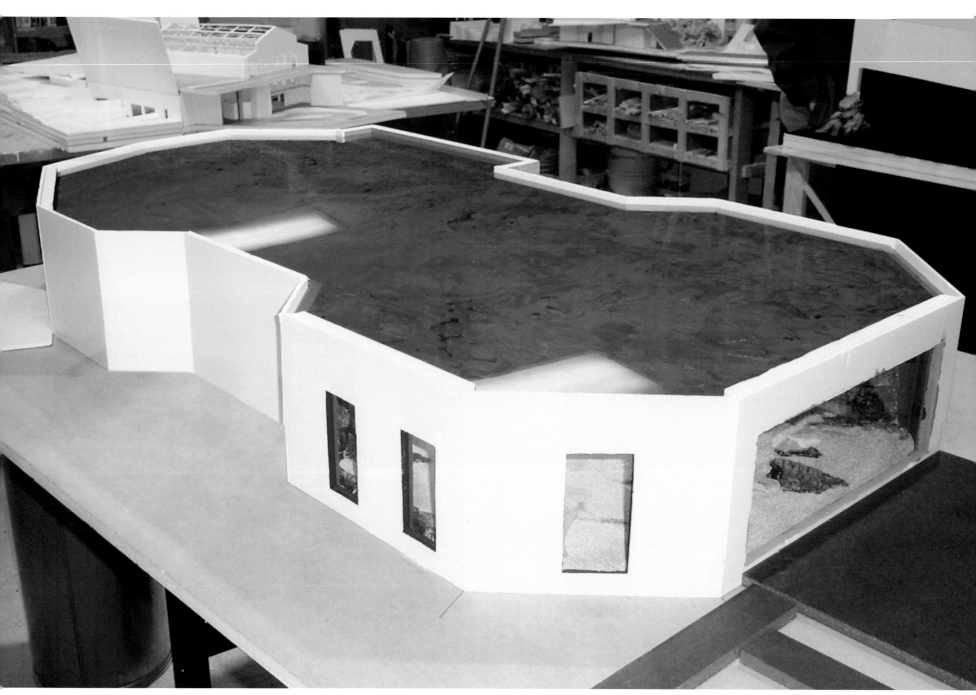

39. A scale model of the Ocean Voyager exhibit (May 18, 2003)

CHAPTER TWO:

Conceptual Planning and Design 2002–2003

Conceptual Planning and Design 2002 – 2003

The Georgia Aquarium team started with its first employee, Jeff Swanagan, who knew the Atlanta area very well from his many years of service at Zoo Atlanta. Jeff left Zoo Atlanta in 1998 to serve as the Director of The Florida Aquarium in Tampa, which had been struggling under massive debt and low attendance. Jeff was instrumental in leading The Florida Aquarium out of its depressed state-of-affairs and into a bright new era, and he soon caught the attention of Bernie Marcus. Bernie made an offer to Jeff that he couldn't refuse and on November 19, 2001 — the day that Bernie announced his intention to build the Georgia Aquarium — he also announced the appointment of Jeff Swanagan as its Executive Director.

Jeff got off to a fast start and began recruiting his team even before the announcement. Jim Peterson, a veteran aquarium planner and designer with his own firm, BIOS, came aboard early as a principal advisor during the conceptual design phase. Another key advisor during the first year was Steve Kaiser, whose expertise included the design of exhibits for very large marine animals. On September 10, 2001, Jeff met with the senior author of this book, Bruce Carlson, during the annual meeting of the Association of Zoos and Aquariums in St. Louis and asked if he might be interested in joining the team. At that time, Bruce was Director of the Waikiki Aquarium in Hawaii, but like many employees to follow, he saw this as an once-in-a-lifetime opportunity.

On April 1, 2002, Bruce officially joined the Georgia Aquarium. During this year, he recruited the key Husbandry and Life Support personnel who would be instrumental in guiding the design

and construction of the exhibits, including Ray Davis, a veteran of the SeaWorld parks; Mike Hurst, also from SeaWorld with an impressive resumé of experience in life support system design and operation; and Tim Binder, a marine mammal expert from the Mystic Aquarium in Connecticut. Ray would eventually become the Senior Vice President of the Georgia Aquarium, Mike would become the Director of Plant Engineering and Operations, and Tim would become the Director of Husbandry. Together, they organized the teams and the logistics that would ultimately bring whale sharks, beluga whales and all of the other animals safely to Atlanta. Other key players who arrived early were Angela Peterson, who became the Director of Guest Programs, and Brian Davis, who served until 2006 as the Director of Education. These two were instrumental in developing the concepts and programs for interpreting the exhibits for guests as well as education programs for school groups.

40. Jim Peterson, February 28, 2002

41. One of the first planning workshops. Left to right: Rick Slagle, Jim Peterson, Bruce Carlson, Steve Kaiser (February 28, 2002)

42. PGAV joins the team. Clockwise: Steve Kaiser, Mike Hurst, Bruce Carlson, Jim Moorkamp (PGAV), and Ray Davis (April 22, 2003)

43. Gary Goddard (right) with Bernie Marcus and Jeff Swanagan (May 12, 2002)

During the conceptual planning phase in 2002, the Georgia Aquarium team contracted with Heery International to serve as the Project Management Company under the leadership of David Kimmel. Heery developed the specifications and contracts for all firms associated with this project, and would oversee all phases of construction. Thompson, Ventulett, Stainback & Associates (TVS), under the guidance of Gary Fowler, was selected as the primary architect to create the design for the building and all of its interior spaces. Another specialized architectural firm, Peckham Guyton Albers & Viets, Inc., (PGAV), under Jim Moorkamp and Al Cross, came on board to work with the Georgia Aquarium team to develop all of the exhibits and themed spaces. Bernie enlisted the services of a talented and creative artist, Gary Goddard, and his team at Gary Goddard Enterprises, to create the theatrical highlights and an animated film to ensure that the Georgia Aquarium would become an exciting experience for all visitors. Eventually hundreds more consultants, contractors, and sub-contractors would be recruited to design or construct all of the myriad details of the Georgia Aquarium.

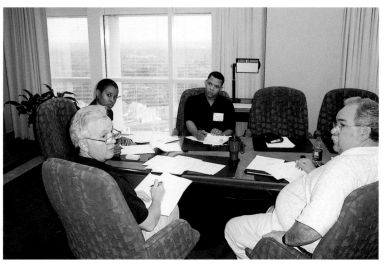

44. Angela Peterson and Brian Davis, with Ray Davis (right) and Bruce Carlson (May 16, 2003)

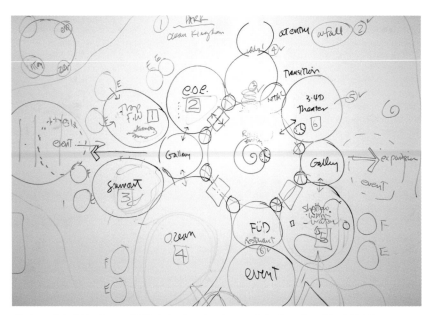

45. An early bubble diagram highlighting functional areas of the Aquarium (May 1, 2002)

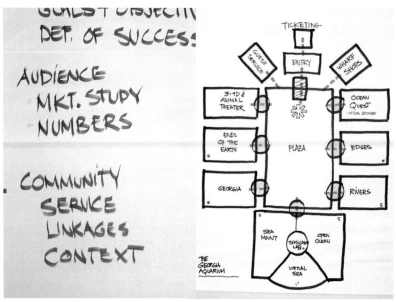

46. Evolving ideas about the purpose of the Aquarium and arrangement of galleries. Left: May 14, 2002; Right: May 31, 2002

During the first year of planning in 2002, the Georgia Aquarium offices were located in The Home Depot world headquarters on Paces Ferry Road in northwest Atlanta. All of the conceptual planning meetings and early design work were conducted in this building. Intensive all day, weeklong workshops commenced in May 2002 and continued throughout that summer under the skillful coordination of Rick Slagle. The mission and goals of the new Aquarium were established early, as well as most of the key exhibits; however, the layout and theming for the exhibits extended well into 2003.

One critical design decision centered on visitor circulation. Many aquariums require visitors to follow a linear pathway to see all of the exhibits, but there is no way to backtrack until reaching the end of the journey. The Georgia Aquarium took a different approach, using the "mall concept" to organize all of the exhibits into galleries surrounding a huge central gathering place or atrium. Visitors entering this atrium can visit any of the galleries in any order they wish and always return to the atrium to rendezvous with family members and plan where to go next. Also, each gallery is independent of the others, allowing each one to tell unique stories about different animals and habitats. This concept appeared in the earliest sketches laid out in May 2002.

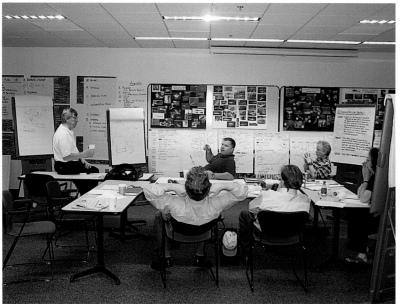

47. The Georgia Aquarium planning team (May 14, 2002)

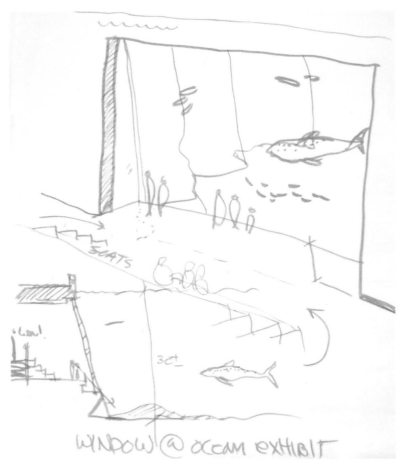

48. The earliest sketch of what would become the Ocean Voyager exhibit (May 23, 2002).

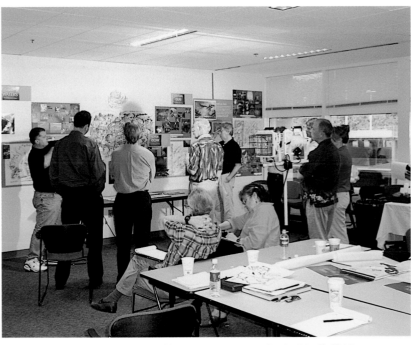

49. At the end of the day, the team would give a presentation to Bernie (May 31, 2002).

Bernie was clear that he wanted an aquarium that would open the eyes of every visitor to the wonders of the underwater world, from the waters of Georgia to the most remote corners of the planet. He wanted to showcase the variety of life found in streams and rivers, coastal marshes, coral reefs, the polar seas, and the open oceans. He wanted the world to know that much of this incredible diversity of life needs protection to ensure its survival. The Georgia Aquarium, in Bernie's view, would not only present this diversity of life to the public but it would make a difference in helping conservation efforts around the world. How would the planners and designers create suitable habitats and exhibits for this wealth of aquatic life, and at the same time make it interesting and accessible to visitors? Completing that task took the rest of 2002 and didn't end until the last animals were introduced to their exhibit habitats in 2005.

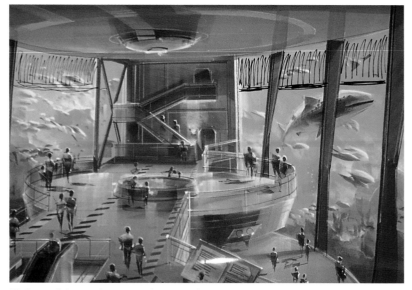

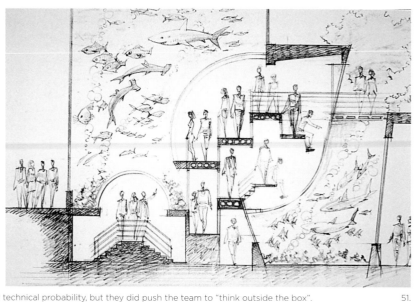

50. Some of these early concepts for the whale shark exhibit would have been beyond financial or technical probability, but they did push the team to "think outside the box".

51.

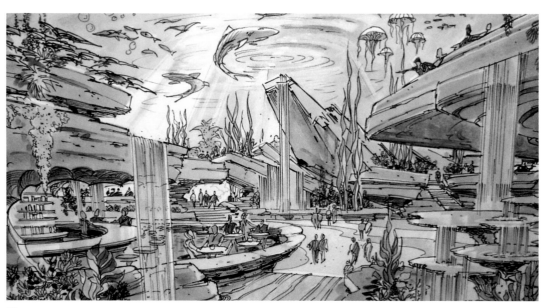

53. Concepts for the central atrium inside the building included lights, waterfalls and ceiling panels. Elements of these ideas remained in the plans right to opening day.

52.

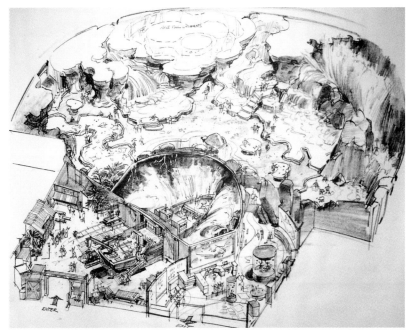

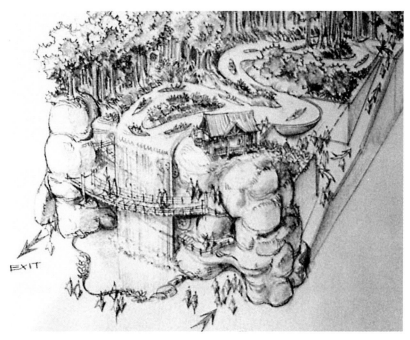

54. This early concept for the Georgia Explorer gallery would have been as large as the entire Georgia Aquarium is today. The shrimp boat and touch pools remained in the final plans.

55. A waterfall and the idea of walking under the river, as seen in this early rendering, are still part of the actual River Scout gallery.

With all the key planners on board, and conceptual design well underway in 2002, one final significant player remained to be selected. Who would be selected to build the Georgia Aquarium? This project was more complex than anyone could imagine and came with a completion deadline that was all but impossible to achieve. Ultimately, the firm of Brasfield & Gorrie from Birmingham, Alabama was selected as the general contractor. There is no doubt that much is owed to this firm, and other outstanding subcontractors — particularly Henderson Electric and McKenney's, Inc., for completing this monumental project in record time while striving to maintain the highest standards of craftsmanship. Brasfield & Gorrie, under the relentless oversight of Eric Young, Dewayne Strickland and Michael Freberg kept the pace of construction going so fast, day and night, that the old adage of "design-build" often seemed like the other way around.

By March 2003, Brasfield and Gorrie began mobilizing in preparation for more than two years of round-the-clock construction, which is the topic of Chapter 3.

56. Bernie was adamant that the Georgia Aquarium would be about animals, not rides so this concept was omitted.

57. Groundbreaking ceremony May 28, 2003

58

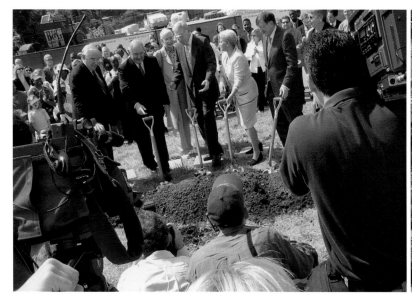

59. Governor Sonny Perdue, Billi and Bernie Marcus, Mayor Shirley Franklin and other guests participate in the ground-breaking ceremony.

60.

CHAPTER THREE:

Construction

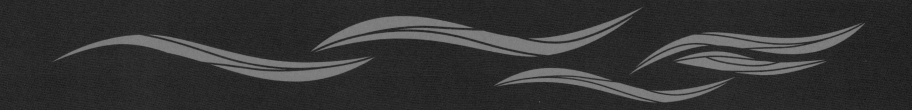

Construction

From groundbreaking on May 29, 2003, to the completion of construction in September 2005, the world's largest aquarium in downtown Atlanta was completed in an astonishing 28 months. Bernie was insistent that the Georgia Aquarium would open before Thanksgiving 2005 and that deadline was met. What happened in the intervening two and a half years was nothing less than Herculean.

Site preparation began early in March 2003. By June, construction officially began when the first of 2,500 auger-cast piles was driven into the ground to bedrock below. One month later, construction began simultaneously on Ocean Voyager and the Beluga Whale habitat. The Ocean Voyager aquarium is massive, with walls up to 4' (1.2 m) thick and over 30' (9.1 m) high. Engineers and contractors who design and build "normal" buildings can begin to appreciate the complexity of pouring this much concrete to create walls of this height and thickness – and in a single pour with no cold joints. Equally impressive, just one of the walls in Ocean Voyager contains more than 300 tons of steel reinforcing bars (rebar). Nearly 100,000 cubic yards of concrete were used in the Georgia Aquarium, enough to build a 100-story office building, and more than was used to build The Georgia Dome.

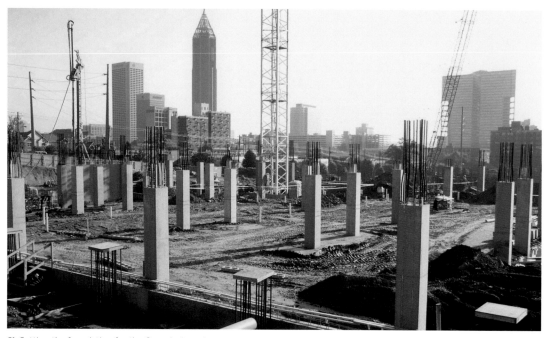

61. Setting the foundation for the Georgia Aquarium

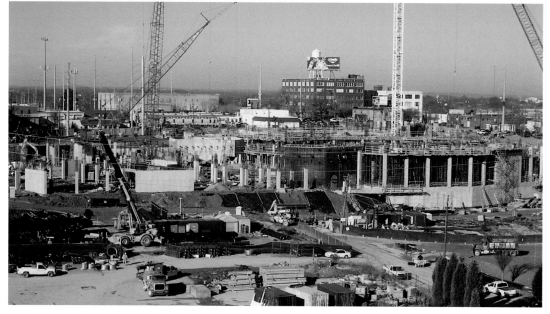

62. Rising from the ground (January 2004)

Waterproofing the concrete was a significant concern. The walls had to be perfectly smooth so that the sharks and other fishes would not be harmed if they rubbed against them. Before the waterproofing could be applied, the walls had to be completely dry and the temperature and humidity controlled for the proper adhesion of the waterproofing to the concrete. The surrounding air had to be free of dust, which is not easy to accomplish on an active construction site. To manage the environmental conditions, a deck was constructed over the entire Ocean Voyager exhibit along with a surrounding plastic curtain to control the environment inside. When the waterproofing was finally set, it was smoothed to a fine finish—a process that took teams of 15 or more people to complete.

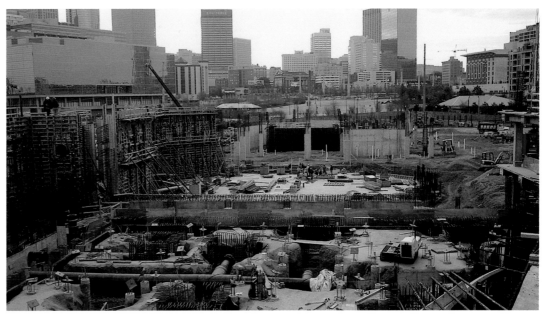

65. Ocean Voyager under construction, view looking to the south (January 2004)

63. Beluga whale exhibit (February 2004)

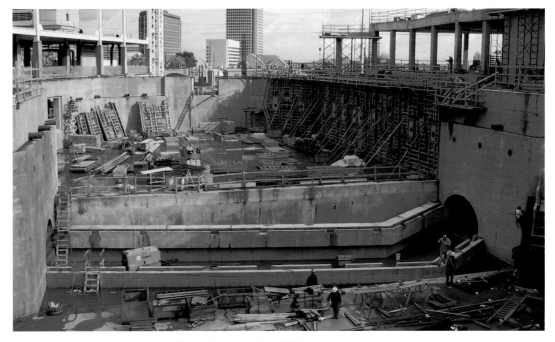

64. Oceans Ballroom (January 2004)

66. The foundation for the tunnel inside Ocean Voyager (April 13, 2004)

Forming and creating the gigantic opening for the acrylic window was an incredible construction feat. The Brasfield and Gorrie team created this huge opening with a nearly perfect two-inch gap all around to allow for the proper installation of the window. The window itself was fabricated in Japan by the Nippura Corporation and arrived in six sections, each 24" (61 cm) thick and weighing just under 20 tons (18 metric tons). Due to the proprietary nature of their work, the team from Nippura worked in complete secrecy to bond the six sections together and seal the window in its concrete frame. The bonds between the sections took three months to properly cure under a constant temperature of 179°F (81.6°C). This was achieved by constructing a waterproofed enclosure made of plywood that spanned the entire height and width of the window. The completed Ocean Voyager acrylic window weighs 119 tons (107,955 kg) and is the second largest window of its kind in the world (the largest is at the Churaumi Aquarium in Okinawa, Japan).

The life support systems (LSS) for the Georgia Aquarium are said to be larger than any city water purification system in the state of Georgia. Some of the pipes that move water through the Ocean Voyager are 54" (137 cm) in diameter. All combined, the Georgia Aquarium life support systems house 218 pumps using 4,160 horsepower and move 261,000 gallons (988,000 liters) of water per minute. In Ocean Voyager alone, the entire 6.33 million gallons (24 million liters) of water flows through the LSS every 60 minutes. Controlling all of these pumps, valves, filters, and the flow of water through miles of pipes is a dedicated computer system connecting 3,200 control points via 25 miles (40.2 km) of wiring.

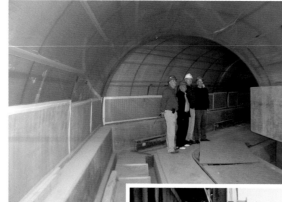

67. Bernie and Jeff on an inspection tour inside the Ocean Voyager tunnel (October 14, 2004)

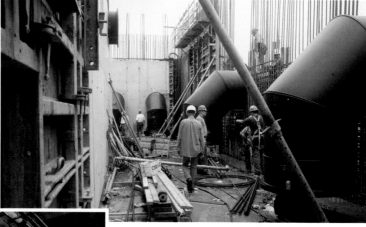

68. 54" high-density polyethylene (HDPE) pipes handle the water in Ocean Voyager (Mike Hurst walking)

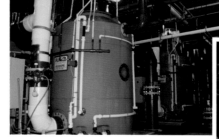

69.

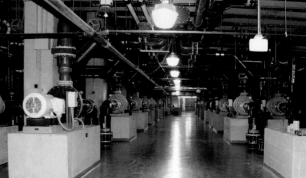

70. Two views of the pumps and filters in the Ocean Voyager life support system

A concrete waterproof vessel with an elaborate plumbing system is only part of the way to completion. Rockwork and other habitat themes are also required to transform a bare tank into an aquarium environment suitable to sustain aquatic life in excellent condition—indefinitely. The amount of concrete and fiberglass rockwork required in all of the galleries was more than any single company could manage. In the end, four different companies were hired to work on separate galleries.

From the beginning, Bernie stressed the importance of reliable systems. For Bernie, this meant Life Support, Ticketing, Web Site, and Communications had to be up to the challenges of running the world's largest aquarium. Thanks to technical assistance from Accenture, Microsoft and UNISYS, a powerful Data Center was designed and installed on the driest and safest area of the Aquarium's top floor to manage the information systems throughout the building. As an example

of the workload, the ticketing system had to handle over one million visitors every 100 days and direct them to the best times to book their visit. In its first year, the Aquarium's on-line reservation system sold nearly 2 million tickets – allowing the Aquarium to handle the unprecedented crowds that visited the first year. The system was so successful it won the Computerworld 100 Best in Class Award for the year 2006.

During the months prior to opening, Husbandry staff was spread around the globe collecting animals. Staff relied on the Internet and cellular phone technology to keep the logistics of collecting, permitting, and transportation running smoothly. On one flight from Taiwan back to the U.S, Ray Davis kept tabs on other husbandry projects using an Internet phone on his laptop computer through the wireless Internet connection on the plane.

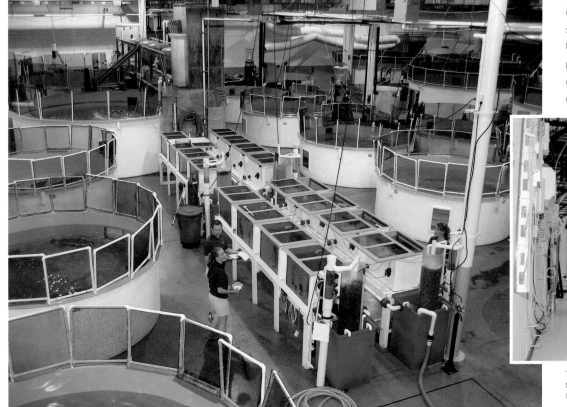

71. A 75,000 sq. ft. warehouse west of Atlanta was secured in late 2002 to quarantine all of the fishes destined for the new Aquarium. Mark Olsen and Lisa Cloudt, Christine Light (far right)

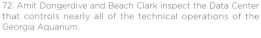

72. Amit Dongerdive and Beach Clark inspect the Data Center that controls nearly all of the technical operations of the Georgia Aquarium.

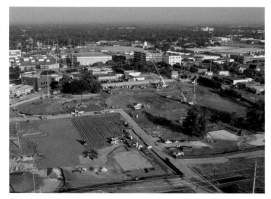

73. May 2003

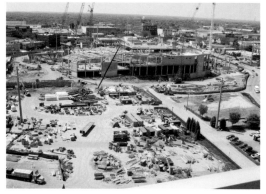
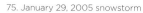

74. April 19, 2004

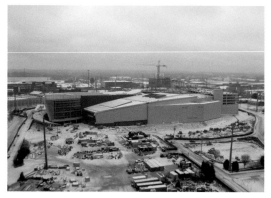

75. January 29, 2005 snowstorm

76. May 14, 2007

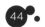 44

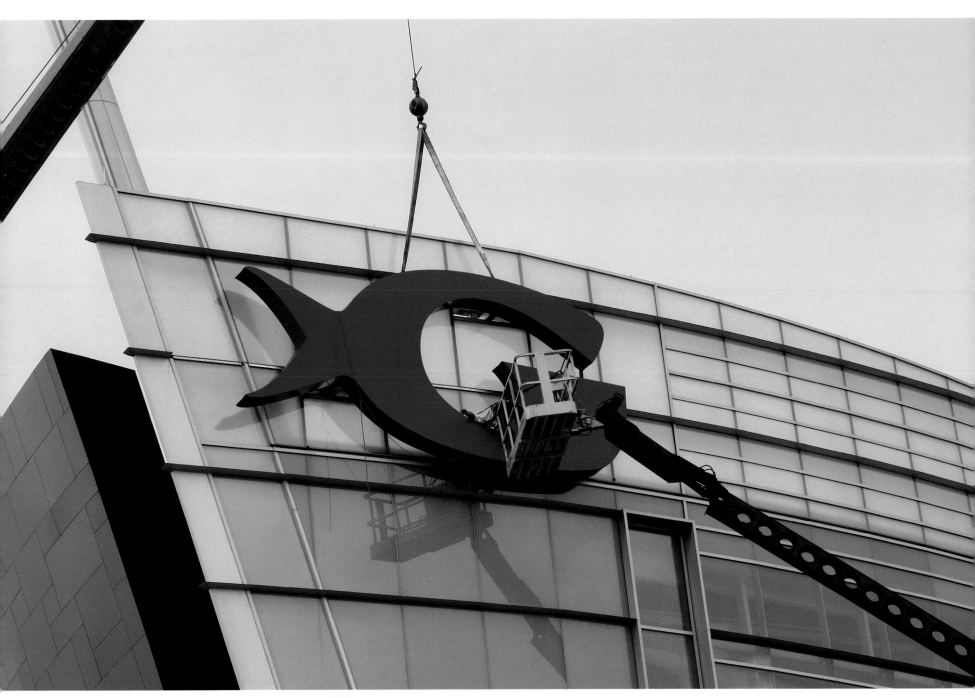

77. Installing the Georgia Aquarium logo, September 29, 2005

Turning over the building to the Georgia Aquarium staff took place in phases – 14 phases to be exact. Ocean Voyager was first to be completed in March 2005, and only three months later this exhibit welcomed its first whale shark. The Tropical Diver gallery was next in line and was turned over to the staff in early July 2005 to give them time to establish a living reef ecosystem. One by one, the remaining galleries were completed and handed over. As the workload increased so did the staffing and the level of activity. Bernie, himself a master of marketing, entrusted the advertising, marketing and public relations for the Aquarium to two advisors, Joel Babbit and Donna Fleishman. Greg Rancone, who joined the Aquarium, worked tirelessly on promotions and event marketing. Throughout that summer and fall, any thought of an eight-hour workday, leisurely weekends, holidays or vacations was at best wishful thinking.

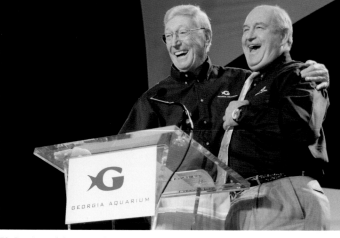

79. Bernie and Governor Sonny Perdue November 19, 2005

The Grand Opening

November 2005 is a blur for just about everyone who was on the staff at that time. Bernie said the Aquarium would open that month, and indeed it did. Here is the sequence of events that took place:

Friday, November 18, 2005: The families of the Aquarium staff and construction workers were given their first opportunity to see all of the exhibits.

Saturday, November 19, 2005: Bernie and Billi Marcus, Governor Sonny Perdue, Mayor Shirley Franklin, and the major sponsors of the Georgia Aquarium galleries cut the ribbon at 2:07pm and officially opened the Aquarium. The ribbon cutting ceremony was followed by a tour of the aquarium for the 425 international media who attended. Later that evening an elaborate dinner was held in the Oceans Ballroom for the presenting sponsors.

Monday, November 21: This day began with a live broadcast of the TODAY show from NBC with Matt Lauer and Al Roker at the Aquarium. The rest of the day the Aquarium was open exclusively to Annual Pass holders. Public response after the TODAY Show aired was huge. Millions of people tried to access the Aquarium's web site and it crashed!

Shortly afterwards, the web site was upgraded to increase its capacity 25-fold.

Tuesday, November 22: The Aquarium was again open exclusively to Annual Pass holders. Bernie Marcus and Jeff Swanagan were featured on a live satellite media tour broadcast nationwide. Later that evening, another elaborate dinner event was presented for all the corporate sponsors.

Wednesday, November 23: The general public finally had their first opportunity to see the Aquarium. Radio, television and print media were everywhere, including CNN, *The Early Show* from CBS, and *Good Day Atlanta* from Fox 5.

Thursday, November 24: Aquarium staff and volunteers enjoyed a Thanksgiving dinner prepared by volunteers from the Atlanta Reef Club and Restaurant Associates.

78. Bernie and honored guests at the opening ceremonies, November 19, 2005.

80. Governor Sonny Perdue, Mayor Shirley Franklin and Billi Marcus, November 19, 2005

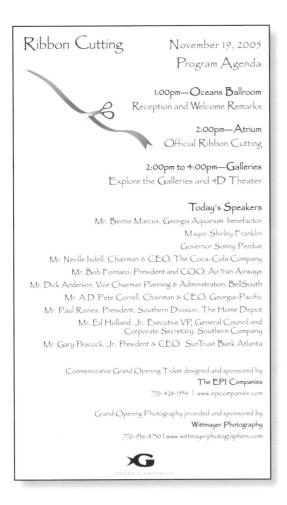

Ribbon Cutting November 19, 2005
Program Agenda

1:00pm—Oceans Ballroom
Reception and Welcome Remarks

2:00pm—Atrium
Official Ribbon Cutting

2:00pm to 4:00pm—Galleries
Explore the Galleries and 4D Theater

Today's Speakers
Mr. Bernie Marcus, Georgia Aquarium benefactor
Mayor Shirley Franklin
Governor Sonny Perdue
Mr. Neville Isdell, Chairman & CEO, The Coca-Cola Company
Mr. Bob Fornaro, President and COO, AirTran Airways
Mr. Dick Anderson, Vice Chairman Planning & Administration, BellSouth
Mr. A.D. Pete Correll, Chairman & CEO, Georgia-Pacific
Mr. Paul Raines, President, Southern Division, The Home Depot
Mr. Ed Holland, Jr., Executive VP, General Council and
Corporate Secretary, Southern Company
Mr. Gary Peacock, Jr., President & CEO, SunTrust Bank Atlanta

Commemorative Grand Opening Ticket designed and sponsored by
The EPI Companies
770-428-1554 | www.epicompanies.com

Grand Opening Photography provided and sponsored by
Wittmayer Photography
770-936-8730 | www.wittmayerphotographers.com

G
GEORGIA AQUARIUM

By the end of November 2005, more than 100,000 visitors had streamed through the Aquarium's doors. By January 2006, sales of annual passes were suspended when the total reached 300,000 (the original projection was 80,000). One hundred days after opening, on February 28, 2006, Richard Rainey and his family from Mableton, Georgia, were surprised when they arrived at the Aquarium and were greeted by TV cameras, fanfare, and a special welcome from Bernie Marcus as the one-millionth guest. As the year continued, another million people would enter the Aquarium every 100 days, and by the end of the first twelve months the total attendance exceeded 3.6 million, well beyond the original projection of 2.4 million.

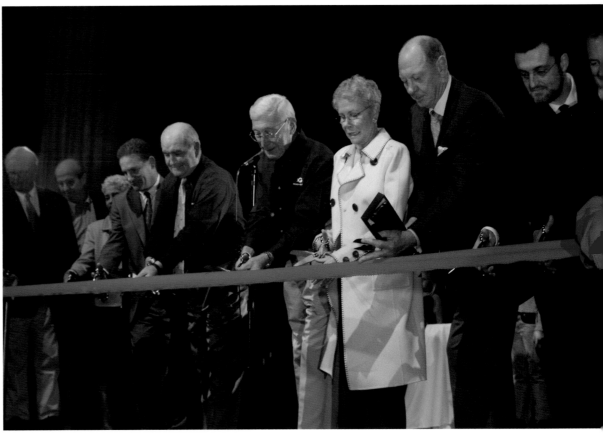

81. At 2:07 pm November 19, 2005 the ribbon cutting ceremony officially opened the Georgia Aquarium.

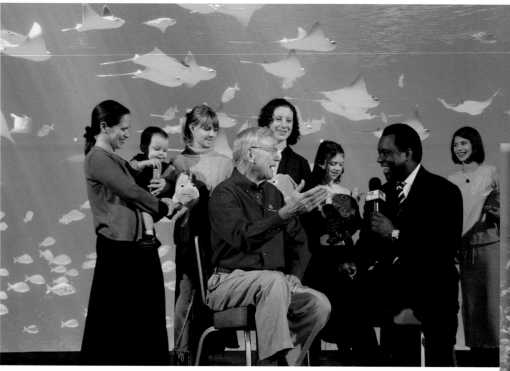

82. Bernie and family with reporter Mark Hayes from Fox 5 Good Day Atlanta. (November 23, 2005).

83. Bernie and family greeting the first guests on opening day (November 23, 2005).

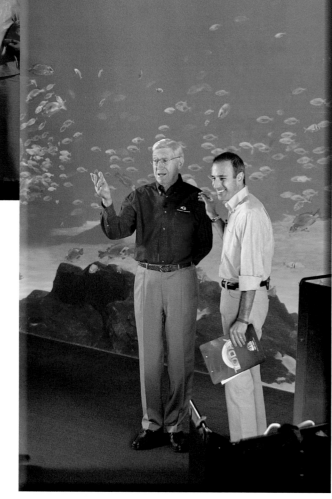

84. Matt Lauer interviewing Bernie on the TODAY Show (November 21, 2005).

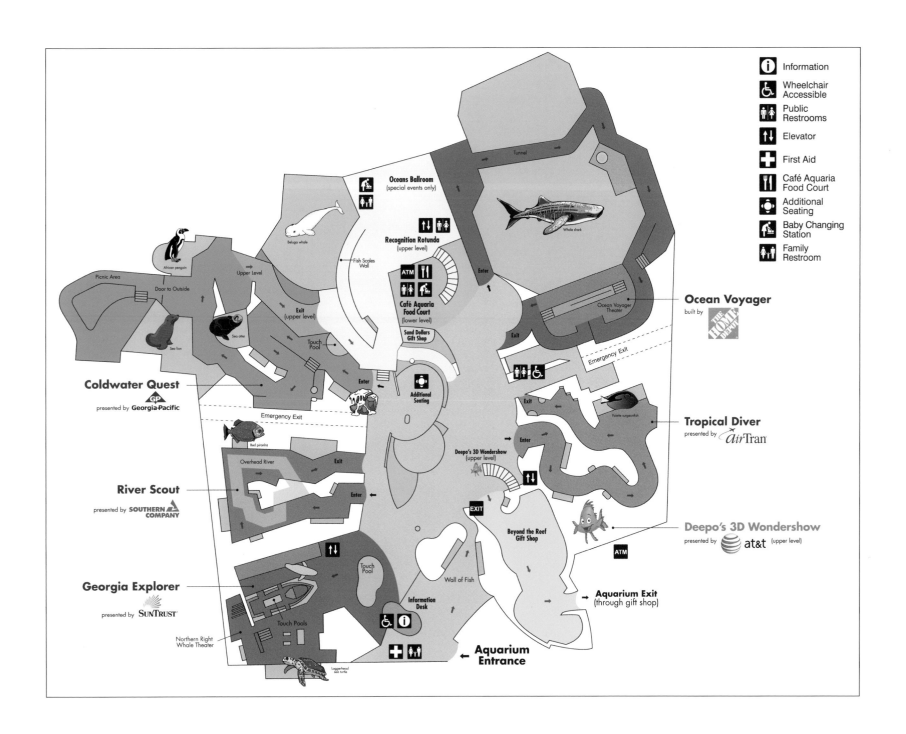

Information

Wheelchair Accessible

Public Restrooms

Elevator

First Aid

Café Aquaria Food Court

Additional Seating

Baby Changing Station

Family Restroom

Oceans Ballroom
(special events only)

Tunnel

Whale shark

Beluga whale

Recognition Rotunda
(upper level)

Fish Scales Wall

African penguin

Picnic Area

Upper Level

Door to Outside

ATM

Café Aquaria Food Court
(lower level)

Sand Dollars Gift Shop

Enter

Ocean Voyager Theater

Ocean Voyager
built by THE HOME DEPOT

Exit
(upper level)

Sea otter

Touch Pool

Sea lion

Emergency Exit

Coldwater Quest
presented by **Georgia-Pacific**

Enter

Additional Seating

Exit

Palette surgeonfish

Tropical Diver
presented by air Tran

Emergency Exit

Red piranha

Enter

Exit

Overhead River

Exit

Deepo's 3D Wondershow
(upper level)

River Scout
presented by **SOUTHERN COMPANY**

Enter

EXIT

Deepo's 3D Wondershow
presented by at&t (upper level)

Beyond the Reef Gift Shop

ATM

Touch Pool

Wall of Fish

Aquarium Exit
(through gift shop)

Georgia Explorer
presented by **SunTrust**

Information Desk

Touch Pools

Northern Right Whale Theater

Aquarium Entrance

Loggerhead sea turtle

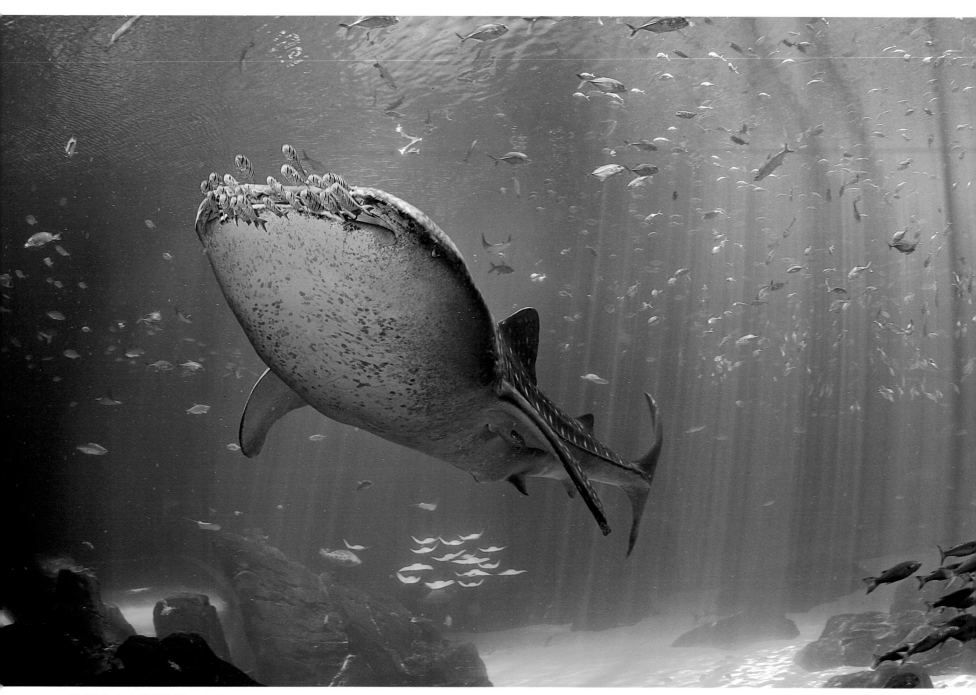

85. Whale shark "Ralph", *Rhincodon typus*

OCEAN VOYAGER

Built by:

Creating the Exhibit

86. Dr. Senzo Uchida, Director of the Churaumi Aquarium, Japan

When Bernie visited Japan on his world tour, he was awed by the presence of whale sharks (*Rhincodon typus*) at the Churaumi Aquarium in Okinawa and he knew they would be a spectacular attraction at the new Georgia Aquarium. The whale shark is also a species of great interest to scientists and conservation biologists since it is not easy to find or study in the ocean. Having a whale shark in an aquarium environment could offer tremendous opportunities to learn more about this great animal. Trouble was, no one had ever transported whale sharks by airplane — let alone halfway around the world — and none of us knew for certain where we would obtain a whale shark. But on a fateful day late in 2002, the decision was made to proceed with the design and construction of the centerpiece exhibit, "Ocean Voyager," with the hoped-for feature animal being the whale shark. This decision was made on the premise that if the Japanese could keep these animals alive in an aquarium, we should be able to do so too. The next two years were spent figuring out how to design the appropriate exhibit and most importantly, where to find a whale shark and how to bring one (or more) to Atlanta.

In February 2003, Ray Davis joined the Georgia Aquarium and he brought the right expertise and knowledge to make the whale shark project succeed. For more than two decades Ray had worked with sharks at his previous job with SeaWorld in Orlando and had dreamed of the possibility of keeping whale sharks in an exhibit in the United States. During the next year, he assembled the team and led the planning effort that would ultimately bring whale sharks to their gigantic new aquarium-home in Atlanta.

In 1980, the original Okinawa Expo Aquarium, under the leadership of Dr. Senzo Uchida, was the first aquarium in the world to successfully exhibit whale sharks. In the early years, their whale sharks were maintained in a relatively small aquarium 88' x 40' x 11.5' deep (27m x 12m x 3.5m) containing 303,000 gallons of seawater (1.1 million liters). Eventually their success allowed them to create the new Churaumi Aquarium, which opened in 2002 with a huge new whale shark exhibit that holds 1.98 million gallons of water (7.5 million liters). Dr. Uchida graciously allowed the Georgia Aquarium team to visit and inspect all of their facilities for transporting and maintaining whale sharks, and he arranged meetings with his staff so they could share their experiences and advice on how to care for these huge sharks. But the answers to how and where to obtain a whale shark remained elusive to the Georgia Aquarium team.

During his travels in Japan in 2003, Ray heard about whale sharks in Taiwan, Republic of China. Until recently, the Taiwanese government granted permits to local fishermen to capture and sell whale sharks, but these were all destined for the fish market, not aquariums.[1] Thousands of e-mails, and tens-of-thousands of air-miles later, Ray had established all of the contacts that the Aquarium needed to have a reasonable hope of procuring one or more whale sharks from Taiwanese fishermen. The fishermen were told to be on the lookout for "small" whale sharks, no larger than 16' (4.9 m). If a small whale shark turned up in the nets, they were to immediately transfer it to a sea pen anchored offshore and await word from the Georgia Aquarium.

Concurrently, the Georgia Aquarium planning team, working with all of the architects, consultants, project managers, and the general contractor, had to come up with a plan for designing and building what would become the largest aquarium exhibit ever created for fish. We knew in advance that it would not be a round exhibit. Decades of aquarium experience have conclusively shown that most sharks do not thrive swimming in circular vessels. The process of continually turning while hugging the walls consumes considerably more energy and is far less efficient than swimming and gliding in a straight line. Straight-line swimming is more natural for most sharks but obviously there is a limit to how large an exhibit can extend in any horizontal direction. Ultimately, the footprint of Ocean Voyager was expanded to nearly the size of a football field, and the deepest section of the exhibit, at 30' (9.1 m), is deep enough for an adult whale shark to orient vertically, which they sometimes do when feeding.

87.

88. Two views of Hualien, Taiwan, Republic of China

[1] The Taiwan Fisheries Bureau manages the annual catch of whale sharks in Taiwanese waters and in 2007 announced that the quota for catching whale sharks would be reduced to zero in 2008.

89. The Ocean Voyager exhibit ready to receive whale sharks

one outside the planning group was to know what we were planning and the name "whale shark" would never appear anywhere in any printed document. Even the *Atlanta Journal Constitution* never cracked this code when they reported in an article that we were developing a very large exhibit that was labeled "Ralph" on the construction documents. Why the secrecy? Partly it was to build suspense, but it was also because Bernie firmly stated his philosophy: "never advertise the hammer until you have it on the shelf!" Until we had done the impossible and had a whale shark safely in Ocean Voyager, no one on the outside had any hint of what was being planned. Bernie's desire to create anticipation and surprise was applied to all aspects of the Aquarium, its employees, and contractors. Everyone worked under an agreement of strict confidentiality.

Whale Sharks in Taiwan

On February 2, 2005 we received word from Taiwan that a small whale shark had been caught.

By January 2005, the new Ocean Voyager exhibit was ready for water testing. The acrylic windows were in place and the rockwork was finished. When the aquarium was finally filled, no one knew exactly how much water it held. We knew that the volume was over 5 million gallons but we needed a more exact number that included all of the water contained in the pipes, sumps and filters. A clever way to determine the exact volume was derived by knowing how much salt was added to the system. On March 18, 2005, we began emptying super-sacks of Instant Ocean sea salts into the Ocean Voyager exhibit. Each sack weighed 2,400 lbs (1088 kg) and after a day-and-a-half of dumping salt, exactly 750 bags had been emptied into the water. At that point the salinity had reached 35 parts-per-thousand. This means that for every 1,000 lbs of water we had added 35 lbs of salt. Since we added 1.8 million lbs of salt, we could

easily calculate how many pounds of water were in the exhibit and since freshwater weighs 8.34 lbs/gallon, we finally determined that this exhibit contained 6.167 million gallons of water. This is truly a gargantuan exhibit![2]

In 2007, the addition of more filters and plumbing increased the total volume of Ocean Voyager to 6.33 million gallons (24 million liters). The pump room now contains 36 pumps, each producing 50hp to run water through the sand filters, and another 34 pumps, each 25hp, operating the protein skimmers. Together they are capable of moving all 6.33 million gallons of water through the filtration system every 60 minutes.

The codeword "Ralph" was used for whale sharks from the beginning of the Georgia Aquarium project. Bernie made it abundantly clear that no

90. Will Ramsey adding salt to Ocean Voyager

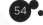

[2] If the salinity is 35 parts/thousand, the formula to back-calculate gallons is: (total lbs salt/.035) x 0.12 gallons/lb = total gallons of water).

Chapter 4

91. Mark Miller and Chris Schreiber (snorkeling) with a whale shark in the sea pen

92. Mark Olsen hand-feeding a whale shark in the sea pen

As requested, this animal was not sent to the market but was transferred to the holding pen. Ray Davis and Chris Schreiber, the Assistant Manager for the Ocean Voyager exhibit, headed to Taiwan immediately to check on the condition of the animal. From that day until June 2005, teams of Georgia Aquarium biologists rotated back and forth between Atlanta and Taiwan to care for the whale shark.

Feeding the shark was the first priority. We had learned from the Japanese that it was critically important for whale sharks to begin feeding very soon after collection. So the first priority was to figure out the best way to teach "Ralph" how to feed. Several times each day the biologists entered a small rubber raft and drifted over the center of the net pen. They brought with them buckets of small shrimp known as "krill" and as the whale shark swam by they released small amounts of krill into the water. Gradually the shark learned that the krill was food and eventually it would come up to the rubber raft to feed. Over time, it learned to follow a ladle on the surface filled with krill. This practice kept it swimming horizontally, which we preferred, rather than assuming a vertical feeding position.

On May 4, 2005, a second whale shark came into our possession and was given the codename "Norton." Both Ralph and Norton acclimated well to their net pen surroundings and fed ravenously on buckets of krill.

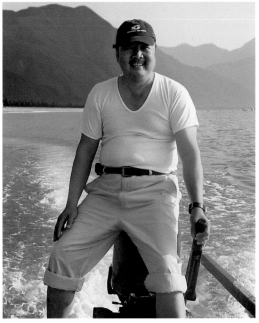

93. Huang Tong-Ping, owner of Dong Chong Fish, was immensely helpful to the team.

94. Silhouette of whale sharks during training sessions in the sea pen

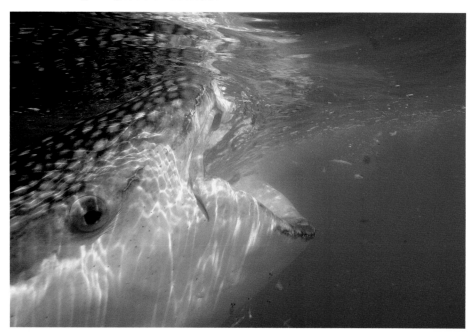

95. Whale shark sucking in water at the surface during feeding (note shrimp in the water)

Flying Whale Sharks

By the end of May 2005 all of the equipment, staff and logistical arrangements were in place to bring the sharks to Atlanta. When the day arrived to move the two sharks, teams of Taiwanese fishermen, crane operators, boat and truck drivers, and Georgia Aquarium biologists began the difficult process of capturing the whale sharks and transferring them to cargo planes. Adding to the complexity of the day, five languages were spoken among the crewmembers: Taiwanese, Mandarin, Cantonese, Spanish and English.

The process to move the sharks is straightforward: lift the shark out of the ocean and into a container of water on a boat, drive the boat to the harbor, lift the animals into another container on a truck, then load this container into an airplane and fly to Atlanta. Of course, coaxing a reluctant animal that weighs over 1,000 lbs (454 kg) into a net, and then lifting it onto a moving boat is every bit as difficult as it sounds and there was never any guarantee that the crane could lift the animal until it was finally accomplished. After many hours of arduous effort, both animals were on their way to the waiting aircraft. Despite the time difference (Taiwan is 12-hours ahead of Atlanta on the other side of the international dateline), Ray Davis sent constant reports via cell phone to Jeff Swanagan who relayed the news to everyone anxiously waiting in Atlanta.

The two whale sharks were each transported in a specially designed fiberglass box that included a life support system to ensure that water motion and sufficient oxygen were delivered to the animals. The lids on the boxes were sealed tightly to guarantee that no saltwater would spill into the airplane.

96. WXIA cameraman, Willis Boyd and Brett Dodson

97. The international team (left to right): Cao Guang-Bin, Tina Chang, Huang Ray-Yu, Ray Davis, Huang Tong-Ping, Fred Fan, Takayoshi Yoshiomi

98. Ray Davis on the boat calling Jeff Swanagan in Atlanta with update

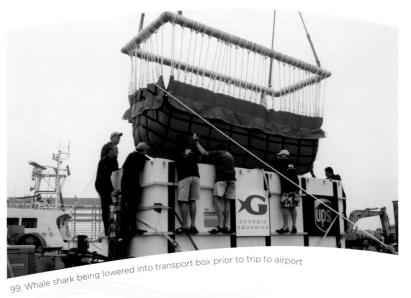

99. Whale shark being lowered into transport box prior to trip to airport

A window on the side of the box allowed the biologists and accompanying veterinarian to check on the condition of each animal during the flight.

Ralph and Norton were treated like first-class passengers. The two of them shared the 747-cargo plane with a team of three biologists and one veterinarian from the Georgia Aquarium, and the flight crew. United Parcel Service (UPS) generously donated the aircraft and all transportation costs to move the whale sharks and all the collecting equipment between Taiwan and Atlanta. The expertise of the UPS crews was critical to the success of this project especially when it came to moving the huge containers on and off the planes.

At 6:20 am (EST) on June 3, 2005 Ralph and Norton were both swimming peacefully in the Ocean Voyager habitat in Atlanta. At the same time, the news of this momentous event was spreading around the world. Reporters in Taiwan picked up the story and it became front-page headlines there. It didn't take long for translations to hit the Internet and send off media alarms in Atlanta. By dawn that day, reporters in Atlanta were on to the story and Bernie and Jeff finally revealed the secret that had been so tightly held for the previous two years.

In the subsequent two years, four more whale sharks made the journey to the Georgia Aquarium. "Alice" and "Trixie," two female whale sharks, arrived in June 2006 and one year later two small males arrived. The Georgia Aquarium has built a strong and lasting relationship with the people of Taiwan. There are many personal and professional friendships that continue to this day. As a sign of respect to the people of Taiwan, the two young male whale sharks that arrived in 2007 were

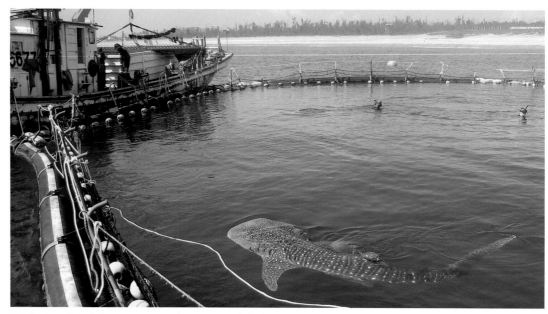

100. Boats and snorkelers at sea pen ready to capture whale shark

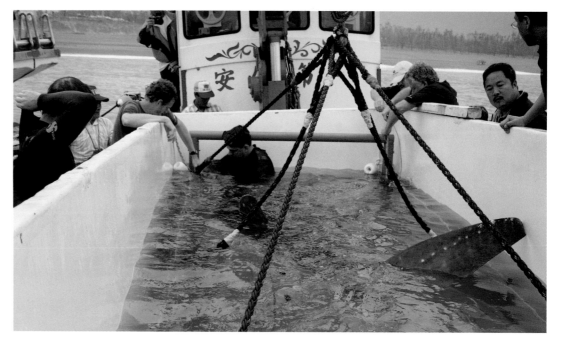

101. Whale shark in transport tank on boat

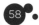

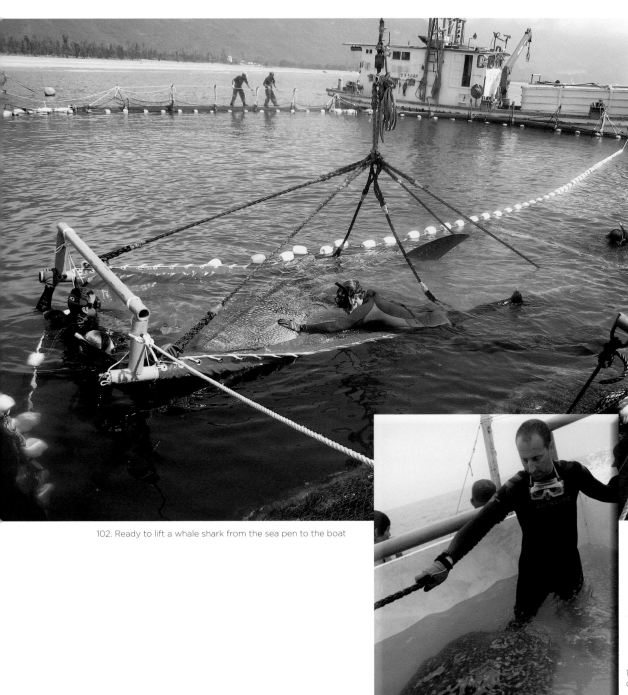

named after very important places in Taiwan. "Taroko" is named after an amazing and beautiful gorge and National Park located in the northeast of this island country. "Yushan" (sometimes spelled Yu Shan) is named for the highest peak in Taiwan and the highest peak in Asia outside of the Himalaya Mountains. In translation, "Yushan" means Jade Mountain.

Each shark is fed twice each day, once in the morning and again in the afternoon. Their diet consists of krill, chopped squid, small fish, other prepared foods and dietary supplements totaling 15 lbs (6.8 kg) per feeding per shark (this ration is likely to increase as the animals grow). And just like they were trained in Taiwan, they receive their food from a ladle held just in front of their mouth at every feeding.

Alice grew 62" (157 cm) from June 2006 to August 2007 and as of that date measures 19' (579 cm) in total length. During the same period Trixie grew 51" (130 cm) and measures 19'8" (600 cm) in total length. The two male whale sharks are both smaller than the females. Taroko arrived in June 2007 measuring 15.3' (467 cm), and Yushan measuring 13.5' (413 cm).

102. Ready to lift a whale shark from the sea pen to the boat

103. Chris Coco with a whale shark during transport to the harbor

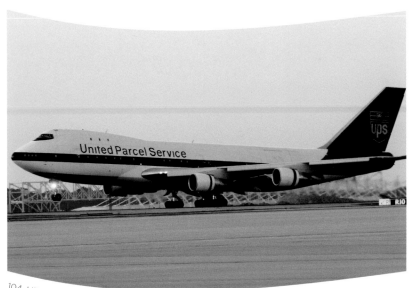
104. UPS 747 arriving in Atlanta with two whale sharks

105. Jeff Swanagan (left), Tim Binder, Chris Coco with precious cargo onboard the 747

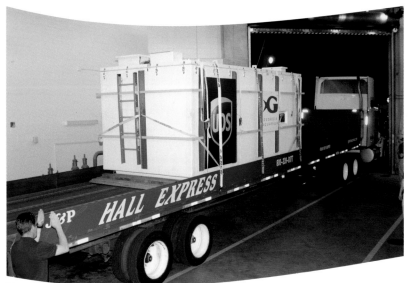
106. One whale shark arriving at the Aquarium loading dock

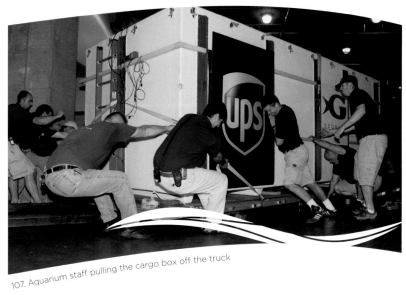
107. Aquarium staff pulling the cargo box off the truck

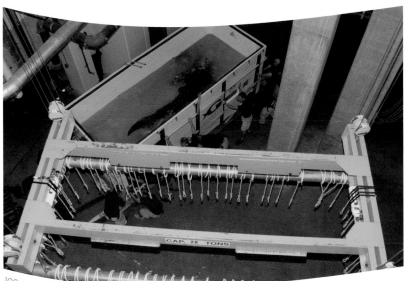

108. Maneuvering the transport box and whale shark to the hoist

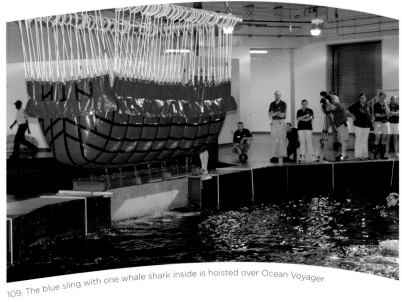

109. The blue sling with one whale shark inside is hoisted over Ocean Voyager

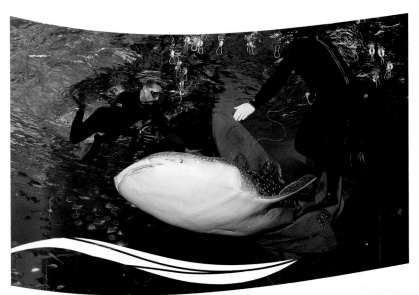

110. Releasing whale shark into Ocean Voyager

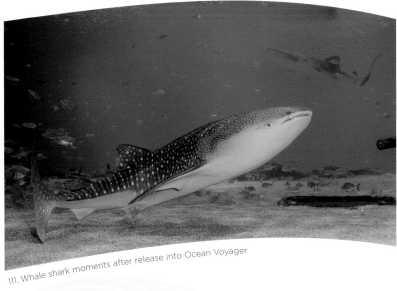

111. Whale shark moments after release into Ocean Voyager

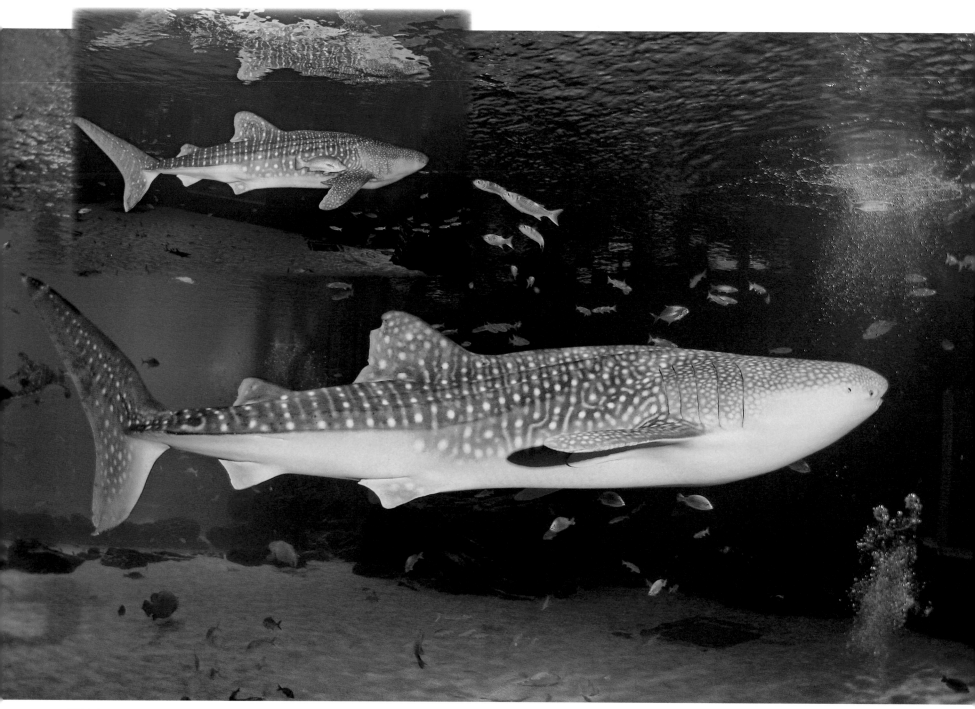

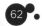

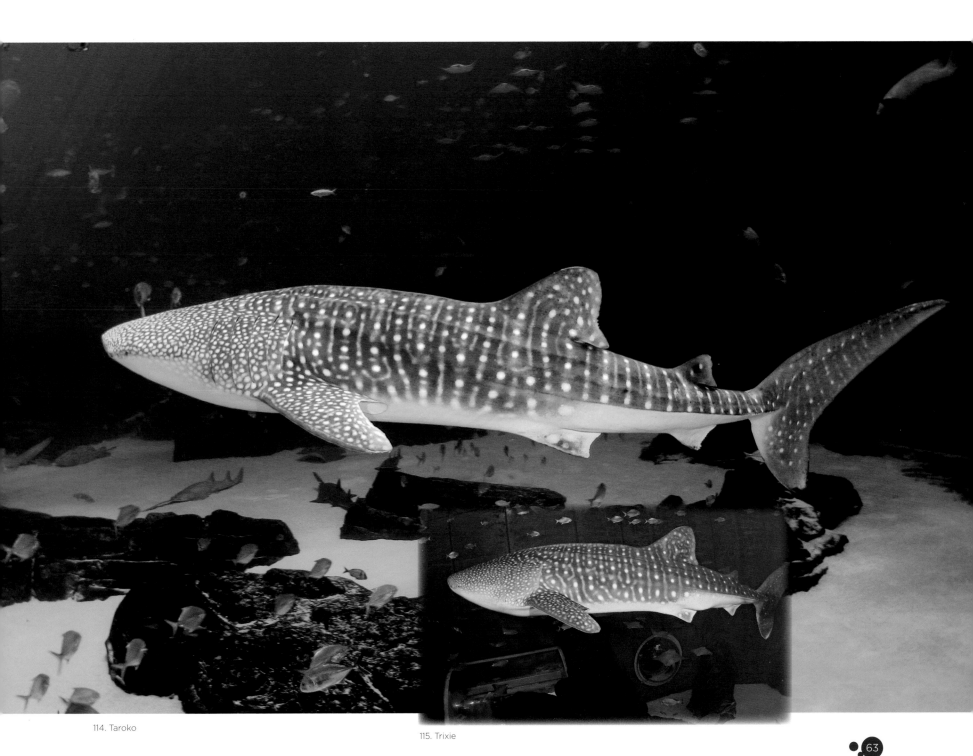

114. Taroko

115. Trixie

Ralph and Norton

By the end of their first year in the Ocean Voyager exhibit, we discovered that Ralph and Norton were carrying leeches — a common parasite found on many sharks and rays in the wild. In aquariums, parasites have few predators to control their numbers and if allowed to multiply unchecked could create serious health problems for the sharks. Georgia Aquarium husbandry managers, in consultation with veterinarians, prescribed a drug that is often used to control a variety of parasites in aquariums. Both Ralph and Norton received several treatments during the spring and early summer of 2006 and when examined later they were free of leeches. Both sharks also stopped feeding. This did not raise any immediate alarms because many animals (including humans) often stop eating after drug treatments.

As the weeks progressed with no resumption of appetite, supplemental feeding was provided. Administering food through a tube to whale sharks was something no one had ever attempted but it did keep the animals in relatively good condition. An unexpected side benefit of this work was the development of new methods to capture whale sharks and hold them in a sling underwater allowing veterinarians to collect blood samples and monitor their health. While not easy, this technique could be applied to whale sharks in the ocean, allowing scientists to monitor the health of wild animals.

Ultimately, Ralph and Norton both succumbed and this was a tremendous blow to everyone. However, their time in Atlanta was a great benefit for their species, and much was learned about the biology of whale sharks. The necropsies of the two animals led to discoveries about the anatomy of these sharks and especially the elaborate filtering mechanism in their gills that enables them to capture extremely small planktonic animals.

Where once the fate of these two animals was to end up in a fish market, instead they became living ambassadors for their species. During Norton's tenure at the Georgia Aquarium, over five million visitors had the opportunity to see him and be inspired by his presence. This effect is probably best summarized by one of the many letters written in the aftermath:

....As to whether my opinion has changed because of the aquarium deaths, I must respond with an emphatic NO. If the aquarium had not opened in Atlanta and brought whale sharks to us, I would probably have never even known that they existed.

Now I understand how very much we do not know about them and what we have to learn. Who knows what we can gain by further understanding their lives? I am especially proud to share the knowledge that we have gained from their close proximity to us with my three children. My 8-year-old in particular seems keenly aware that we have a lot to learn from these largest of fish. She looks for information in the news about them and is constantly asking to "visit" them....

— Joy Llewallyn, East Cobb

116. Norton

117. Pointed-nose stingray, *Himantura jenkinsii* (Pacific)

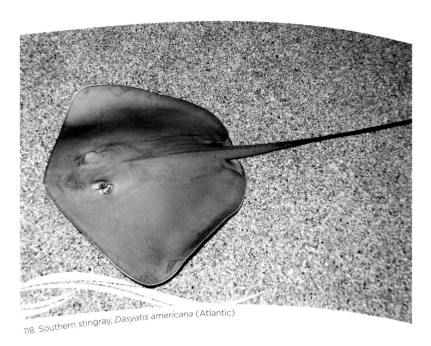

118. Southern stingray, *Dasyatis americana* (Atlantic)

119. Blotched fantail ray, *Taeniura meyeni* (Pacific)

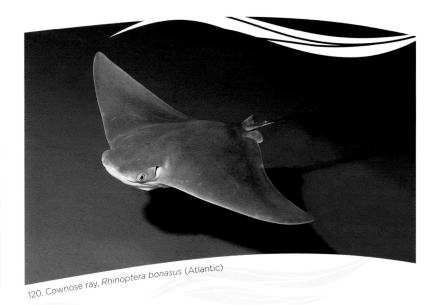

120. Cownose ray, *Rhinoptera bonasus* (Atlantic)

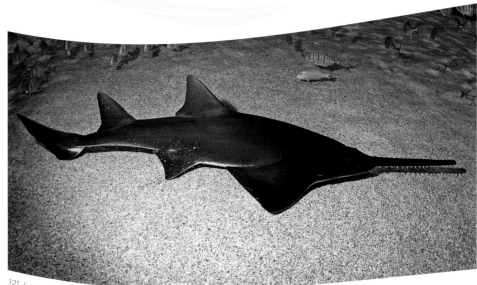

121. Largetooth sawfish, *Pristis microdon* (Pacific)

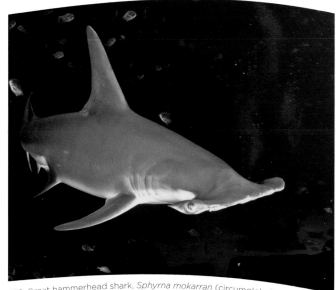

122. Great hammerhead shark, *Sphyrna mokarran* (circumglobal)

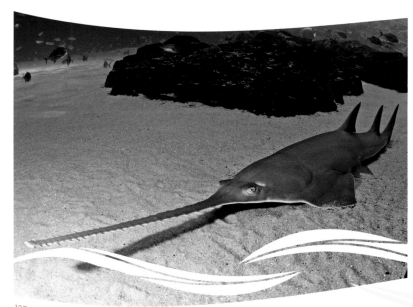

123. Longcomb sawfish, *Pristis zijsron* (Pacific)

124. Ornate wobbegong, *Orectolobus ornatus* (Pacific)

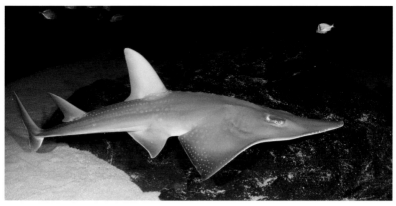

125. Giant guitarfish, *Rhynchobatus djiddensis* (Pacific)

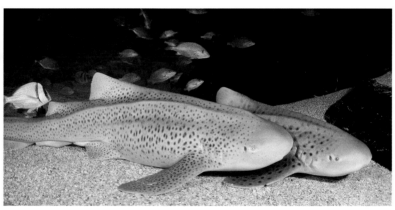

126. Zebra shark, *Stegostoma fasciatum* (Pacific)

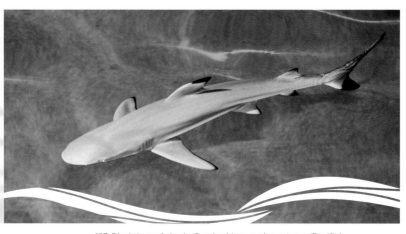

127. Blacktip reef shark, *Carcharhinus melanopterus* (Pacific)

128. Tasseled wobbegong, *Orectolobus dasypogon* (Pacific)

129. Gray snapper, *Lutjanus griseus* (Atlantic)

131. Tiera batfish, *Platax teira* (Pacific)

130. Potato grouper, *Epinephelus tukula* (Pacific)

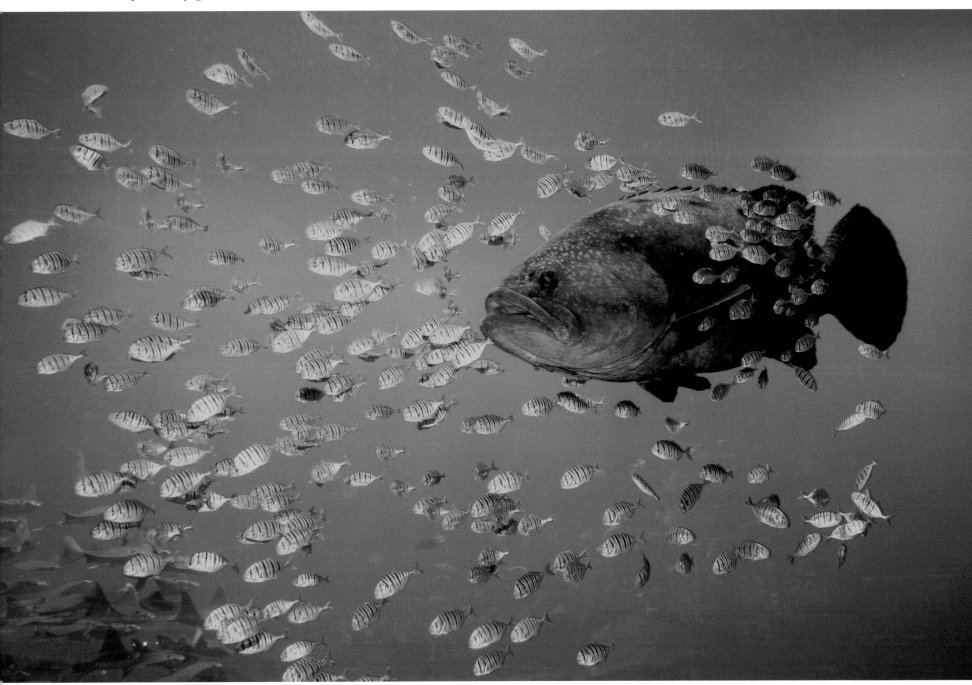

132. Giant grouper, *Epinephelus lanceolatus*, with golden trevally, *Gnathanodon speciosus* (both Pacific)

133. Humphead wrasse—male, *Cheilinus undulatus* (Pacific)

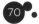

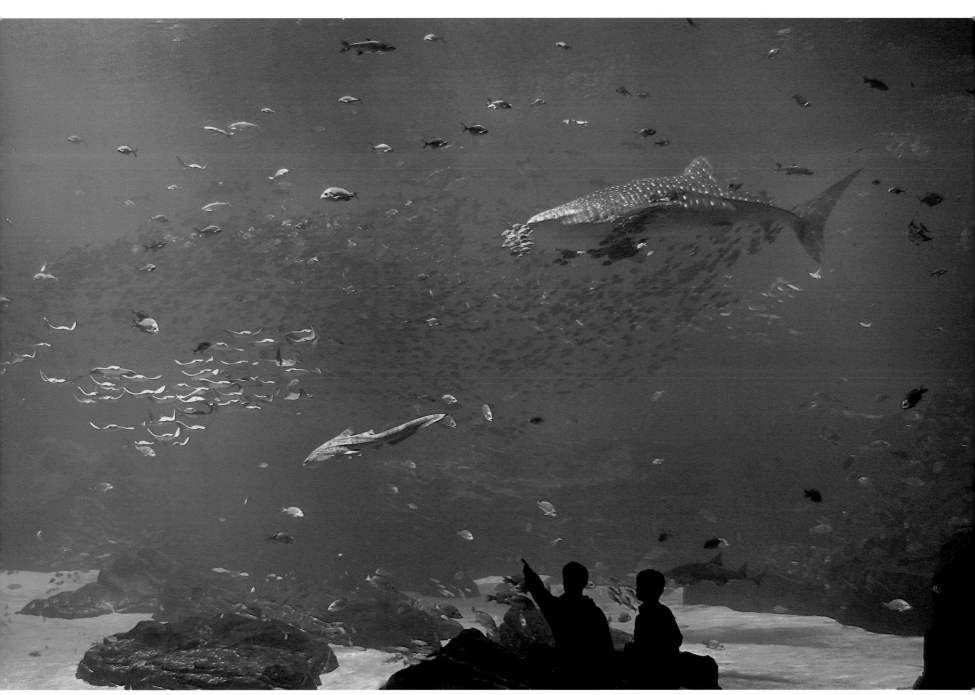

134. Visitors enjoying a view into the Ocean Voyager exhibit

Zebra Shark Pups

The zebra shark (*Stegostoma fasciatum*) has a tawny brown body with spots reminiscent of a leopard. So, why is it called a "zebra" shark? The name refers to the pattern on the pups. After hatching, the young have a brown and white pattern that is zebra-like. Georgia Aquarium zebra sharks began producing large egg cases in 2006, and after nine months incubation, the eggs began to hatch. More than a dozen pups have hatched as of the time this book went to press and more eggs are still being produced. The accompanying photograph shows the pregnant female zebra shark in Ocean Voyager bulging with eggs. The eggs are deposited on the gravel and among the rocks. Divers retrieve them on their morning dives. The pups are 8–10" (20–26 cm) long at hatching.

The zebra shark is a slow moving, non-aggressive shark. It is found on coral reefs from the west Pacific to South Africa and the Red Sea. The adults reach a total length of 11.5' (3.5 m). It feeds on snails, shrimp, crabs, sea urchins and small fishes.

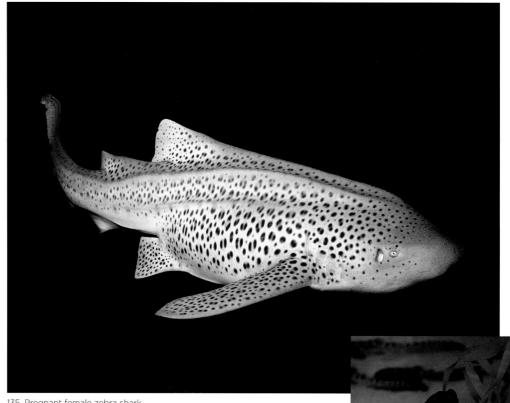

135. Pregnant female zebra shark

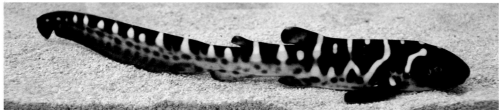

136. Zebra shark pup

As this book goes to press, visitors on Behind the Scenes Tours can view the zebra shark pups in the Aquaculture Laboratory on the Education Loop, and they are also on display in the Tropical Diver gallery. Everyone else can watch them in real-time on the Georgia Aquarium web cam (www.GeorgiaAquarium.org).

137. Egg case

Whale Shark Research

During the early planning for the Georgia Aquarium, Bernie Marcus was clear that he wanted the Aquarium to engage in research, conservation and education programs, and to "give back" to the community and to nature. Since then, the Aquarium has devoted considerable resources supporting these commitments. One exciting program that is gaining worldwide recognition just as this book goes to press is the discovery of large numbers of whale sharks that aggregate every summer off of Mexico's Yucatan peninsula.

In 2003 the senior author of this book received a call from Dr. Robert Hueter, the Director of the Center for Shark Research at the Mote Marine Laboratory in Sarasota, Florida. Bob had been working for years on sharks in the bays around the northern Yucatan peninsula of Mexico. He had heard stories from local fishermen that whale sharks congregate in the offshore waters during the summer months. There are about a dozen areas in the world where whale shark aggregations have been discovered, but scientists did not know about this location. Bob learned that perhaps a dozen whale sharks might appear there each summer and he thought the Georgia Aquarium ought to sponsor a research program to study this population. The Aquarium readily agreed and has now become the principal sponsor of this research.

How many whale sharks visit the Yucatan region? It turned out to be a lot more than a dozen — more like a "hundred dozen" according to Bob. By the summer of 2007, more than 600 whale sharks had been identified and tagged, and many more are out there. In one outstanding aerial photograph, 76 whale sharks are visible.

The work in Mexico is conducted under the auspices of the Comision Nacional de Area Naturales Protegidas (CONANP) of the federal Secretaria de Medio Ambiente y Recursos Naturales (SEMARNAT) in Cancun, Quintana Roo, Mexico. Dr. Jaime Manuel Gonzalez Cano, Rafael de la Parra, Dr. Jose Francisco Remolina Suarez and their colleagues in Mexico have been the driving force for this research. From the United States, Dr. Hueter has been accompanied by his colleague, John Tyminski, also from the Mote Marine Laboratory, and more recently by Dr. Phil Motta, Professor of Biology at the University of South Florida in Tampa. Together they are working alongside their counterparts from Mexico and they hope to get a more thorough understanding of how many sharks visit the area each year, where they go at the end of summer, their size range and sex, growth rates, and the genetic relationships among whale sharks based on DNA sampling.

Some of the whale sharks have been fitted with "satellite tags" that record the movements of the sharks and how deep they swim. The satellite tags pop off the sharks at pre-determined times (usually a few months) and float to the surface where they transmit data via satellite to the researchers in Florida. Information gleaned from satellite tags indicates that after their summer feeding off the northeastern Yucatan coast, some of the whale sharks disperse north into the Gulf of Mexico, others swim east to the Florida Straits, and the rest swim south into the Caribbean. More startling, the data have revealed that they swim to depths as great as 4,514' (1,376 m) for brief periods where temperatures drop to 39.2°F (4°C)! Why they descend to such depths remains a mystery.

Mike Maslanka from the Georgia Aquarium has also joined the research team to sample plankton in areas where the whale sharks are actively feeding. Data from the plankton tows indicate that the whale sharks are feeding mostly on small crustaceans known as copepods, as well as a variety of other tiny shrimp-like animals, crab larvae and fish eggs. This information and subsequent analysis will be valuable to help the Aquarium develop a more nutritious diet for the whale sharks in Ocean Voyager.

All of the findings of these research efforts will help the Mexican government develop sound policies to govern access to the whale sharks. Whale shark tours are now blossoming in this region but too many whale shark watchers and too much development may be detrimental to the environment and to the animals. The results of this research will lead to sound conservation policies that will benefit the whale sharks as well as the people of that region.

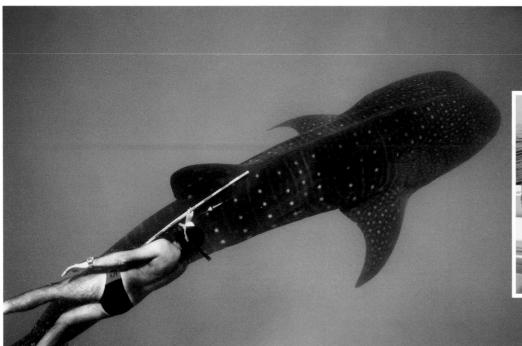

138. Rafael de la Para measures the length of the dorsal fin of a whale shark.

139. Mike Maslanka sampling plankton where the whale sharks feed near Holbox, Mexico

140. Copepods from the plankton net

141. Researchers preparing to tag a whale shark

142. Oscar Reyes took this remarkable aerial photograph of 76 whale sharks (not counting three in the inset) in blue water near Cancun, Mexico on September 10, 2006. This aggregation is part of the on-going research sponsored by the Georgia Aquarium.

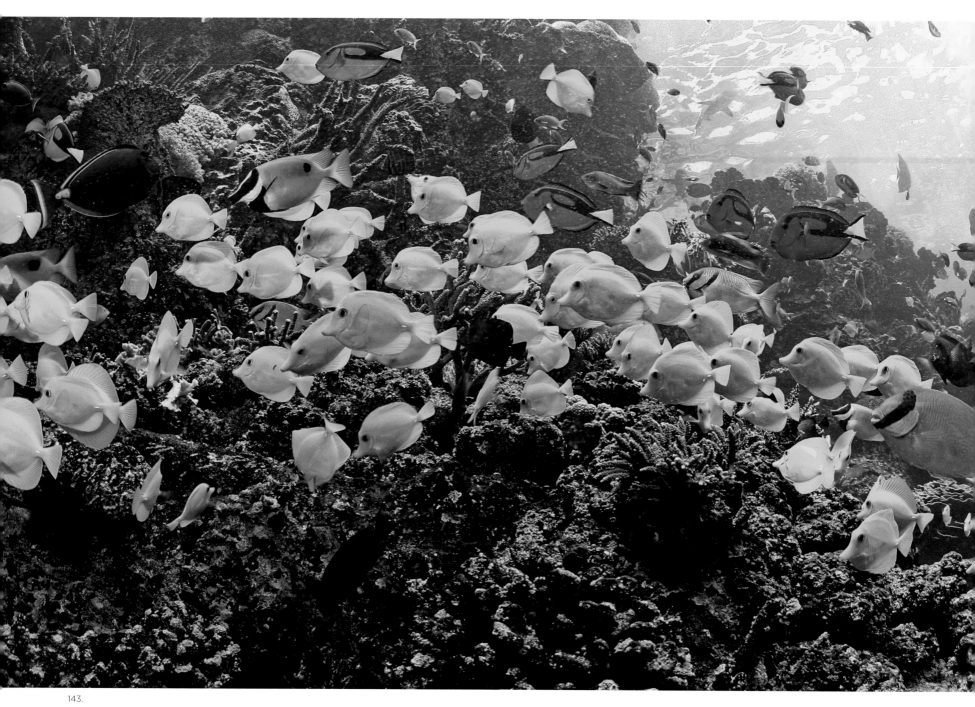

143.

CHAPTER FIVE:

Tropical Diver, The Coral Kingdom

TROPICAL DIVER

Presented by: airTran

Pacific Barrier Reef

Few places on the planet can match the diversity and beauty of life on coral reefs. They are places that most people dream of visiting someday. A gallery devoted to life in tropical seas has always been a high priority for the Georgia Aquarium. The Aquarium can play an important role helping people see and experience these animals from faraway locations in exhibits that represent a close simulation of nature. These exhibits can also generate a heightened awareness and appreciation of aquatic animals and can lead to a greater desire to protect these animals and their native habitats. This is an important role that the Aquarium can help fulfill by creating positive and direct conservation action. The Tropical Diver gallery is a great example of how exhibits, people and conservation action work together.

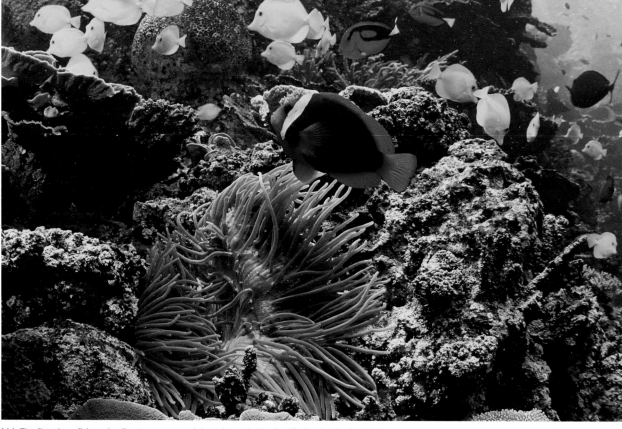

144. The fire clownfish and yellow tangs seem right at home in the Pacific Barrier Reef exhibit.

145. The Barrier Reef exhibit at Georgia Aquarium 146. A real reef in the Solomon Islands

A Pacific Barrier Reef was selected as the theme for the centerpiece exhibit in this gallery. More than 3,000 species of fishes and over 500 species of corals live on Pacific coral reefs, making this one of the most diverse aquatic regions on the planet. There is an additional benefit of a Pacific reef exhibit: many species of corals from the Pacific have been cultivated in home aquariums and public aquariums for over 20 years. This has allowed us to obtain propagated corals rather than wild-caught corals to stock the new exhibit.

But how would we create a full-scale living reef exhibit? Even though the methods and technology have been perfected for more than two decades, few public aquariums have ever attempted to maintain a live reef of more than a few hundred gallons. The few aquariums that do have large living reef exhibits are located close to the ocean and natural seawater; not so in downtown Atlanta. The Georgia Aquarium living reef would have to be designed to be completely self-contained.

The senior author of this book, Bruce Carlson, has lived and worked on coral reefs in the Pacific since 1971 and played a major role in developing the concept and design of the Pacific Barrier Reef exhibit. He and the Aquarium team decided to simulate a reef drop-off similar to those found in the Solomon Islands in the South Pacific. The vertical reef wall allowed the viewing window to be situated close to the corals so visitors could see and appreciate their intricate beauty. But a vertical window so close to the reef restricts the amount of room that the fishes have to swim. To create more horizontal swimming room for the fishes, the viewing window curves up and over the heads of visitors. This gives the fishes approximately 850 ft^2 (79 m^2) of swimming room at the surface. Having water overhead also allows us to simulate a wave crashing on the reef, and recreate the experience of diving beneath the surf.

At the surface, the Pacific Barrier Reef exhibit is 49' long x 47' wide, and it is 18' deep (14.9 x 14.3 x 5.5 m). The entire system holds 163,765 gallons (619,920 liters). The public sees only a small portion of the exhibit from below the surface. Above water we have created a complete cross-section of a reef from the wave zone, to the reef crest, to the lagoon, and finally a living mangrove swamp. This upper level view is only available to school groups and to Behind the Scenes Tours on the Education Loop, but it offers us the opportunity to convey to the public how an entire reef ecosystem functions in nature.

147. Kevin Curlee inspects the Pacific Barrier Reef exhibit populated with artificial corals during consruction.

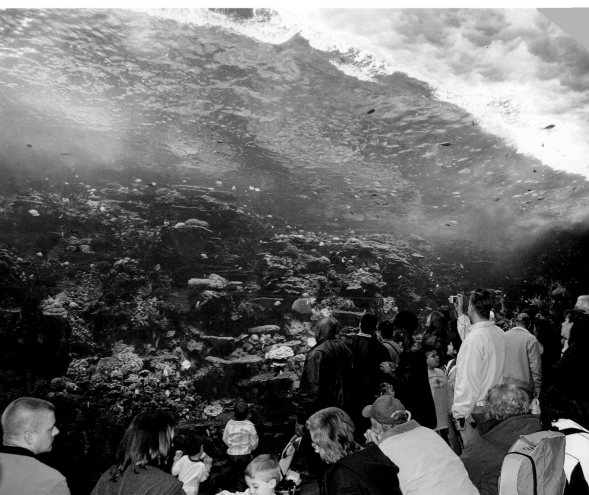

148. Surf, sun and living corals bring this reef to life for visitors of all ages.

149. The skylight over the Pacific Barrier Reef and the metal halide lamps provide year-round illumination similar to the tropics.

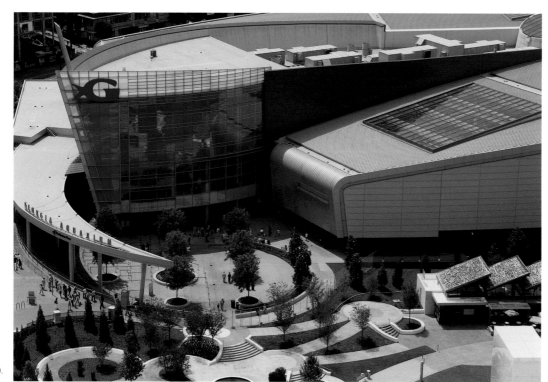

150.

Creating this complex environment required more elaborate life support systems than any other exhibit at the Georgia Aquarium. The reef environment is enhanced by a 55' x 65' (16.8 x 19.8 m) skylight fitted with clear Starphire glass that allows up to 40% of the sun's ultraviolet light to pass through to the exhibit. Natural sunlight is important to corals that have a type of microscopic plant living in their tissues. These plants, called *zooxanthellae*, use sunlight to manufacture carbohydrates through photosynthesis. Some of these carbohydrates leak out of the algal cells and provide nutrition for the corals. Without sufficient light of the right spectrum to keep the *zooxanthellae* alive, the corals will die. During the summer months in Atlanta, ample sunlight enters the exhibit through the skylight to simulate natural conditions found on coral reefs. But during the winter months, additional artificial lighting is required. To meet this need, Lithonia Lighting provided sixty metal halide lamps over the exhibit, and collectively they provide 60,000 watts of artificial light for the corals.

Water motion and proper chemistry are also critical for corals. To simulate the back-and-forth surge action that occurs in nature, we installed pumps on either side of the exhibit to generate an alternating surge of water that first flows from left-to-right, and a minute later flows from right-to-left. The 6,000-gallon (22,700 liters) wave machine that crashes overhead every two minutes also provides some additional water motion across the top of the exhibit. Lastly, and perhaps most important, maintaining the water chemistry within the very narrow range of temperature, salinity, pH, calcium and alkalinity required for coral growth is critical and difficult to manage. These water chemistry parameters are continually monitored in the laboratory.

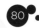

151.

Given the narrow range of conditions required to keep corals alive in this exhibit, it comes as no surprise to learn that corals in the natural world are highly sensitive to changes in their environment. Coastal development, pollution, and over-fishing have all had devastating effects on coral reefs as human populations continue to increase along tropical coast lines. In the recent years we have witnessed the wholesale die-off of entire reefs throughout the world's oceans due to unprecedented high sea surface temperatures. The Georgia Aquarium is helping to reverse this trend through education and by directly sponsoring efforts to restore and manage pristine coral reef ecosystems, as discussed later in this chapter.

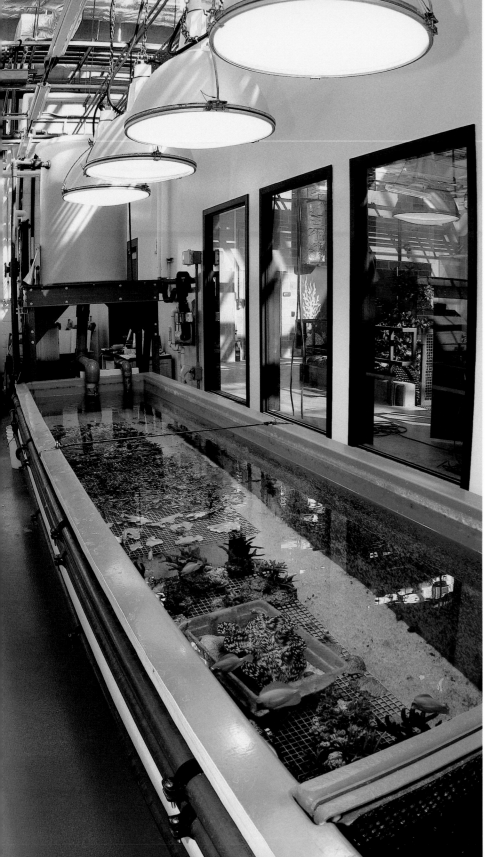

Coral Culture and Live Rocks

Whenever possible, the Georgia Aquarium has obtained animals that have been cultured rather than collected from the wild. Many of the corals exhibited at the Georgia Aquarium were obtained from other public aquariums and other sources that have coral culture facilities. Corals were also obtained as confiscations when importers tried to bring corals into the United States without the proper permits and paperwork. Prior to 1980, few people believed that corals could be maintained in aquariums, let alone cultured. Today, reef aquariums with living corals are found in homes, offices, restaurants, and of course, at public aquariums.

How are corals cultured? The parent stock has to be obtained from the wild. Usually, broken fragments can be found lying on the reef that can be easily collected without damaging the main colony. Each piece has to be protected throughout the entire collection and shipping process to ensure it is not damaged. Corals are easily shipped in plastic bags with seawater and oxygen, then packed inside insulated cardboard boxes and sent via air cargo to destinations around the world. In the aquarium, corals can be attached to rocks using epoxy putty formulated for use underwater. The corals grow rapidly if provided the proper conditions, including temperature, salinity, pH, alkalinity, calcium, nitrate and phosphate, as well as sufficient light and water motion. Keeping these parameters in balance is the key to success and it isn't easy, but when it all works some corals can grow 8" – 10" (20 – 25 cm) per year. This rapid growth provides sufficient new material to fragment and share with other aquarists, and that is exactly what people working in public aquariums, and hobbyists too, have been doing for the past two decades. A good example is the whip gorgonian (*Rumphella sp.*) in the Pacific Barrier Reef exhibit. The senior author collected it in the Republic of Palau (west Pacific) in 1988 and cultured it at the Waikiki Aquarium in Honolulu. Several fragments from that colony (along with other corals) were sent to the Georgia Aquarium in 2004 and the new daughter colony is now thriving in downtown Atlanta almost twenty years from the date when it was originally collected. (Note: the parent colony in Palau no longer exists. It was destroyed when a small boat harbor was created.)

152. Visitors on Behind the Scenes Tours can view the coral culture facility in the aquaculture laboratory

"Live rocks" have long been an important component of living reef aquarium systems. A traditional live rock is a rock collected from a coral reef that contains microorganisms, plants, sponges, mollusks, crustaceans and other marine life. When placed in the aquarium, these live rocks inoculate the aquarium with a wide diversity of plant and animal life and establish a foundation for the aquarium ecosystem. To minimize disruption to natural reefs, some companies have begun making artificial live rocks using concrete and sand. When the concrete has cured, the rocks are placed in the ocean on sandy areas adjacent to coral reefs. After a year or more underwater, they are harvested and shipped to aquarists. The Georgia Aquarium purchased 11,023 lbs (5 metric tons) of cultured live rocks from Fiji to use in the Pacific Barrier Reef exhibit.

153. This whip coral, *Rumphella* sp., has been cultured in aquariums for twenty years.

154. Mike Daniel holding a "cultured" live rock from Fiji

155. Artificial rocks in Fiji destined for two years in the ocean before shipping to Atlanta

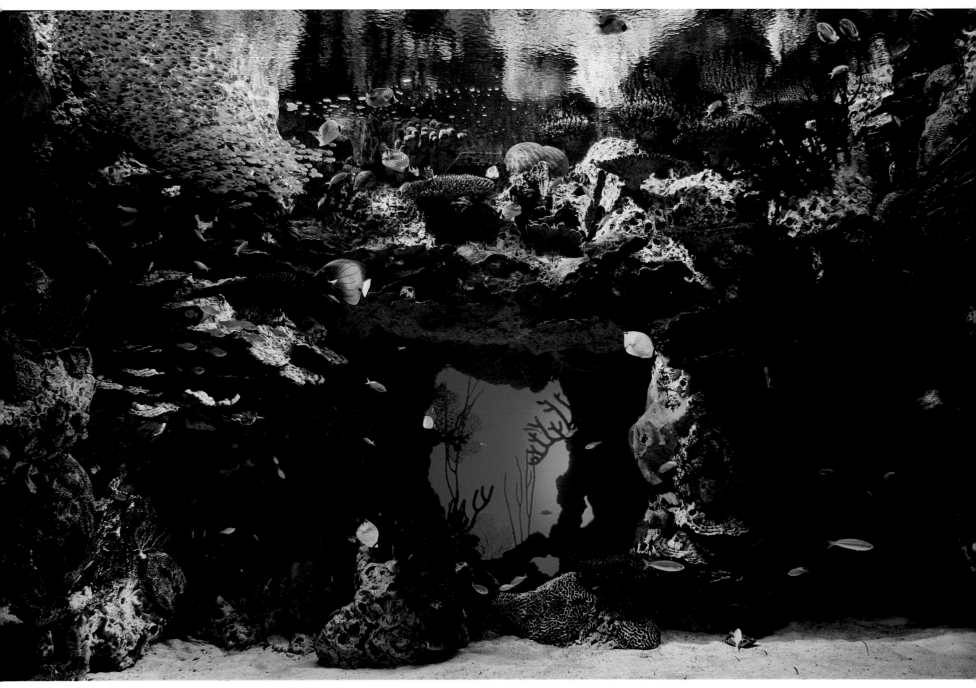

156.

Garden Eels

On his world tour of aquariums, one of the exhibits that Bernie most admired was an exhibit of garden eels at Aquamarine Fukushima in Japan, and he wondered if a similar exhibit could be created at the Georgia Aquarium. The Director of Aquamarine Fukushima, Yoshitaka Abe, was very gracious allowing us to meet with his staff to learn how their exhibit was created. Later, he helped by supplying us with pigmy sweepers and garden eels that are an eye-catching part of this display.

Garden eels are found in tropical oceans around the world. They are often abundant on sandy slopes adjacent to coral reefs and from a distance their thin, undulating bodies appear like a meadow of plants waving in the breeze, hence their name "garden" eels. Two species are displayed at the Georgia Aquarium: the spotted garden eel (*Heteroconger hassi*), and the splendid garden eel (*Gorgasia preclara*).

To create a proper habitat for them, a sand bed about 24" (61 cm) deep is required. The eels burrow into the sand tail-first and they rarely leave the burrow. They emerge from the burrow just far enough to grab plankton as it drifts past them. This makes it difficult to provide food to them in a community aquarium. If the food is added at the surface, all the other fish will eat it before any drifts to the bottom where the eels can get it. We borrowed the technique used by the Japanese aquarists: a long tube hidden in the rocks extends from the surface down to a spot about 10" (25.4 cm) above the sand. Food is inserted into this tube at the surface, and it travels down the tube and exits at just the right height for the eels to feed. A strong current pushes the food over the surface of the sand so all the eels are able to eat.

The pigmy sweeper (*Parapriacanthus ransonneti*) is a fascinating addition to this exhibit; just as it is in the original exhibit in Japan. These little copper-colored fish are often abundant in caves and tunnels on coral reefs throughout the Pacific but they are seldom collected and they are quite delicate. Abe-san once again provided us with much needed assistance in obtaining a school of these little fish from Japan. Thanks to the expert care given to these sweepers, nearly all of them (and the garden eels too) survived the long trip from Japan to Atlanta.

157. Dr. Yoshitaka Abe, Director of Aquamarine Fukushima, Japan, with Ray Davis and Akira Komoda, General Curator

158. The splendid garden eel, *Gorgasia preclara*, from Japan

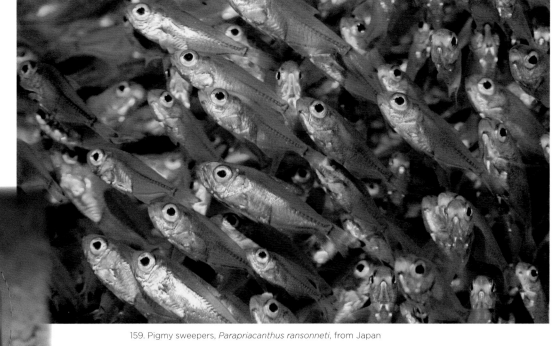

159. Pigmy sweepers, *Parapriacanthus ransonneti*, from Japan

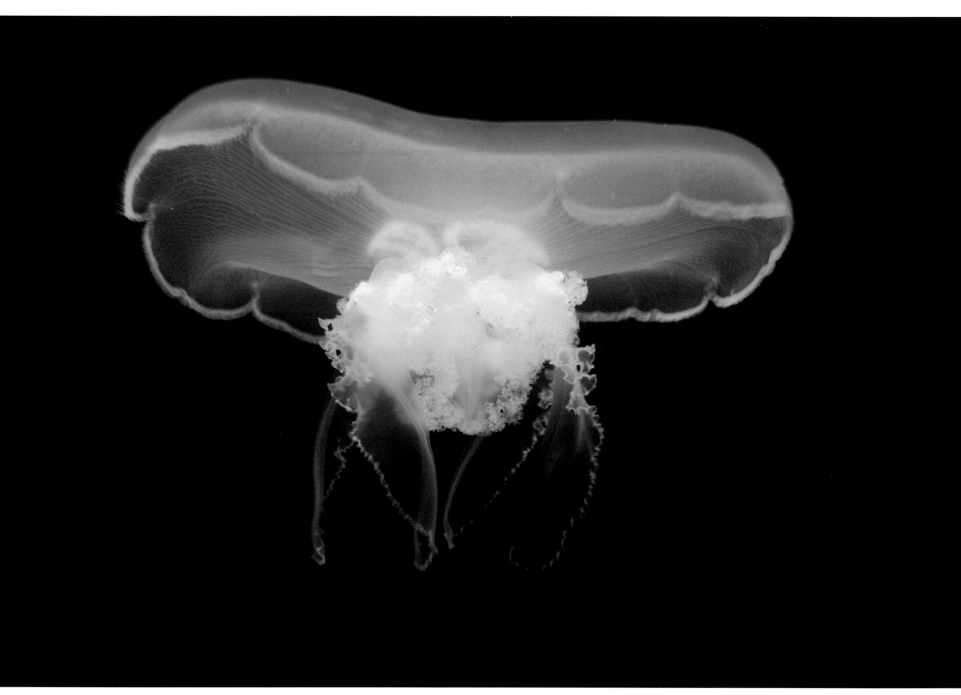

160. Moon jelly, *Aurelia aurita* (circumglobal)

Chapter 5

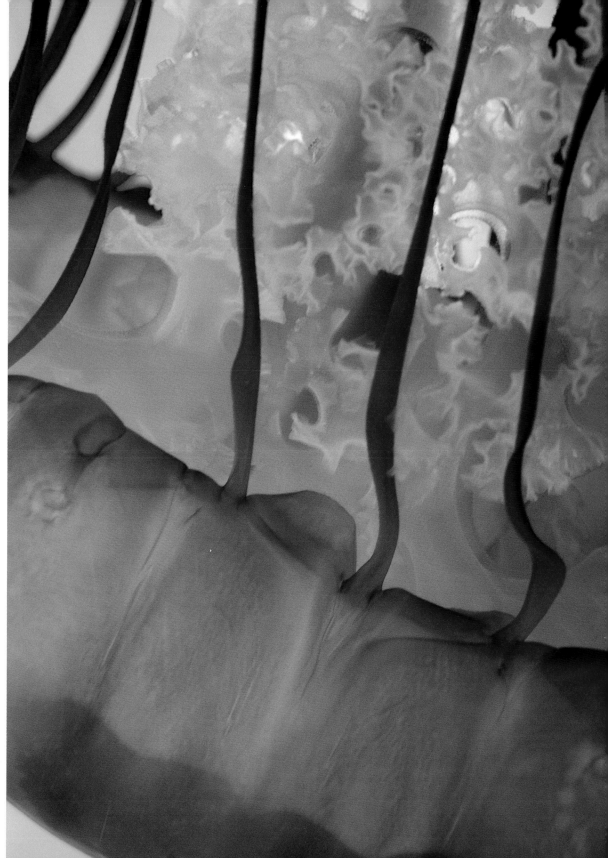

Jellies

The delicate beauty of jellies belies their true nature as stinging predators that feed on fishes and other small marine animals. They are distant relatives of anemones and corals and share with them the same microscopic stinging cells in their tentacles. Jellies are ephemeral and from time-to-time the Georgia Aquarium jelly exhibits are changed to display species that are seasonally available. Some species are also being cultured by our aquarists.

161. Close-up view of the Sea nettle, *Chrysaora fuscescens*

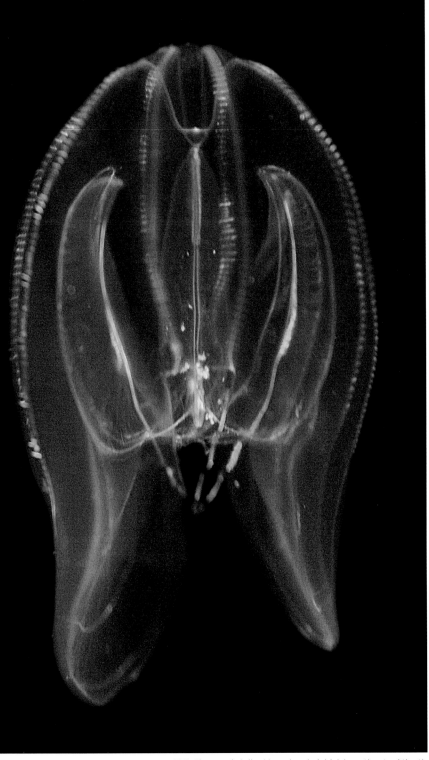

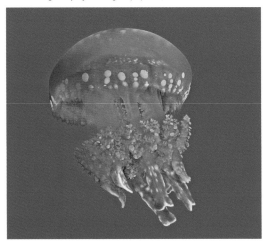
162. The lagoon jelly, *Mastigias papua* (Pacific)

163. The big pink jelly, *Drymonema dalmatinum* (Atlantic & Pacific)

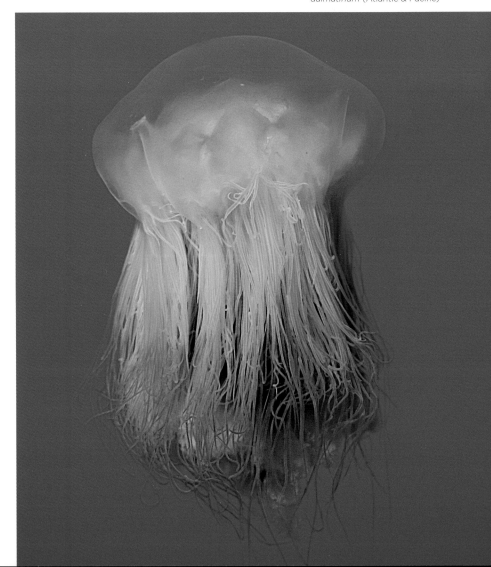

164. The comb jelly, *Mnemiopsis leidyi*, is native to Atlantic waters, including Georgia, but has become a significant pest in the Black Sea where it was accidentally introduced via ballast water from ships.

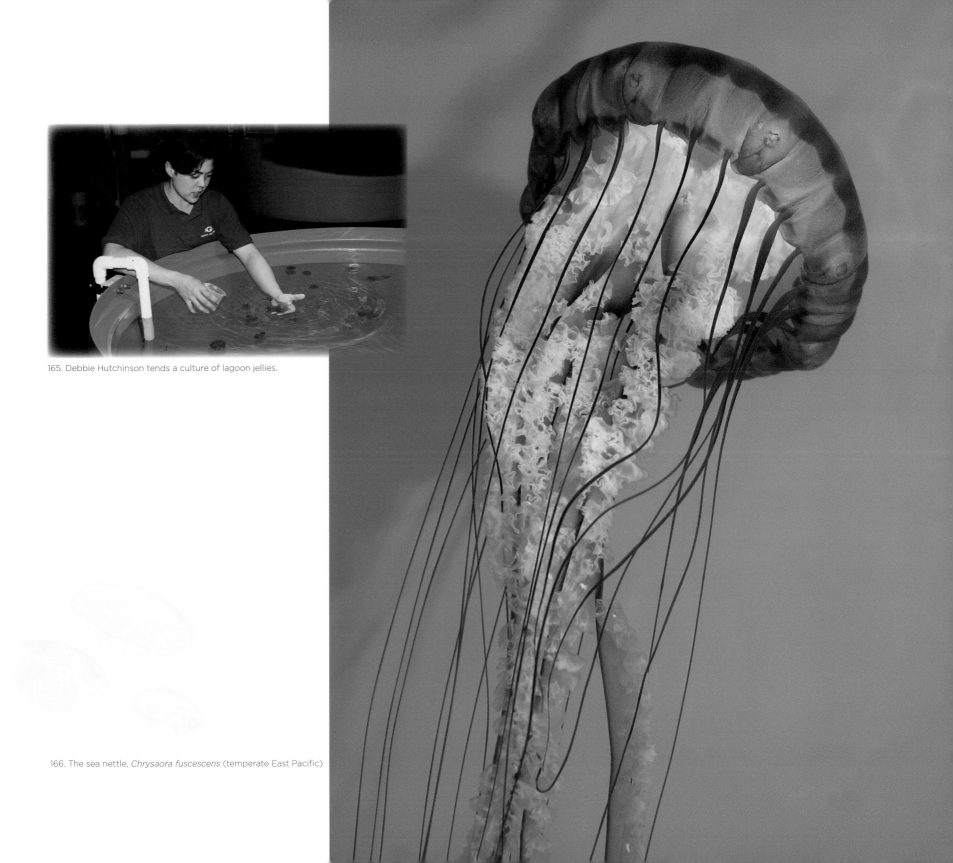

165. Debbie Hutchinson tends a culture of lagoon jellies.

166. The sea nettle, *Chrysaora fuscescens* (temperate East Pacific)

167. Fire anemonefish, *Amphiprion melanopus*, in a bubble-tip anemone, *Entacmaea quadricolor* (both Pacific)

168. Clown anemonefish, *Amphiprion percula* (Pacific)

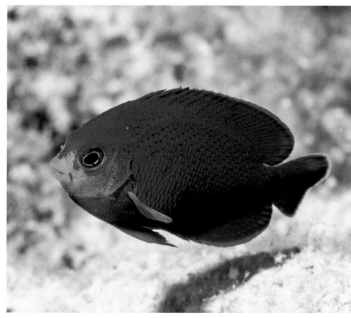

169. Cherubfish, *Centropyge argi* (West Atlantic)

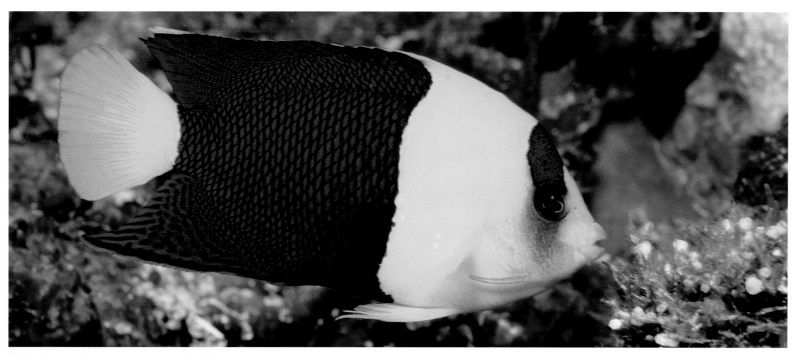

170. Bicolor angelfish, *Centropyge bicolor* (Pacific)

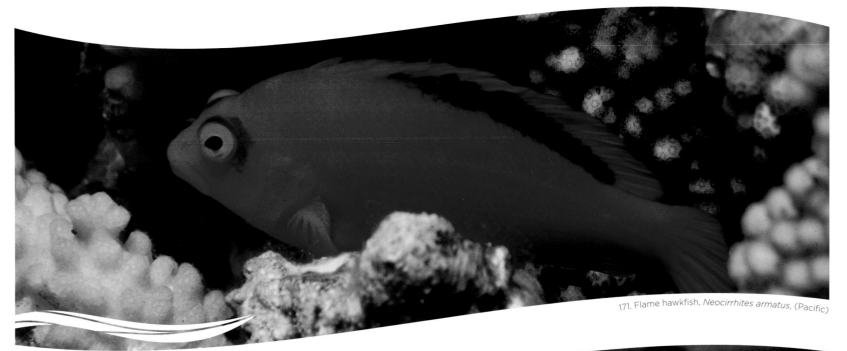

171. Flame hawkfish, *Neocirrhites armatus*, (Pacific)

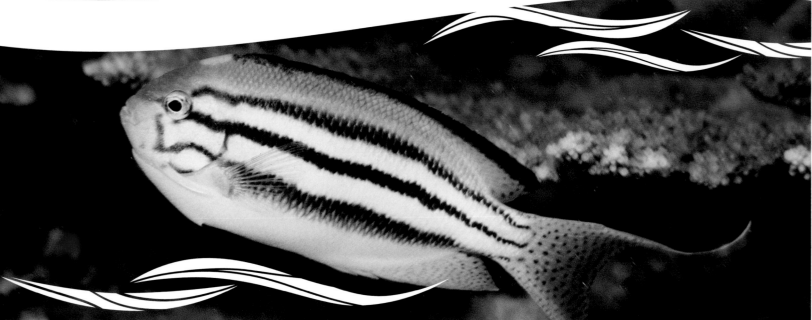

172. Blackstriped angelfish, *Genicanthus lamarck*, male (Pacific)

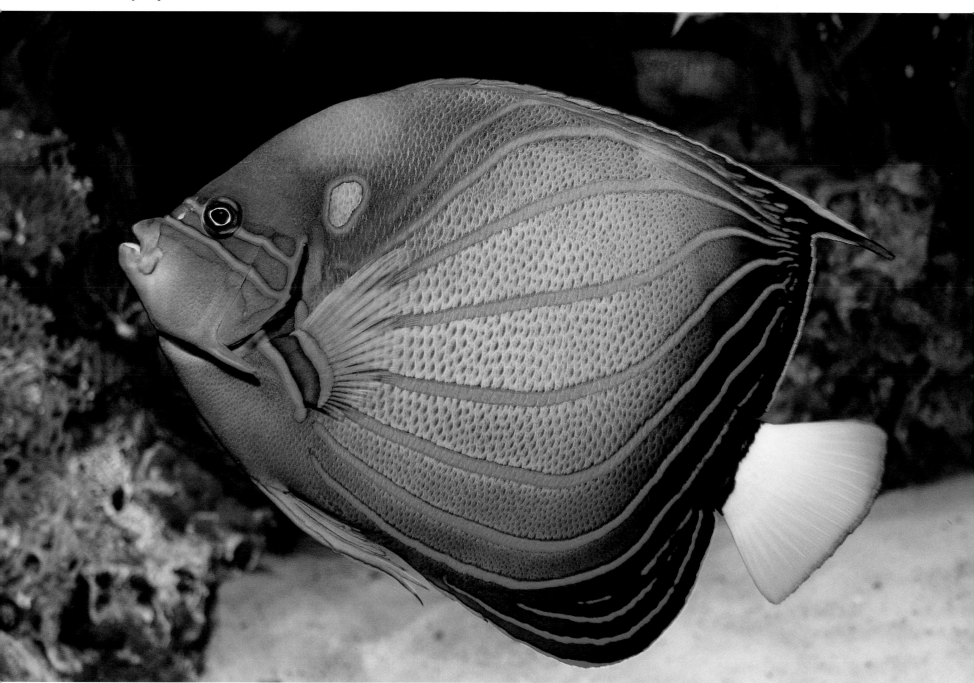

173. Bluering angelfish, *Pomacanthus annularis* (Pacific)

174. Square-spot fairy basslet, *Pseudanthias pleurotaenia*, male (Pacific)

175. Square-spot fairy basslet, *Pseudanthias pleurotaenia*, female (Pacific)

176. Painted anthias, *Pseudanthias pictilis*, female (Pacific)

177. Painted anthias, *Pseudanthias pictilis*, male (Pacific)

178. Bartletts' anthias, *Pseudanthias bartlettorum*, male (Pacific)

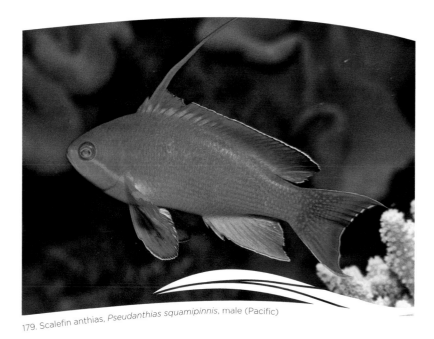

179. Scalefin anthias, *Pseudanthias squamipinnis*, male (Pacific)

180. Hawaiian cleaner wrasse, *Labroides phthirophagus*, (Hawaii)

181. Two-spot basslet, *Pseudanthias bimaculatus*, male (Pacific)

182. Yellow and blueback fusilier, *Caesio teres* (Pacific)

183. Redheaded fairy wrasse, *Cirrhilabrus solorensis* (Pacific)

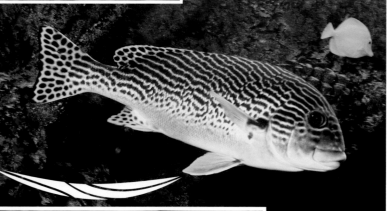

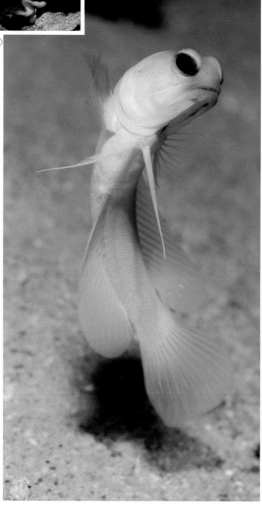

184. Yellowbanded sweetlips,
Plectorhinchus lineatus (Pacific)

185. Mandarinfish, *Synchiropus splendidus* (Pacific)

186. Yellowhead jawfish, *Opistognathus aurifrons* (West Atlantic)

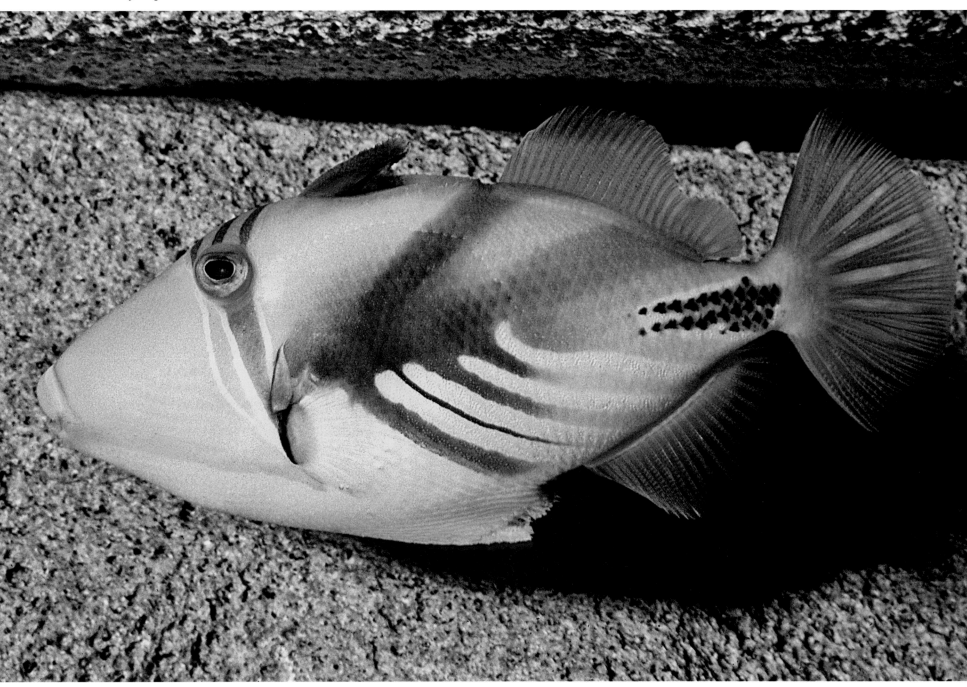

187. Blackbar triggerfish, *Rhinecanthus aculeatus*, from the Pacific is sometimes known as the Picasso triggerfish, and in Hawaii it is known as the humuhumu nukunuku apua'a.

Conservation

The mission of the Georgia Aquarium printed on the inside cover of this book, concludes with this statement:

"...(to) promote the conservation of aquatic biodiversity throughout the world."

The Georgia Aquarium presents a wide diversity of life from waters around the planet, including Georgia, and through these exhibits millions of people have had an opportunity to see animals that otherwise might only be seen as snapshots in books, or fleeting images on a television screen. There is no doubt that many people have been moved and inspired by viewing the Georgia Aquarium exhibits. Certainly, there are children who will see these animals and decide to dedicate their lives to ocean science or conservation biology. People who are inspired will also be concerned and will want to help, especially when they learn that some of these animals or their habitats are in peril. This is perhaps the most profound impact that the Georgia Aquarium will have on the planet for many decades into the future.

The Georgia Aquarium has formulated plans for conservation efforts on many levels, from the day-to-day activities of employees who recycle or reduce consumption; to field conservation projects in Georgia; to international efforts to help protect and preserve aquatic animals and habitats. The Georgia Aquarium Training Program includes a two-hour mandatory session for all staff to help every employee learn how their individual conservation activities can make a difference on a global scale. The staff has also organized themselves into working groups to come up with more ideas and projects to pursue, such as stream clean-ups, special events to help the public learn more about conservation, and recommendations to help protect animals and habitats.

188. Striped blenny, *Ecsenius prooculis* (West Pacific)

189. Chris Horne of the Atlanta Reef Club taking photos on a coral reef in the Solomon Islands

190. The bumphead parrotfish, *Bolbometopon muricatum*, is making a comeback in the Arnavon Conservation area, Solomon Islands.

98

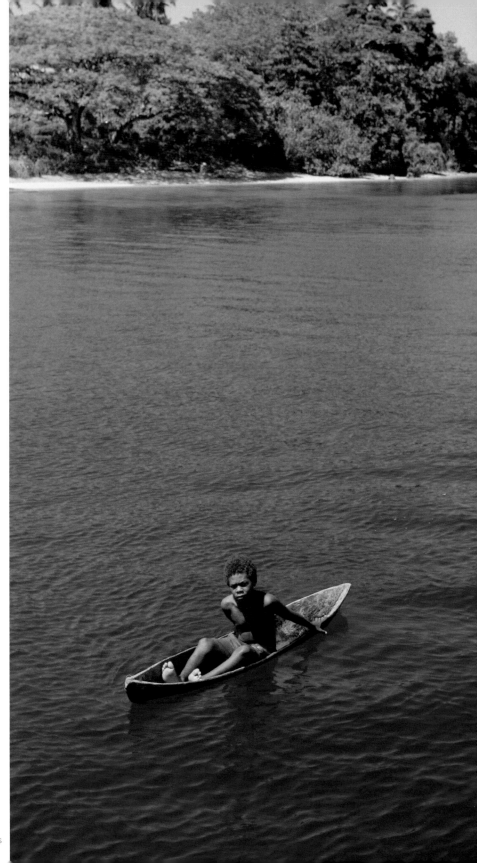

Georgia Aquarium, The Nature Conservancy, and the Solomon Islands

One of the first international conservation projects to receive aid from the Georgia Aquarium is a small group of islands and coral reefs in the South Pacific. Worldwide, coral reefs are in decline due to pollution, siltation from land development, dynamite blasting, over-fishing, and in recent years from unusually high sea surface temperatures. It came as a welcome surprise, therefore, when we learned from The Nature Conservancy (TNC) that some coral reefs in the South Pacific are making a remarkable comeback due to the efforts of local villagers. In 1995, three villages in the northwest Solomon Islands teamed up with TNC to create the Arnavon Community Marine Conservation Area (ACMCA). The two islands and coral reefs in this protected area had once been thriving reef communities but years of over-fishing had greatly reduced the population of fishes, giant clams and other reef animals. These islands also harbor one of the world's largest populations of endangered hawksbill turtles. With the resources available from TNC, a management plan was established and over the past decade these protected coral reefs have flourished. Several key species of fishes that had been depleted are now making a comeback, including the humphead wrasse (which is displayed in Ocean Voyager), the bumphead parrotfish, and giant clams.

Despite the success story of the recovery of these coral reefs, the villages have been cash-strapped to maintain patrols and monitoring efforts. This is where the Georgia Aquarium stepped forward to help. The Georgia Aquarium's Pacific Barrier Reef exhibit is modeled after reefs in the Solomon Islands so there is a natural affinity between the Aquarium and these islands. Through a partnership with TNC, the Georgia Aquarium has provided funding equal to the annual budget of the ACMCA for three years. Ultimately, the goal is to establish an endowment fund to make this area the world's first sustainably financed community marine protected area (Note: as this book goes to press, TNC has published an announcement that this goal will indeed be attained by 2010).

This is the Georgia Aquarium's first major sponsorship for field conservation, and the beginning of what we expect will be a long-lasting relationship with The Nature Conservancy. This is a natural partnership since both organizations have the same mission to help preserve the diversity of life on this planet by protecting the habitats that plants and animals need to survive.

191. Dugout canoes are the primary means of transportation in the Solomon Islands

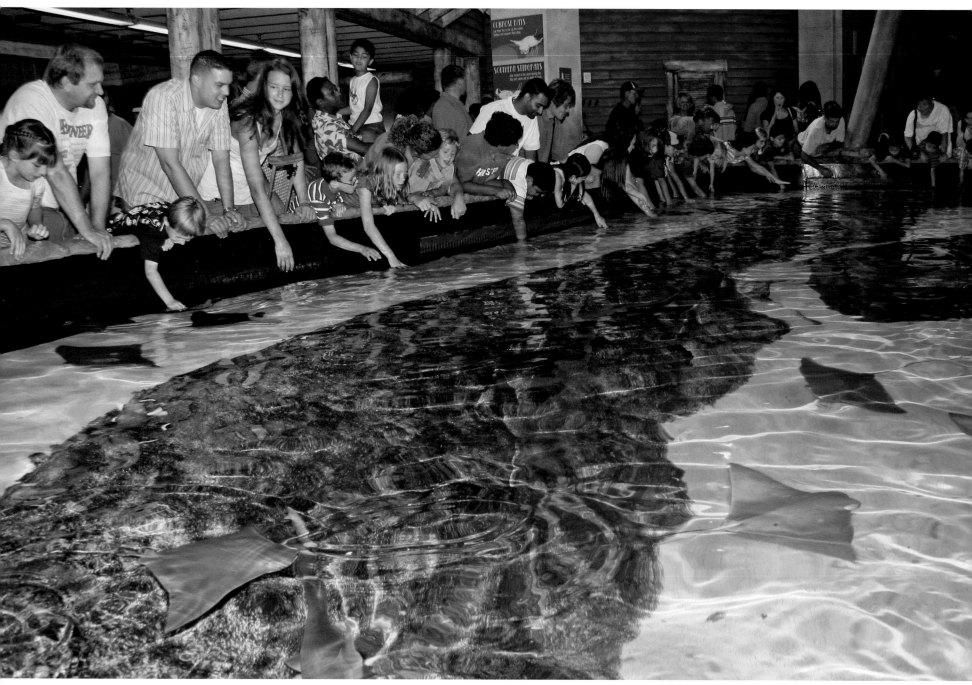

CHAPTER SIX:

Georgia Explorer, Discover Our Coast

GEORGIA EXPLORER

Presented by: 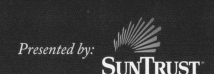 SUNTRUST

Georgia Coast

If you have visited the Georgia coast, you will remember the hospitality and fun that you experienced in this beautiful area where the land gently disappears into the sea. The short coastline is only 100 miles (161 km) in length, but along this coast are hundreds of thousands of acres of marshlands that are critical habitat for migratory birds, and a nursery for many of Georgia's commercially important fishes and shrimp. Georgia has the highest tides on the southeast coast, ranging from six to nine feet (1.8 – 2.7 m), but the waves that come ashore are low-energy because they travel so far across the shallow continental shelf. About two-thirds of Georgia's barrier islands are state or national parks, and Gray's Reef National Marine Sanctuary is located about 17 miles (27 km) off of Sapelo Island. This special undersea sanctuary has low, rocky ledges filled with invertebrates, fishes (including the goliath grouper), loggerhead sea turtles, manta rays, and in the winter months it is home to the endangered northern right whale—Georgia's state mammal.

The Georgia Explorer gallery brings some of the fun and excitement of the Georgia coast to our visitors. This gallery, with its variety of touch-tanks, play areas, and a simulated shrimp boat, is especially entertaining for children.

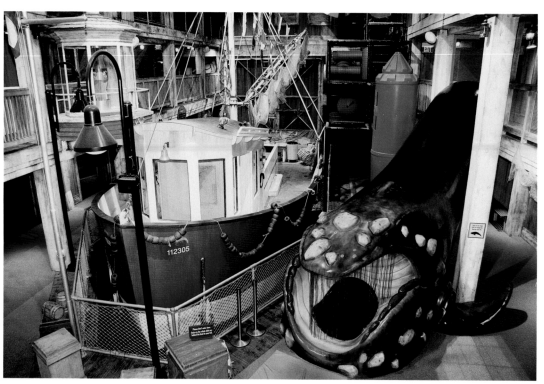

193. A shrimp boat and a whale slide are highlights of the Georgia Explorer gallery.

194. Brown shrimp, *Farfantepenaeus aztecus*

195. Shrimp are a valuable fishery in Georgia but rarely do people get to see—or touch—live shrimp.

196. Cownose ray, *Rhinoptera bonasus*

197. Forbes' common sea star, *Asterias forbesi*

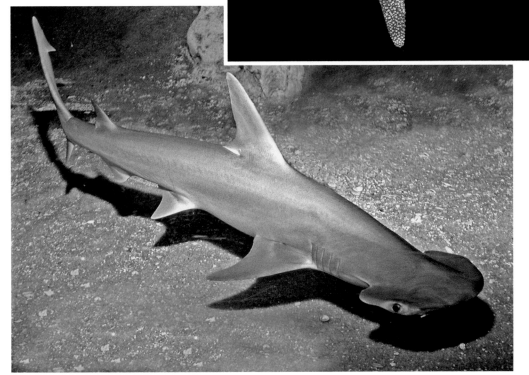

198. Bonnethead shark, *Sphyrna tiburo*

A Touching Experience

Many children and adults living in the city or far inland never have the opportunity to get close to creatures that live along the Georgia coastline. A highlight of the Georgia Explorer gallery is the variety of accessible exhibits that allow people of all ages to touch cownose rays, bonnethead sharks, shrimp, horseshoe crabs and seastars. There are two rules to follow for the safety of the animals as well as our guests: use a gentle touch with only two fingers, and never remove the animal from the water (they cannot breathe in air!). Periodically, we give the animals a rest period when touching is not permitted.

199. The ray touch pool is popular with kids.

Horseshoe Crabs

The ancestors of the durable horseshoe crab (*Limulus polyphemus*) have been crawling around the ocean floor for 360 million years, and in all that time its basic body structure has barely changed. The horseshoe crab is truly a living fossil. But it is not a true crab; its relationships lie closer to spiders and ticks, and thousands of extinct species known as trilobites. This gentle creature looks rather ominous with its spines and a long pointed tail, but the tail spine is only used to right itself if it happens to be turned upside down.

The horseshoe crab has become a useful species for medical science. Its large optic nerve has been useful to scientists who study vision. Curiously, this animal does not have an immune system. Instead, it has a variety of compounds that bind to and inactivate bacteria, fungi and viruses. Its blood is used with many of our injectable drugs and vaccines to ensure that the product is free of bacterial contamination. A part of the shell is used to make absorbable sutures, dressings for wounds, and to speed clotting. Unfortunately, this remarkable and useful animal is also being over-fished for use as bait; so greater protection for the horseshoe crab is necessary.

200. Guest Programs interpreters are located throughout the galleries to help answer questions and give presentations about the animals in the exhibits. In this photo, Melanie Brown helps children have a close encounter with a horseshoe crab.

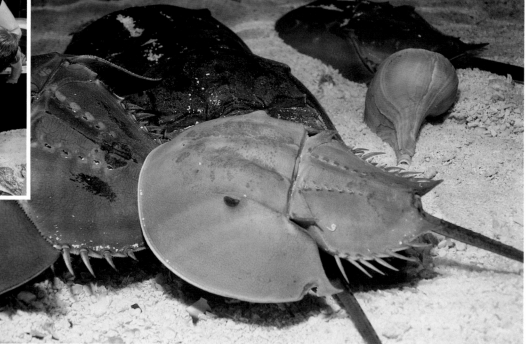

201. Horseshoe crab, *Limulus polyphemus*

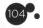

202. A loggerhead sea turtle swims in the Gray's Reef exhibit in Georgia Explorer.

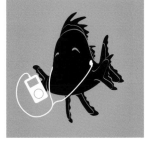

203. An audio tour with interesting information about all of the exhibits is available as a free download from the Georgia Aquarium website (www.GeorgiaAquarium.org) or as a free podcast from iTunes.

Gray's Reef National Marine Sanctuary

On January 16, 1981 a little known patch of rocky outcropping 17.5 miles (28.2 km) off of Sapelo Island was designated a National Marine Sanctuary. Most of the ocean bottom off the Georgia coast is sand and mud and a good habitat for shrimp, which forms the basis of a major commercial fishery. In the area of Gray's Reef, there are rocky outcroppings and ledges forming an ideal habitat for sponges, sea fans, and a variety of fishes and other animals including mantas, sea turtles, and even the northern right whale during the winter months. The reef is named for Milton "Sam" Gray, a biologist who was the first to extensively survey the area in 1961, while he served as Curator at the University of Georgia Marine Institute. Today, Gray's Reef is the location for a variety of research projects including satellite tagging of loggerhead sea turtles, fish surveys, and studies on the history and formation of the reef. The latter work is particularly interesting because the bones of a mastodon were found underwater at this site, as well as human-made projectile points, which strongly suggest that this area was once dry land when sea levels were lower during the last ice age. The Georgia Explorer gallery includes an exhibit featuring loggerhead sea turtles and some of the fishes found in the Gray's Reef National Marine Sanctuary.

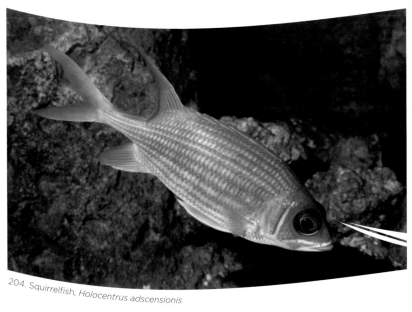

204. Squirrelfish, *Holocentrus adscensionis*

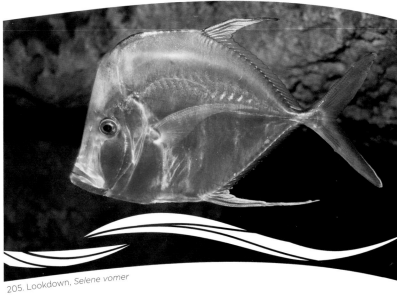

205. Lookdown, *Selene vomer*

206. Permit, *Trachinotus falcatus*

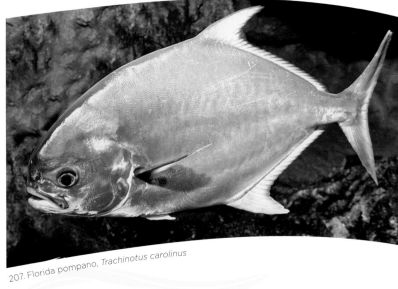

207. Florida pompano, *Trachinotus carolinus*

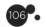

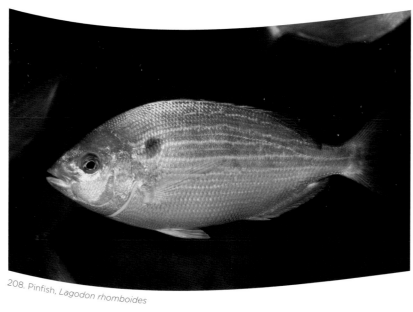

208. Pinfish, *Lagodon rhomboides*

209. Sheepshead, *Archosargus probatocephalus*

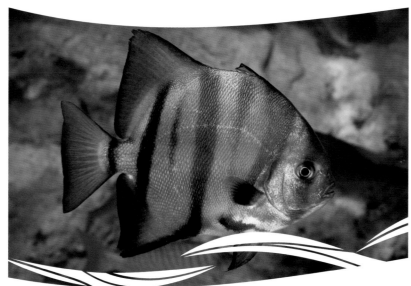

210. Spadefish, *Chaetodipterus faber*

211. White grunt, *Haemulon plumieri*

212. Northern red snapper, *Lutjanus campechanus*

213. Vermillion snapper, *Rhomboplites aurorubens*

214. Yellowmouth grouper, *Mycteroperca interstitialis*

215. Black seabass, *Centropristis striata*

216. Goliath grouper, *Epinephelus itajara*

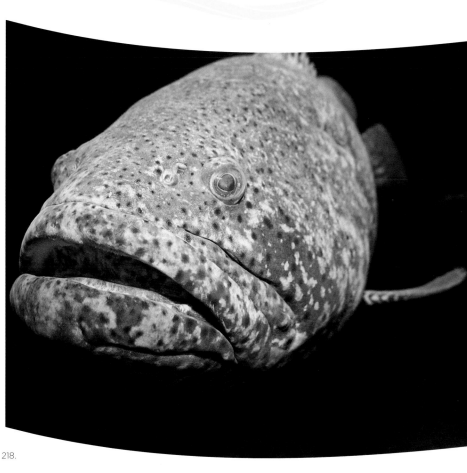

218.

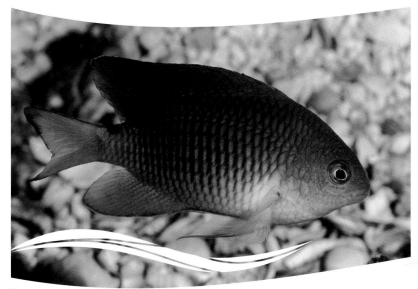

217. Cocoa damselfish, *Stegastes variabilis*

The Saga of Dylan the Loggerhead Sea Turtle

The first loggerhead sea turtle (*Caretta caretta*) to live at the Georgia Aquarium was named "Dylan." Dylan was a straggler who didn't emerge from an underground nest after hatching August 26, 1998 on Jekyll Island, on the Georgia coast. He was rescued and lived at the Tidelands Nature Center for several years, until he arrived at the Georgia Aquarium on November 17, 2005. As the most conspicuous resident of the Gray's Reef Exhibit, he delighted visitors, young and old alike for the first year-and-a-half after the Aquarium opened. But on May 15, 2007 Dylan made his way back to Jekyll Island as the first step towards his new life in the ocean. As we go to print, Dylan is residing at the new Georgia Sea Turtle Center on Jekyll Island where he will be trained to fend for himself in the sea. Upon his release, sometime in early 2008, he will be fitted with a satellite transmitter so scientists can track his movements. Through Internet technology, everyone should be able to find out where Dylan has traveled—at least until the battery on the transmitter eventually wears out. For updates on his progress, check the Georgia Aquarium website (www.GeorgiaAquarium.org), or the Georgia Sea Turtle Center (www.GeorgiaSeaturtleCenter.org).

The loggerhead sea turtle gets its name from its massive head. This species can grow very large—up to 350 lbs (159 kg) and 3' (91 cm) in carapace length, and it may live for 100 years. The loggerhead sea turtle uses its massive beak to crush the shells of mollusks, crabs and other hard-bodied animals, but it may also eat jellies. It starts out life hatching from an egg laid in the sand on a beach. Along the Georgia coast, there are a number of loggerhead turtle nesting sites where these turtles lay eggs from April through September. The 2" (5 cm) hatchlings make their way to the ocean and live out at sea for the first few years of their lives, and during that period they are rarely seen by anyone. But as they grow older they move closer to the coastline and hunt for food in areas like Gray's Reef.

The loggerhead sea turtle is found in all but the coldest oceans around the world. It is a threatened species due to over-harvesting for its shell and for food, but also because its nesting sites have been lost to development, or to nest robbers. There are many organizations devoted to saving sea turtles. For more information on how you can help too, here are a few organizations in the state of Georgia that you can contact:

Tybee Island Marine Science Center (www.tybeemsc.org/)

Caretta Research Project (www.carettaresearchproject.org/)

St. Catherines Sea Turtle Conservation Program (http://seaturtle.sdsmt.edu/001welc.html)

U.S. Fish and Wildlife Service Savannah Coastal Refuge (www.fws.gov/savannah/management.htm)

Cumberland Island National Seashore (www.nps.gov/cuis/)

Georgia Department of Natural Resources, Coastal Resources Division (http://crd.dnr.state.ga.us/content/displaynavigation.asp?TopCategory=1)

THE GEORGIA SEA TURTLE CENTER

JEKYLL ISLAND, GEORGIA

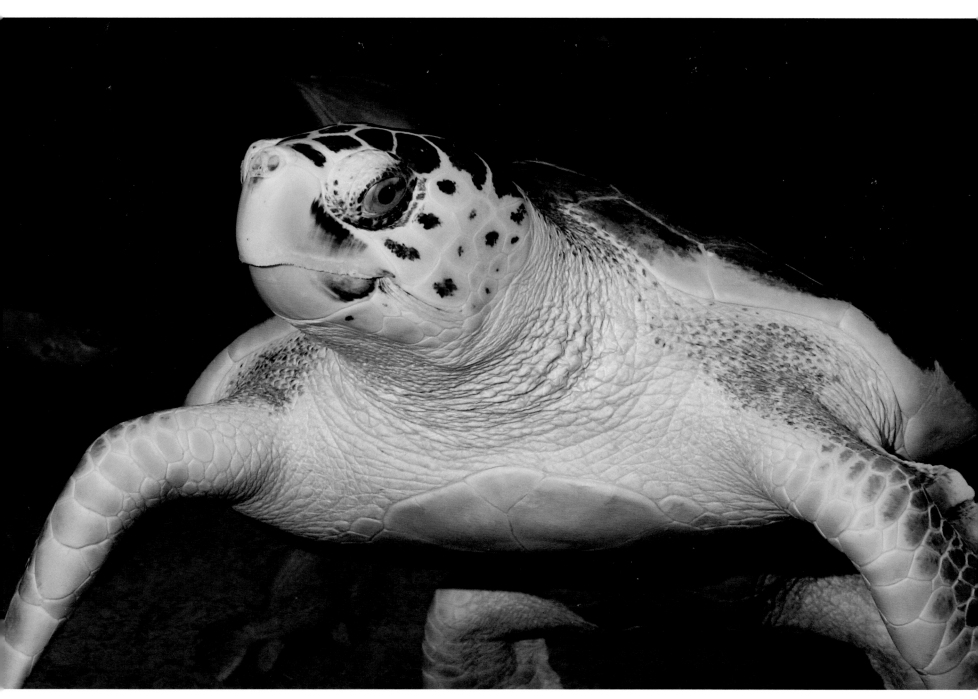

219. "Dylan" a loggerhead sea turtle, *Caretta caretta*

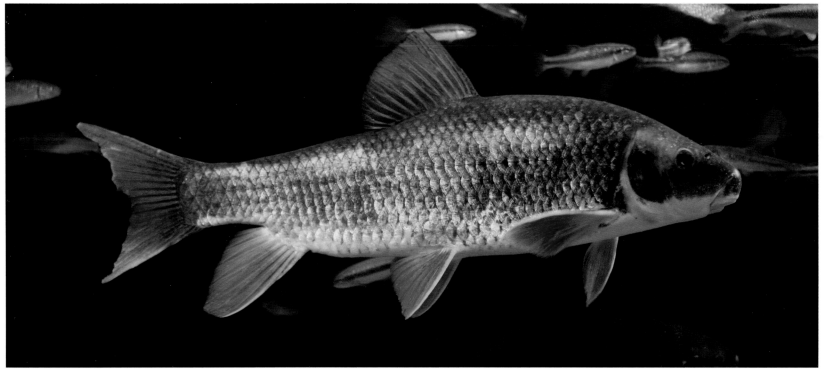

220. Robust redhorse sucker, *Moxostoma robustum*

Back From the Brink of Extinction

All of the exhibits in the Georgia Explorer gallery focus on saltwater animals—with one exception. The robust redhorse sucker is a freshwater fish found in a select few rivers in Georgia, North Carolina, and South Carolina. When a specimen was collected from the Oconee River in 1991, it was a mystery to everyone. Eventually, it was identified as the robust redhorse sucker (sometimes known as the smallfin redhorse), *Moxostoma robustum*. This species was originally described in 1869 based on one six-pound specimen, but after that it was lost to science until its re-discovery 122 years later. Today, a consortium of public and private companies and organizations in partnership with government agencies are working diligently to preserve the habitat of the robust redhorse sucker, and augment natural populations with fish raised in aquaculture facilities.

The robust redhorse sucker is a member of the sucker family, Catostomidae, which has about 72 species. It can attain a length of 30" (76 cm), and weigh up to 17 lbs (7.7 kg). Jimmy Evans of the Georgia Department of Natural Resources provided the robust redhorse suckers on display at the Georgia Aquarium. Jimmy was one of the people instrumental in unraveling the mystery of this remarkable fish.

Georgia's State Mammal

Hawaii and Georgia have at least one thing in common: both states have designated a whale as their state mammal. In Hawaii it is the humpback whale. The Georgia state mammal is the northern right whale (*Balaena glacialis*), the most endangered of all species of whales. The Georgia Aquarium cannot exhibit one of these massive animals, and the loss of even one animal from the breeding population would seriously harm this species' chances for survival. The northern right whale was relentlessly hunted from around the 11th century to the early 20th century, and nearly disappeared from north Atlantic waters. In 1984, northern right whales were re-discovered off the Georgia coast. They migrate here in the winter months, and this is when their calves are born. In the spring, they migrate north to the Gulf of Maine where they spend the summer months feeding. At one time there may have been as many as 15,000 of these whales in the north Atlantic, but today the population numbers only about 300. Hunting of this species is banned, but it is still declining due to collisions with ships and entanglement in fishing gear.

Even though we can't bring a living right whale into the Aquarium, the next best thing is video. The Right Whale Theater in Georgia Explorer is devoted to helping visitors learn more about this endangered species. Not far from the theater is the right whale "slide" where kids can slide through a whale and exit from its mouth!

The northern right whale is a gentle species that feeds on copepods, krill and other planktonic animals that it filters from the water using 400 – 520 baleen plates that ring its mouth. It can reach a length of 45' – 60' (13.7 – 18.3 m) and weigh up to 50 tons (45 metric tons). Considerable efforts are underway by the National Oceanic and Atmospheric Administration, as well as our colleagues at the New England Aquarium, and many others to track this species as it migrates to our waters to spend the winter. You too can help save this magnificent animal by contacting NOAA and by informing your local and state representatives that greater protection for this species is critical for its survival.

222. Child emerging from the right whale slide

221. The northern right whale theater

223. Life size model of a northern right whale calf on the Education Loop

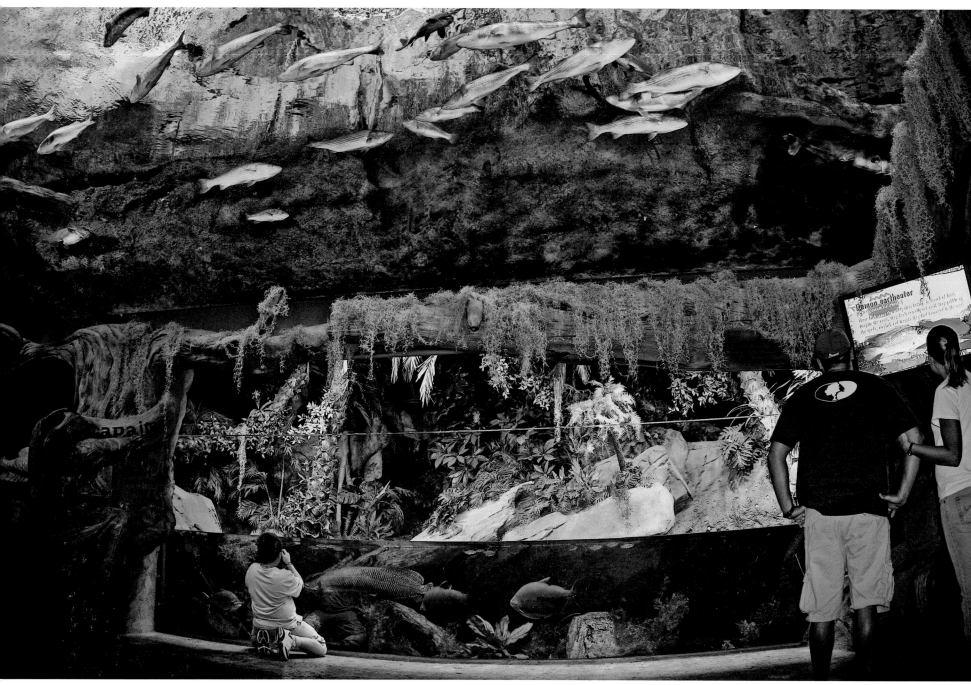

224.

CHAPTER SEVEN:

River Scout, Freshwater Mysteries

RIVER SCOUT

Presented by: **SOUTHERN COMPANY**

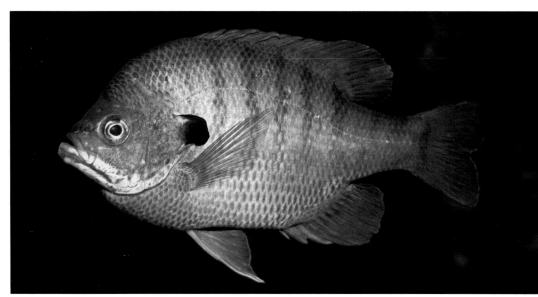

225. Redbreast sunfish, *Lepomis auritus* (Eastern North America)

River Scout

The River Scout gallery offers a completely new perspective on freshwater fishes. A river flows overhead throughout the gallery allowing each visitor an eye-catching, fish-belly point-of-view of a wide variety of North American fishes. This gallery is dedicated to life in the streams, ponds, rivers, and lakes of North America, South America, Africa and Asia. All people everywhere depend on clean freshwater, and so do a myriad of fishes and other aquatic animals and plants. Of all the freshwater on the planet, 99% is frozen in the soil or locked in ice; only 1% of all freshwater on the planet is free flowing.

Sadly, more and more of this water is polluted, and many of the animals in this gallery are disappearing in the wild due to loss of habitat or over-fishing. One amazing statistic is that more than 45,000 dams have been built around the world (including many in Georgia), leaving only 2% of the rivers in the United States, and only 60% in the world completely free flowing. Each dam results in great changes to the ecology of river environments, both upstream and downstream. In the United States, dams are being removed wherever possible to restore rivers to their natural state and allow native fishes to repopulate these waterways, but much more conservation work remains to be done. An estimated 20% of the 10,000+ freshwater fish species in the world have become extinct or endangered in the last century, and that number is accelerating as we place greater and greater demand on our freshwater resources.

The word "river" is often used as a metaphor for life, and the theme "River Scout" connotes the wonders that are still to be discovered in the few wild, untamed rivers that remain on the planet. While you explore this gallery, we want you to marvel at the wonderful diversity of life that you see, and we want you to consider your connections to these animals through your daily activities and water use. Think about where your water comes from, and what you put down the drain. All of your activities are connected to these rivers of life and you can make a significant difference in their future—hopefully for the better!

Fish vs. Fishes—which is correct?

From time to time, the Georgia Aquarium receives messages scolding us for using the word "fishes". Most of us were taught in school that the plural of "fish" is "fish," and "fishes" is incorrect. But among ichthyologists (scientists who study fish or fishes), both terms are correct. We use the word "fish" when we refer to one individual fish, or when we refer to a group comprised of one species of fish. For example if we have a bowl with one or many goldfish, we would refer to them all as "fish." But if that same bowl contains several fish species, such as guppies, swordtails and goldfish, we would correctly say that the bowl contains many "fishes."

226. A belly view of a shovelnose sturgeon, *Scaphirhynchus platorynchus*, in the overhead North American river exhibit

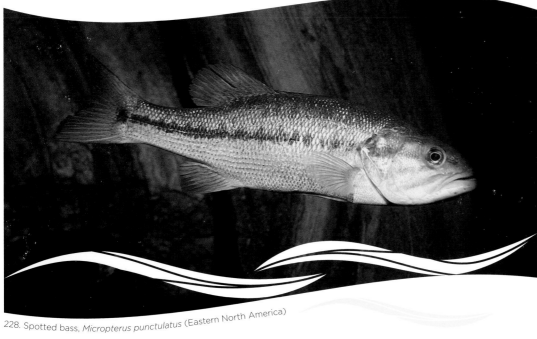

227. Bowfin, *Amia calva* (Eastern North America)

228. Spotted bass, *Micropterus punctulatus* (Eastern North America)

North American Fishes

About 600 species of fishes live in North American waters with the greatest diversity living in the Mississippi River basin. Sunfishes, bass, perch, and catfishes are common, as are more unusual fishes such as sturgeon, paddlefish, and gars. Most freshwater fishes live their entire lives in rivers, streams and lakes, but freshwater eels swim to the ocean to spawn. Many unique species, such as darters, are limited to a few or just one river system and can quickly become endangered due to habitat destruction.

One of the most interesting yet unpretentious fish in the North American River exhibit is the bowfin (*Amia calva*). The bowfin is not colorful, it isn't swift, and it has no special behaviors. But fossil remains of fishes very much like the modern bowfin can be found in rocks dating back more than 200 million years. The bowfin is a living example of what early bony fishes looked like, and therefore it is referred to as a "living fossil." Other "ancient" fishes are to be found in North American waters and in this exhibit, including the gars and the sturgeons. When you find these fishes in the exhibit, or in the accompanying photographs, look at their body structure and the placement of their fins and compare them to the more "modern" fishes such as the bass and sunfish.

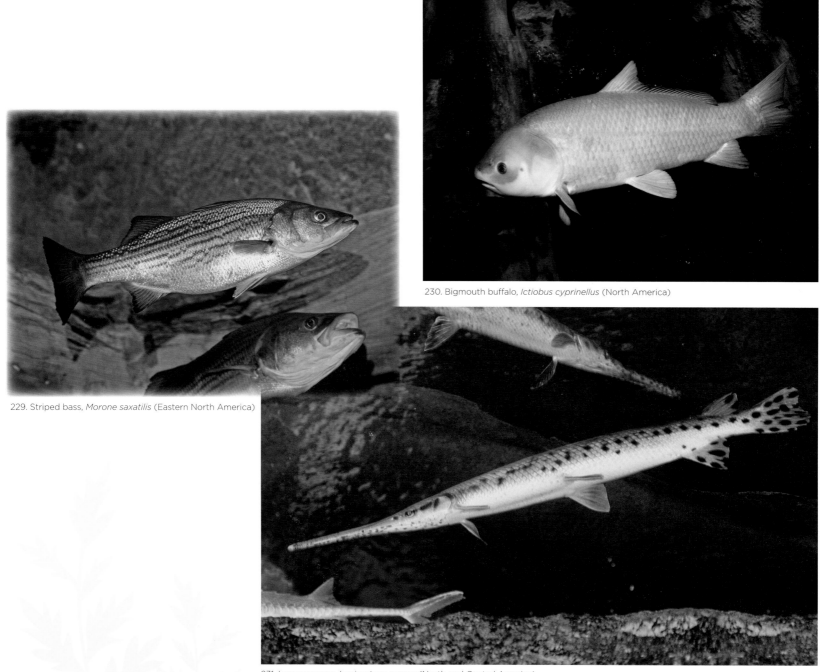

230. Bigmouth buffalo, *Ictiobus cyprinellus* (North America)

229. Striped bass, *Morone saxatilis* (Eastern North America)

231. Longnose gar, *Lepisosteus osseus* (North and Central America)

African Fishes

A curious fact emerged from the rift lakes of Africa when scientists began describing the species they found there. Unlike the rivers of North and South America, which are filled with a high diversity of wildly different kinds of fishes, many of the fishes from the African rift lakes appear to be closely related to each other. Lake Malawi is a good example of an African rift lake that is populated by closely related fishes, and some of these species are featured in the River Scout gallery. The majority of these species belongs to one family of fishes called cichlids (pronounced "sick-lids"). The species differ from each other primarily in coloration, the shape of their mouths, and tooth structure. The most plausible explanation for this huge diversity of closely related species is that they all descended from one ancestral species that invaded the lake when it first formed. Over time, populations of these fishes became specialized to feed on a variety of food items in the lake—and eventually on each other! One trait they all share is the way they care for their eggs. All female Lake Malawi cichlids incubate their eggs in their mouths until the eggs hatch. Many of the African rift lake fishes are becoming endangered and some have gone extinct due to the introduction of exotic species that have eaten or out-competed the native species for space in the lakes.

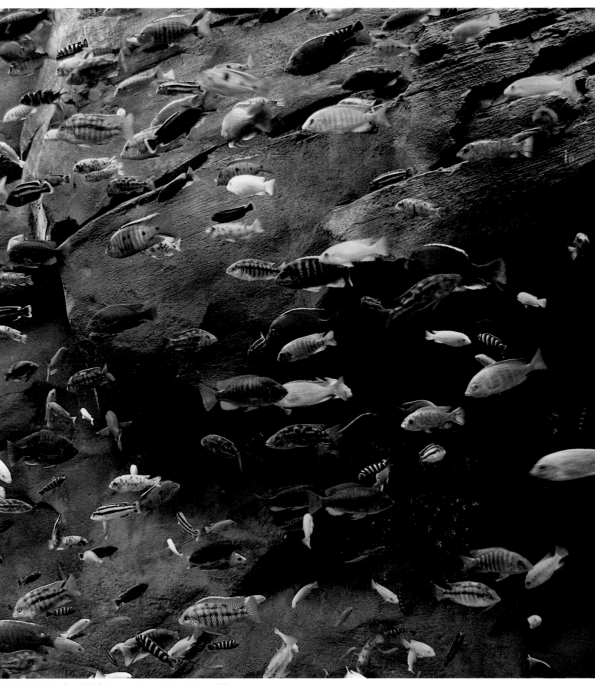

232. A variety of cichlid fishes native to Lake Malawi, Africa

South American Fishes

The Amazon River covers more than 2.5 million square miles and in places is 300' (91 m) deep. This immense river is home to more than 2,500 fish species and nearly 50 new species are discovered there every year. By contrast the Mississippi is home to only 375 fish species. Catfishes of all sizes and shapes abound in the Amazon. They share the river with electric eels, piranha, freshwater stingrays and one of the largest of all freshwater fishes, the arapaima. Equally interesting are the many small, colorful fishes of the Amazon region that have become popular in home aquariums, such as tetras, discus, angelfish and catfishes. Many of these small species are now cultured in farms in Florida and other countries and are no longer collected from the wild. The richness of the Amazon River is of great importance to native people for food, drinking water, and commerce.

233. Arawana, *Osteoglossum bicirrhosum* (South America)

235. Black spot piranha, *Pygocentrus cariba* (South America)

234. Arapaima, *Arapaima gigas* (South America)

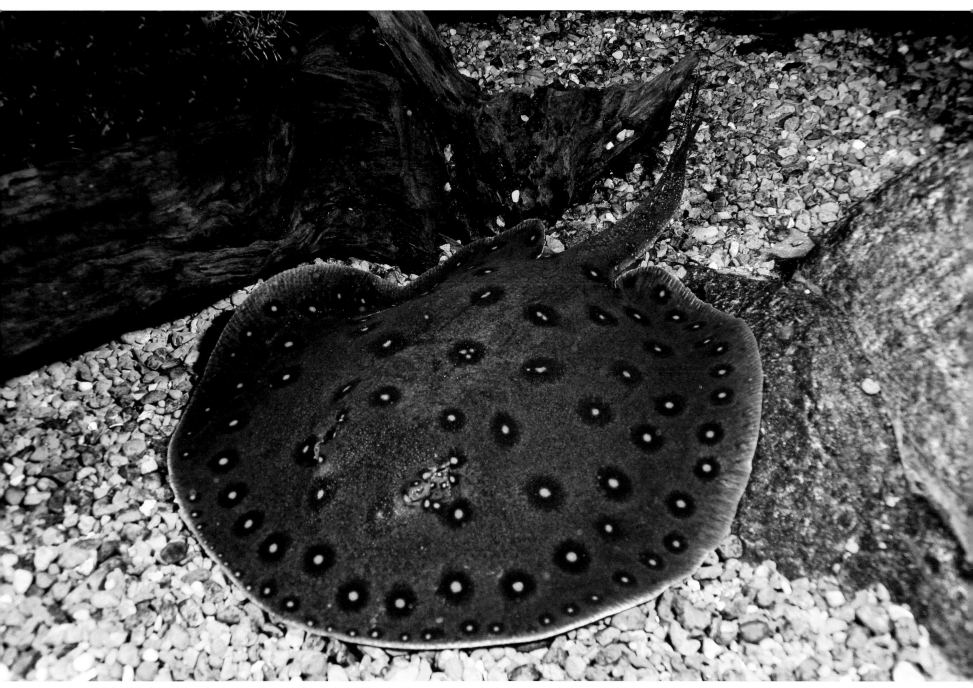

236. Ocellate river stingray, *Potamotrygon motoro* (South America)

237. Cardinal tetra, *Paracheirodon axelrodi*

238. Amazon tropical fishes discus (middle), altum angelfish (middle right) and flameback bleeding heart tetras (lower right)

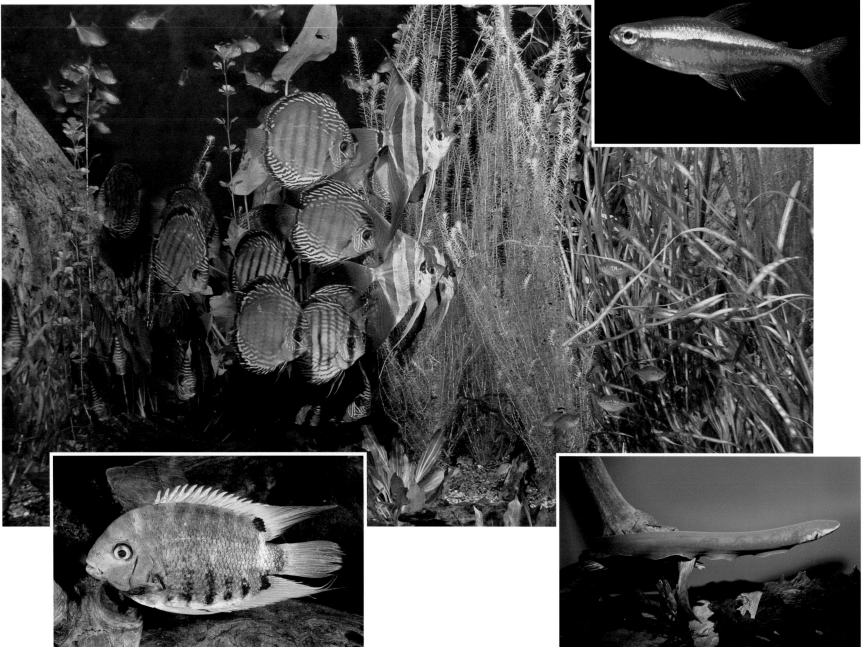

239. Banded cichlid, *Heros severus*

240. Electric eel, *Electrophorus electricus*

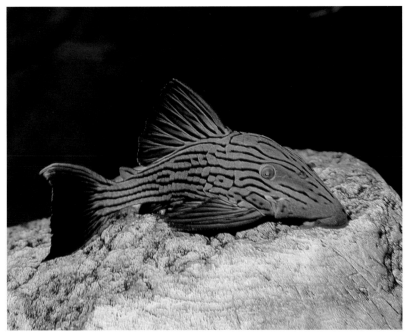

241. Royal panaque, *Panaque nigrolineatus*

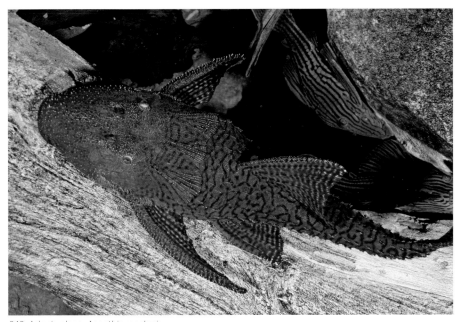

242. Adonis pleco, *Acanthicus adonis*

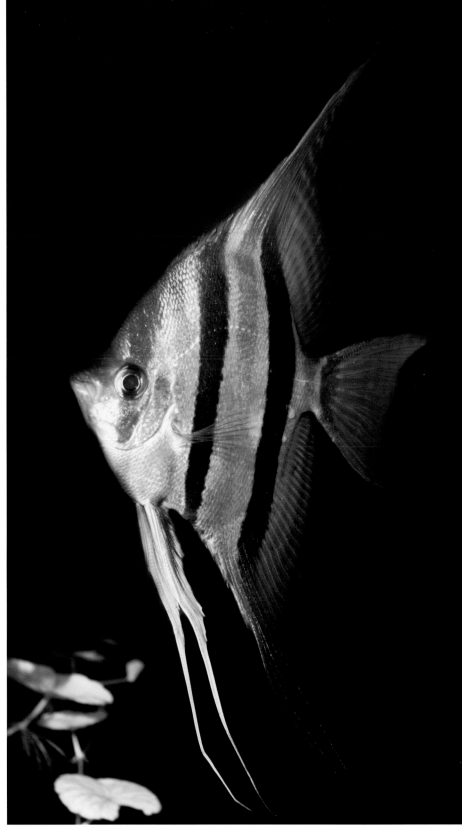

243. Altum angelfish, *Pterophyllum altum*

244. Asian small-clawed otter, *Aonyx cinerea*

Asian Small-Clawed Otters

The agile and active small-clawed otter is native to the wetlands, rivers and mangrove swamps of tropical Asia, including India, China, the Southeast Asia peninsula, Indonesia and the Philippines. Of the thirteen species of otters in the world, this is the smallest species reaching a body length of only 18" – 24" (46 – 61 cm) and a weight of 6 – 12 lbs (2.7 – 5.4 kg). Unlike most otters, this species spends much of its time on land. It has feet that are narrow, but not webbed like its more aquatic relatives, making it more agile on land but somewhat less efficient swimming underwater. Lateral motions of its tail help propel it through the water, and its whiskers help it discern changes in water current and pressure. It is also able to seal up its nostrils and ear canals while underwater, and reduce its heart rate and oxygen consumption. Even its eyes can adjust so it can see clearly underwater as well as on land.

Small-clawed otters produce a strong, musty odor from scent glands at the base of the tail. The scent is used to mark their territory and may also communicate the identity, sex and sexual state of the individuals. You can watch our otters scent-marking the rocks and trees in our exhibit whenever they are awake and active. Even though we have efficient air filters, you may even pick up the scent as you walk by their exhibit.

The Asian small-clawed otter feeds on shelled mollusks, fishes, frogs, crabs and other crustaceans and given its active lifestyle, it feeds often. Sadly, it is fast disappearing in the wild due to the usual causes of human encroachment on its habitat, hunting for its pelt, and reduction of its food sources due to pollution. This species is listed as "vulnerable" on the Red List produced by the International Union for the Conservation of Nature (IUCN).

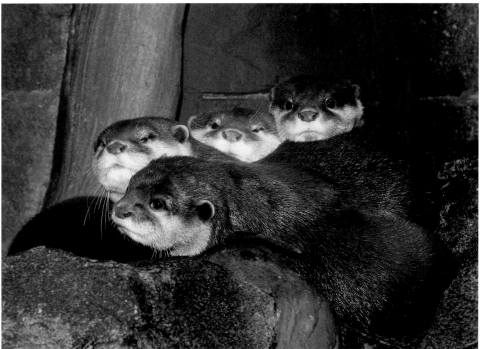

245.

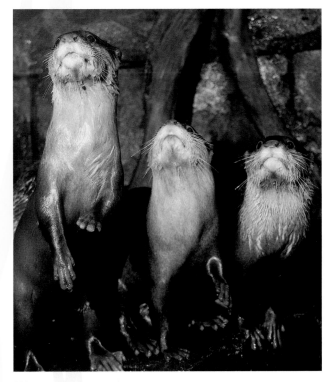

246.

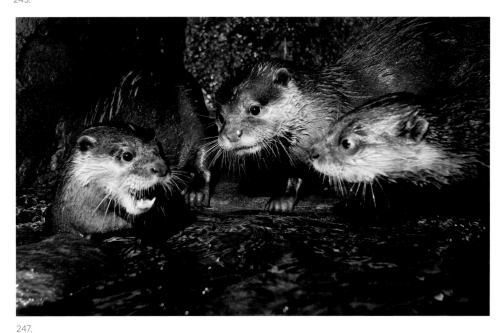

247.

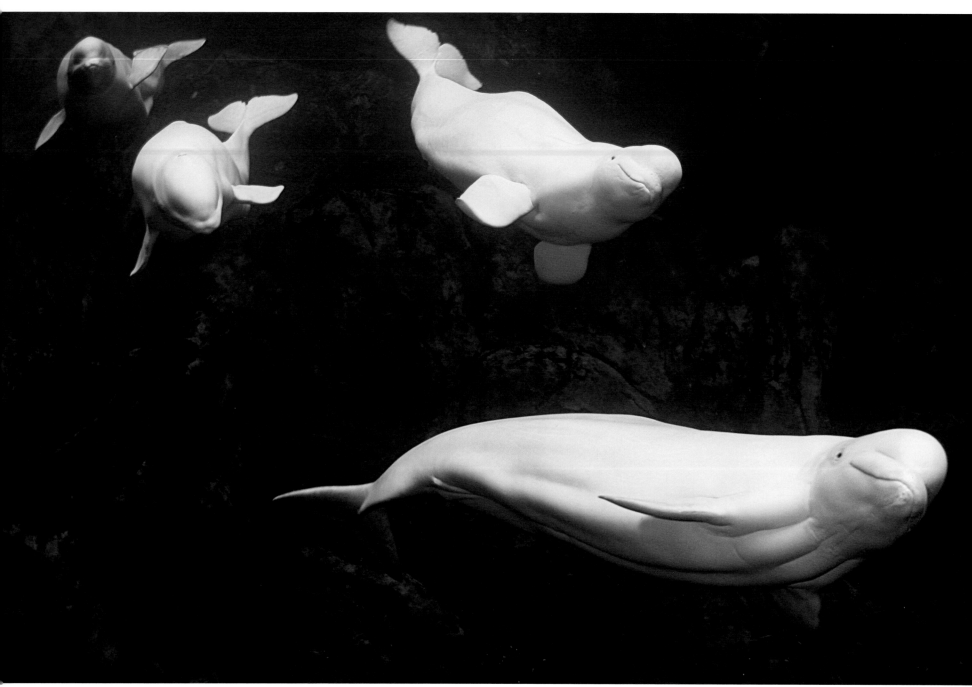
248. Left to right: Marina, Natasha, Nico, and Maris—beluga whales, *Delphinapterus leucas*

126

COLD WATER QUEST

Presented by:
Georgia-Pacific

Cold Water Quest

"Cold" is a relative term when it comes to water, animals and people. To most humans, a water temperature below 68°F (20°C) is usually considered very cold, but to many marine animals that same temperature may be quite warm and near the maximum at which they can survive. The animals in the Cold Water Quest gallery cover the entire range of cold-water temperatures, from near freezing Arctic waters, to the temperate oceans of California, Japan, southern Australia, and southern Africa.

These cool waters often contain high levels of nutrients that are important for the growth of phytoplankton—microscopic plants that drift in the water. These tiny one-celled plants grow prolifically when nutrients are available and turn the water green. Cool waters are also home to plants such as giant kelp that are often so abundant and so tall that they create underwater forests. And, just like on land, when plants are plentiful so are the animals that feed on them. Cool waters around the planet are very productive and are the source of the world's major fisheries, as well as home to whales, sea lions, otters and many other marine mammals and a host of sea birds. Conserving these abundant resources is one of the greatest challenges of our time, as most of the commercial fish species have declined precipitously due to over-fishing, and in recent years, from the effects of unusually warm sea temperatures. Likewise, many marine mammals and sea birds are in peril. For some species, only the heroic efforts of conservation organizations, committed individuals, and enlightened government officials will save them from extinction.

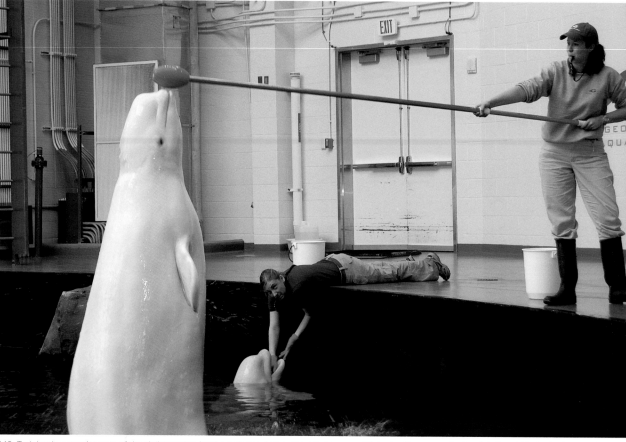

249. Training is a regular part of the daily routine for the beluga whales. Patricia Dove and Natasha (foreground), Jen Odell and Maris (background)

Beluga Whales from the Arctic Circle

Billi Marcus will not hesitate to tell you that her favorite animals at the Georgia Aquarium are the beluga whales. To humans, these large snow-white animals with their playful antics display an intelligence that seems absent among the fishes. People relate to these animals, and this is not surprising since they are mammals like us. They do not have gills but instead have lungs and they must surface periodically to breathe; their paddle-like flippers have an internal bone structure that is much like our own hands and fingers; they are warm-blooded like us; and mother beluga whales feed their calves milk from mammary glands just like all mammals. They do indeed have large brains like their whale and dolphin relatives, so the appearance of intelligence is not an illusion.

Beluga whales are native to the Arctic Circle and are found off the coasts of Canada, Alaska, Russia, northern Europe and Greenland. Occasionally they swim into the freshwaters of the Yukon River of Alaska, the Saint Lawrence River of Canada and the Amur River in Russia. Throughout the Arctic, there are an estimated 200,000 beluga whales so this is not an endangered species, but some local populations have been in a steady decline for many years. The beluga whales in the Saint Lawrence, Canada, and the Cook Inlet, Alaska, are resident populations that are isolated from other beluga whale populations. Beluga whales are also highly susceptible to pollution. Some beluga whales in the St. Lawrence seaway contain such high levels of PCB's (polychlorinated biphenyls) that they are considered to be "toxic waste" when dead animals wash ashore.

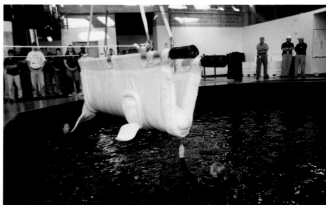

250. Nico arrives at his new home at the Georgia Aquarium on October 16, 2005.

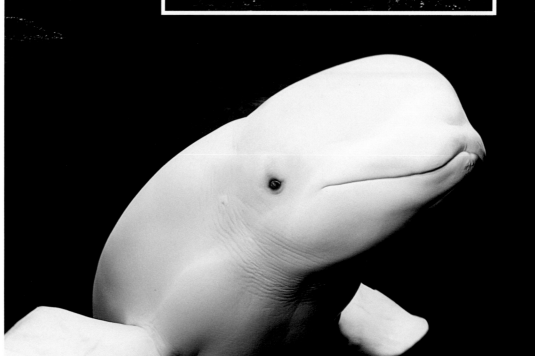

251. "Natasha" one of four beluga whales, *Delphinapterus leucas*, at the Georgia Aquarium

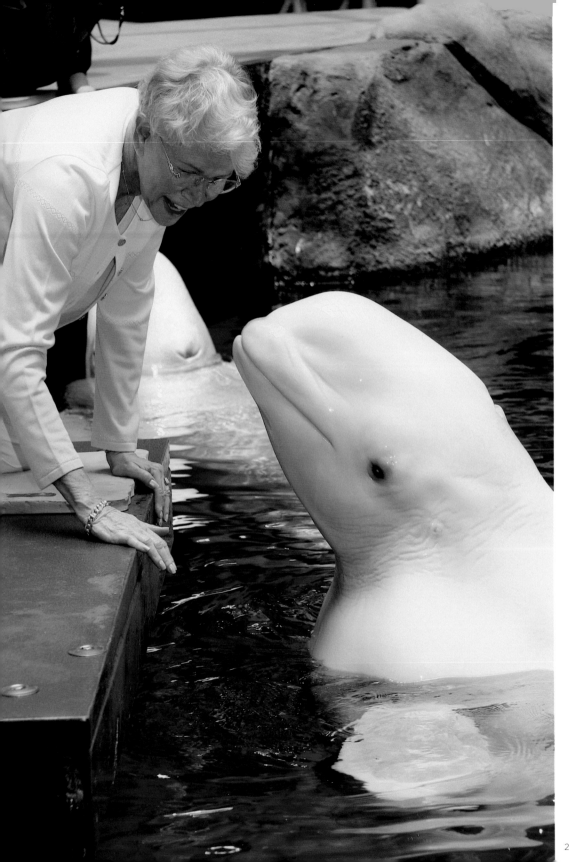

The beluga whales at the Georgia Aquarium arrived here from other aquariums. Nico and Gasper were residents of a theme park in Mexico City where they resided in a pool located under a roller coaster. While their keepers gave them the best possible care, the bare pool reverberated with the sound of the roller coaster and was less than an ideal environment. With the consent of the park owners and the Mexican government, Nico and Gasper flew to Atlanta via a donated UPS flight on October 17, 2005 and were introduced to their new, much quieter environment at the Georgia Aquarium. Donations from the public to the Aquarium's 4R program (Rehabilitation, Relocation, Research and Rescue) were important to provide funds for this effort.

In November 2005, three female beluga whales arrived from the New York Aquarium for Wildlife Conservation: Natasha (born 1981), Maris (born 1994), and Marina (born 1984). Natasha is Maris' mother. All three animals are here on loan as part of a cooperative breeding program that includes nine zoos and aquariums in North America. Since there are so few beluga whales in aquariums, breeding is carefully controlled to minimize inbreeding and to ensure the long-term viability of this species in artificial habitats.

In nature, breeding occurs from March through May, with gestation lasting about 14–15 months. A female will give birth to a single calf every 2–3 years and at birth the young are about 5' long and weigh about 175 pounds. They will nurse for nearly two years from nipples located in abdominal mammary slits on the mother. As this book goes to print, we can report that Nico has been amorously involved with the female beluga whales but it is too soon to know if mating has been successful.

252. Billi Marcus being greeted by "Natasha"

A Tribute to Gasper

When Gasper arrived at the Georgia Aquarium in October 2005, he was significantly underweight and had a serious skin infection, particularly on his flippers. This condition was detected during a physical exam in Mexico. Aquarium officials knew Gasper was ill, but did not realize how critical his condition was. Despite his health problems, the Aquarium decided to bring him to Atlanta where the best veterinary and medical care would be available to him. Doing so undoubtedly improved the quality of his life as well as his lifespan.

A veterinary team from the College of Veterinary Medicine at the University of Georgia, led by Dr. Bran Ritchie, worked closely with the veterinary staff of the Georgia Aquarium assessing Gasper's condition and providing regular treatment. Initially, Gasper gained back a lot of weight that he lost prior to coming to Atlanta and he appeared to be thriving, but the persistent infection grew increasingly worse.

The general public was supportive of the Georgia Aquarium's decision to care for Gasper and followed his story with great interest and concern. When the end finally came, it was no surprise to anyone and the outpouring of sympathy from thousands of people was overwhelming. Gasper's time in Atlanta was brief, but in that short time he brought excitement, joy and a new awareness of beluga whales to millions of people.

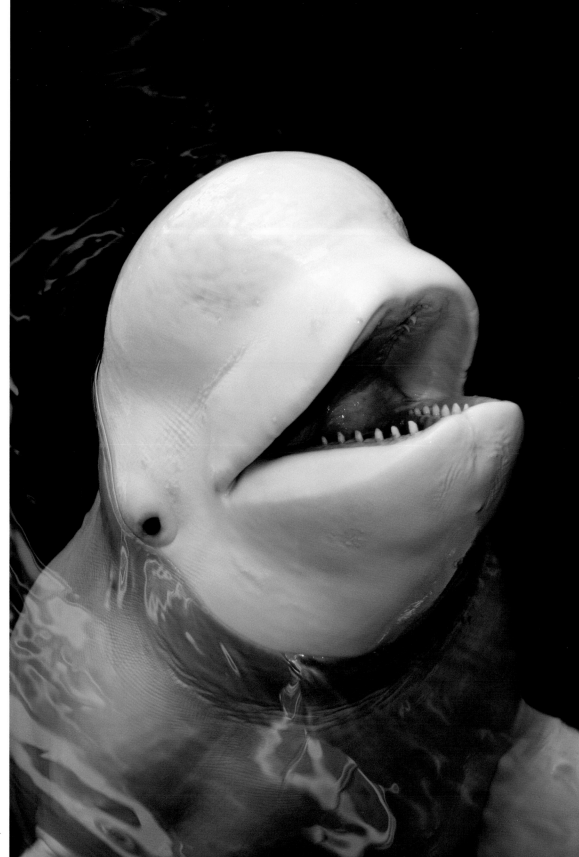

Beluga Whale Research

Modern technology has made the beluga whale one of the most studied species of cetaceans in the field. Satellite tags can record and transmit data on an animal's location, how often and how deep it dives, as well as the duration of each dive. This kind of research has been conducted on beluga whales in many regions, but not, until now, in the Far East of Russia in the Sea of Okhotsk. Little is known about the population dynamics, genetic diversity and migratory habits of beluga whales living in this body of water. In 2007, the Georgia Aquarium entered into a joint venture with Hong Kong's Ocean Park and Moscow's Utrish Dolphinarium under the Russian Academy of Science, to conduct field studies in this region. The United States National Marine Fisheries Service (NMFS) has lent its expertise to this project as well.

Working with local fishermen in the Amur River delta from a camp on uninhabited Chkalov Island, team members from the Georgia Aquarium, Ocean Park, Utrish Dolphinarium and NMFS sampled animals for DNA genetic analysis and attached satellite transmitters to five belugas in the fall of 2007. As this books goes to press, satellite data are being received and these animals are being tracked for the first time in the Sea of Okhotsk. The Georgia Aquarium is optimistic that this pilot study will lead to a broader, long-term research effort that will reveal more about the beluga whales that live in this remote region.

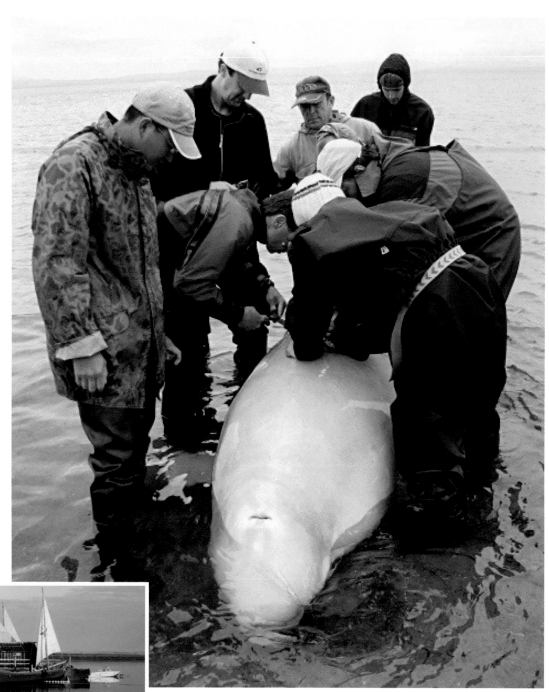

255. Eric Gaglione (tallest person) and Russian researchers attaching a transmitter to a beluga whale on the Sea of Okhotsk, Russia.

254. Floating base camp in the Amur River

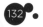

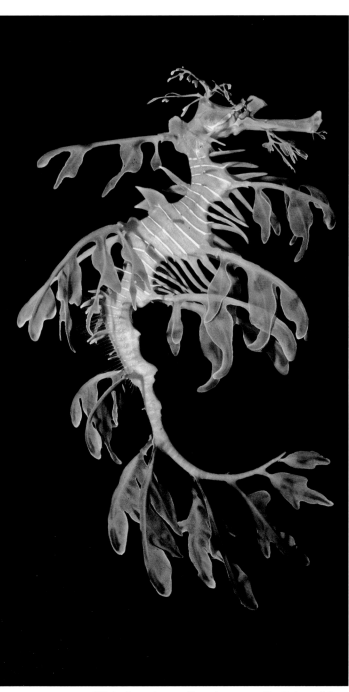

Seadragons

Australia is home to many unusual land animals such as kangaroos, koalas, and wombats, but even stranger animals reside in the cool ocean waters of south Australia: the seadragons. The two species of seadragons live up to their name bearing a resemblance to mythical dragons. The leafy seadragon (*Phycodurus eques*) is adorned with leaf-like appendages that render it nearly invisible among the algae that cover the ocean floor. Its cousin, the weedy seadragon (*Phyllopteryx taeniolatus*) has less elaborate "plumage" but is more colorful. Both species have long tubular snouts like their relatives the seahorses and pipefishes and they use this snout to suck up small shrimps living among the seaweed.

Because seadragons are so unusual they are in great demand. To protect these fishes from over-collecting, the Australian government has made it illegal to capture seadragons without a special permit. One of the few holders of a permit to collect leafy seadragons is Pang Quong who lives in Seaford, Victoria, Australia. Pang doesn't collect adult animals to export them, but rather he seeks out males carrying eggs. Like seahorses and pipefishes, male seadragons incubate the fertilized eggs attached to the underside of the tail. Pang is permitted to raise the hatchlings and sell them to aquarists around the world. The demand is so high that the Georgia Aquarium contacted Pang more than two years prior to opening to ensure that young leafy seadragons would be available in time for the opening of the Georgia Aquarium.

Young seadragons have voracious appetites, but they will only eat small, live shrimp known as mysids. Mysids are readily available and cost only a few cents each, but when you consider that each seadragon may eat more than 200 shrimp every day, it is easy to see that these animals quickly become among the most expensive animals to maintain at the Georgia Aquarium. Fortunately, we are able to wean them off live foods and onto dead (frozen) mysids, which greatly reduces the cost.

No one has succeeded in breeding leafy seadragons in an aquarium, but several aquariums have bred weedy seadragons. The first public aquarium to breed weedy seadragons was the Aquarium of the Pacific in Long Beach, California. Some of their offspring were given to the Georgia Aquarium and were on display on opening day. With proper care, these seadragons may live seven years or more.

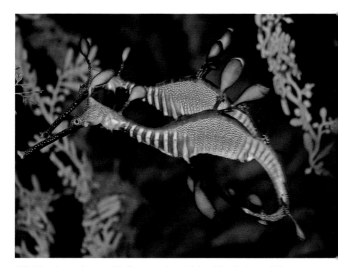

256. Leafy seadragon, *Phycodurus eques* (South Australia)

257. Weedy seadragon, *Phyllopteryx taeniolatus* (South Australia)

The Garibaldi and the Kelp Forest Community

Observant visitors to the Georgia Aquarium will notice that orange is one of the dominant colors used throughout the building. Orange is of course the corporate color of The Home Depot but it is not a color that is usually associated with the ocean. However, there is one spectacular fish from the kelp forests of California that has the most intense orange color of any fish in the sea. This is the garibaldi, a member of the damselfish family that includes anemonefishes and other small, colorful fishes mostly found on coral reefs. The garibaldi is huge by comparison reaching an adult size of nearly 14" (36 cm) and it lives in kelp forests not coral reefs. When the Georgia Aquarium began searching for a fish species to serve as a mascot the garibaldi was an obvious choice to represent the association with Bernie Marcus and The Home Depot.

The garibaldi is a prominent member of the kelp forest community that is characteristic of the coastal waters of California. Kelp is a prolific type of algae that can grow 2' (61 cm) per day and reach lengths of 100' (30 m). The dense growth of kelp creates underwater forests that provide shelter and food for a diversity of fishes and invertebrates such as those depicted in the Aquarium's entry exhibit to the Cold Water Quest gallery.

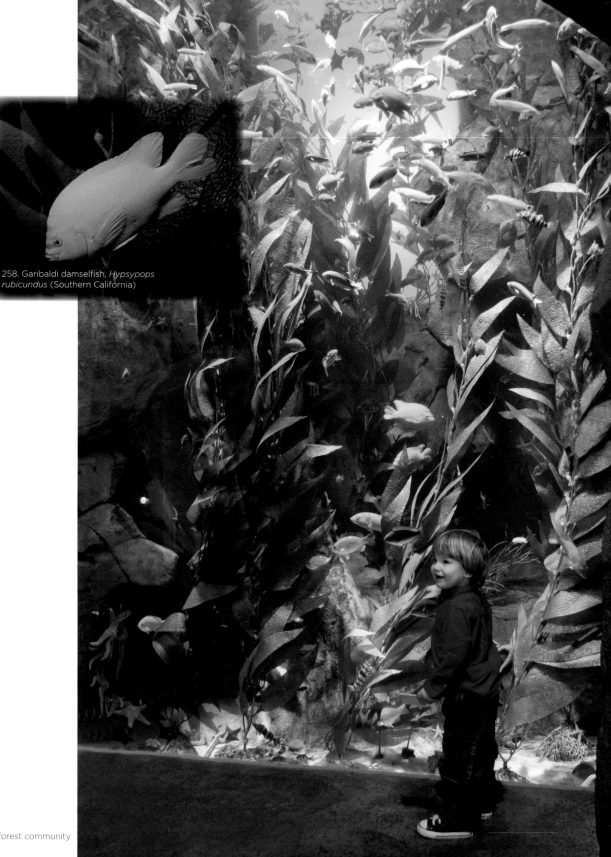

258. Garibaldi damselfish, *Hypsypops rubicundus* (Southern California)

259. The kelp forest community

134

260. Deepo greets guests during the World Ocean Day event, June 8, 2007

The True Story of "Deepo"

In 2002 during the design phase of the Georgia Aquarium, an orange fish was selected to serve as the Aquarium's mascot, but it was not the garibaldi. The first choice was the clown anemonefish and it was dubbed "Deepo" (after "Home Depot"). Not long after the selection was made, word circulated on the Internet about a new animated movie featuring a little fish called "Nemo" and it too was a clown anemonefish. The similarity was striking but purely coincidental. Nonetheless, the decision was made to give Deepo a makeover. The garibaldi was a perfect match for The Home Depot orange and quickly replaced the anemonefish. Ironically the garibaldi is a member of the damselfish family just like Nemo and the original Deepo.

261. Deepo working with Guest Programs interpreter David Benedict at the beluga whale exhibit

Southern Sea Otters

In keeping with the Aquarium's conservation mission and the goals of the 4R Program, the Georgia Aquarium obtained all of its marine mammals from other aquariums, zoos, an amusement park, and rehabilitation centers. And this is how the Aquarium's two sea otters, Gracie and Oz, found their way to Atlanta. Gracie is a female and was rescued from the wild. Despite repeated attempts to rehabilitate her and return her to the wild, her survival skills were inadequate and she was deemed unable to live on her own. She eventually came to Atlanta via the Aquarium of the Pacific in Long Beach, California. At that time, she was seven years old. She is easy to recognize by her smaller size, longer whiskers, longer ears and somewhat whiter head color. And, she has a habit of sucking on her front paws.

Oz had an entirely different origin. He was born in 2001 to parents who were thought to be immature. Ordinarily, southern sea otters are not intentionally bred in aquariums due to the lack of facilities to care for them, but managing planned parenthood among sea otters is challenging! Oz became the first southern sea otter to be successfully raised to adulthood outside of the wild. His name "Oz" refers to his birthplace at the Oregon Zoo in Portland, Oregon. He has a whiter chest and rounder face than Gracie. Both otters are fed 6 to 8 times every day and they are offered a variety of "enrichment devices" to keep them mentally active.

Sea otters live alone or in small groups called "rafts," and have a life span of 15-20 years. They feed on a variety of seafood including worms, sea urchins, abalone, mussels, scallops, octopus, squid, crabs and fish, and they may dive as deep as 200' (61 m)

for 1-4 minutes in search of food. An otter may consume 20-25% of its body weight per day to maintain its high metabolism.

Sea otters were hunted nearly to extinction for their prized pelts. The sea otter pelt is particularly desirable due to its dense fur, with up to one million hairs per square inch (in contrast, dogs have a maximum of 60,000 hairs per square inch). Today, about 2,200 survive in the wild and they are listed as an endangered species on the Red List produced by the International Union for the Conservation of Nature (IUCN), and as a threatened species under the U.S. Endangered Species Act.

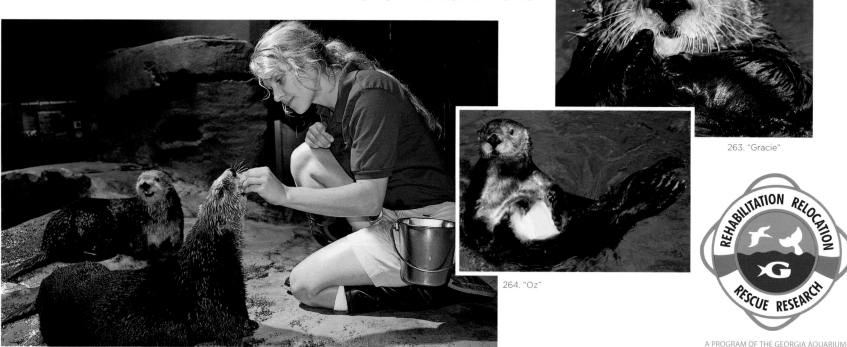

263. "Gracie"

264. "Oz"

262. Gina Fisher feeding "Gracie," a southern sea otter, *Enhydra lutris*

REHABILITATION RELOCATION RESCUE RESEARCH

A PROGRAM OF THE GEORGIA AQUARIUM

African Penguins

Penguins conjure up images of snow and icebergs, but African penguins live in temperate water along rocky coastlines and sandy beaches more than 2,000 miles (3,219 km) from the frozen world of Antarctica. This bird makes a loud braying sound reminiscent of a donkey thus suggesting its other common name, the jackass penguin.

The African penguin is only 18–25″ (45–64 cm) tall and weighs about 6–7 lbs (2.7–3.2 kg). In the wild its lifespan is about ten years but it may live twice that long in zoos and aquariums. It travels widely in search of food swimming up to 60 miles (97 km) in search of fish, crustaceans, squid and worms. Along the way, it may be hunted by predators such as the African fur seal, sharks and other birds. It swims by flapping its stubby wings and almost appears to fly underwater. Normally it swims at a rate of about 4 – 6 miles per hour (6.4 – 9.7 km/hr), with bursts up to 15 miles per hour (24.2 km/hr).

African penguins form life-long pair bonds and can produce two broods per year. In the wild, they lay 2 to 4 eggs in November and March and the eggs hatch in about 39 days, but predators will eat as many as 40% of the chicks. The parents will care for the chicks for three months.

Its numbers have declined by 90% over the past 60 years, and it is listed by the IUCN as an endangered species. Because of its protected status, African penguins at the Georgia Aquarium were not collected from the wild but rather were obtained from the Riverbanks Zoo in South Carolina and the Lisbon Zoo in Portugal. The Association of Zoos and Aquariums (AZA) oversees a breeding program of more than fifty zoos and aquariums in the United States that maintain these penguins. The breeding program ensures that a genetically diverse population is maintained without the need to collect further animals from the wild.

266. Jennifer Odell and friend

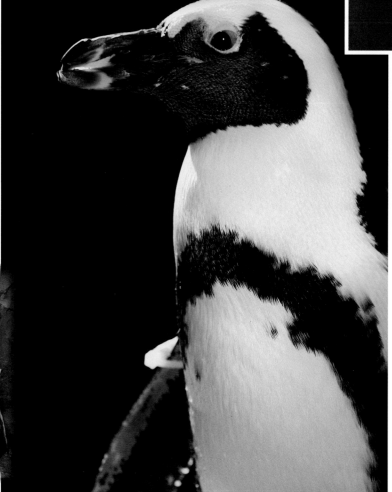

267. African penguin, *Spheniscus demersus*

265. African penguins with guests

137

268. Jeff Reid removing window scratches made by the sea lions

California Sea Lions

All marine mammals in U.S. waters are safe from hunting and commercial exploitation thanks to the Marine Mammal Protection Act. Many marine mammals have faced serious population declines and this protection has been essential to ensure their survival. One species that has fared particularly well under protection has been the California sea lion. This species ranges from British Columbia to Baja California and now numbers between 175,000 to 200,000 animals. In some places they have become nuisance animals occupying docks and boat spaces once reserved for people.

The Georgia Aquarium sea lions all came to us from other facilities. The original group included two older males (22–25 years old), two younger males (8–10 years old), two females (19–20 years old) and two "yearling" males (about 2 years old).

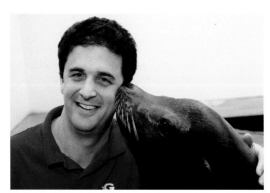

269. Eric Gaglione and "Duke"

270. Erika Stuebing (foreground) and Patricia Dove training California sea lions, *Zalophus californianus*

The females and older males arrived in Atlanta in October 2005 under the Aquarium's 4R program after their home at a facility in Gulfport, Mississippi was destroyed during Hurricane Katrina. The younger animals had been released into their native environment on the west coast, but they were unable to adjust and were relocated to the Georgia Aquarium.

Male sea lions can reach 7' (2.1 m) in length and weigh up to 1,000 lbs (454 kg). Females are smaller attaining only 6' (1.8 m) and 220 lbs (100 kg). At about five years old, males develop a prominent bony bump on their head called the "sagittal crest". Sea lions have been recorded diving as deep as 1,760' (536 m) in search of food, which includes anchovies, squid, sardines, mackerel, rockfish and a variety of other marine life.

Female sea lions give birth from late May through July. The pups are nursed and cared for by the mother until they are about six months old, and then they are on their own. The only natural predators of sea lions are great white sharks and killer whales.

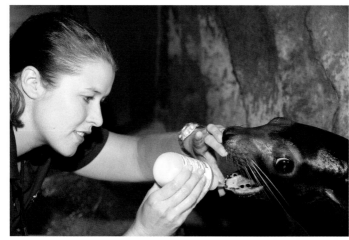

271. Sea lion getting its teeth cleaned by Patricia Dove

Giant Japanese Spider Crab

The giant Japanese spider crab lives at depths of 150' – 1000' (46 – 305m) in the Pacific Ocean near Japan. When fully extended, its legs can span up to 12' (3.6m), which is nearly the size of a small car. The male is slightly larger that the female and has larger claws. It will scrape the ocean floor for plants and algae, eating dead animals and prying open the shells of mollusks. It will sometimes attach sponges and anemones to its back to ward off predators, such as octopus. The giant Japanese spider crab is believed to live up to 100 years.

272. Giant Japanese spider crab,
Macrocheira kaempferi

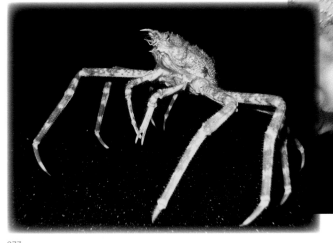

273.

The spotted ratfish, *Hydrolagus colliei*, is abundant in cold waters of the west Pacific from shallow water to depths of 3,000' (914m). This odd fish has features that are shared between sharks and bony fishes. It has a long venomous spine on its first dorsal fin. Females release eggs that hang from her body for 406 days before they are released to settle in the sand. The eggs can take up to a year to hatch. Spotted ratfish eat a variety of items including clams, crabs, shrimps and fishes and will grow up to 4' (1.2m) long.

274.

275. Painted greenling, *Oxylebius pictus* (California)

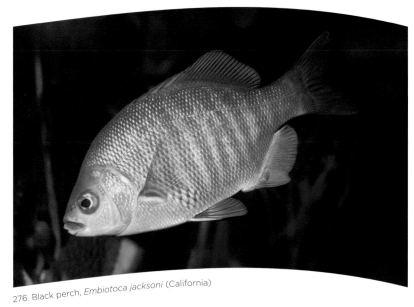

276. Black perch, *Embiotoca jacksoni* (California)

277. Senorita, *Oxyjulis californica* (California)

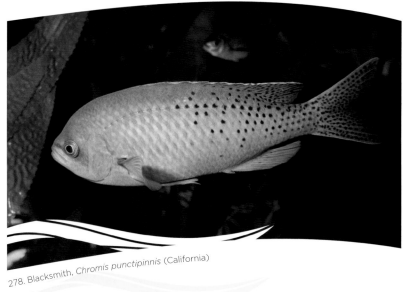

278. Blacksmith, *Chromis punctipinnis* (California)

279. Kelp bass, *Paralabrax clathratus* (California)

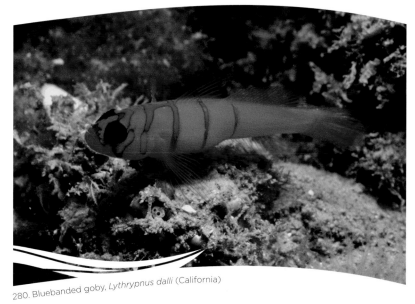

280. Bluebanded goby, *Lythrypnus dalli* (California)

281. Giant kelpfish, *Heterostichus rostratus* (California)

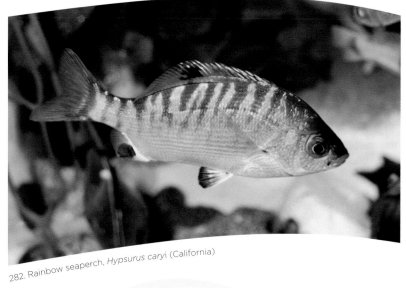

282. Rainbow seaperch, *Hypsurus caryi* (California)

284. Flag rockfish, *Sebastes rubrivinctus* (California)

285. Rock wrasse, *Halichoeres semicinctus*, male (California)

286. Touching animals
in the tidepool exhibit

142

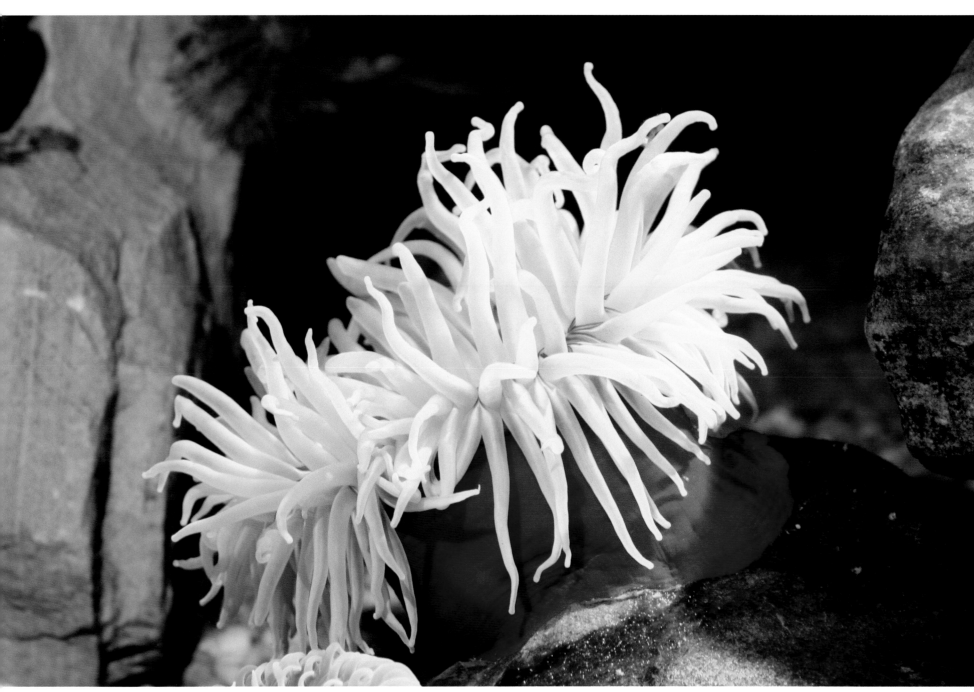

283. Rose anemone, *Urticina piscivora* (California)

The Cephalopods: Octopus, Cuttlefish, and Squid

Some of the most unusual animals at the Georgia Aquarium are the cephalopods—better known as the octopuses, cuttlefish and squids (a more ancient relative, the chambered nautilus, is not displayed here). These animals are all part of a larger group known as mollusks, which includes snails and clams. Representatives of these animals are on display in both the Cold Water Quest gallery and in Tropical Diver, and occasionally on the Education Loop.

Octopuses, cuttlefish and squid all have eight arms. Squid and cuttlefish have an additional two tentacles that can be extended rapidly to capture prey, which includes a variety of fishes, crabs, and shrimp. They can all swim very fast when threatened, especially squid, by shooting water out a funnel located under the head. They may also squirt a cloud of black ink when startled. Squid and cuttlefish have the additional ability to hover in mid-water or swim forward using fins. Shallow-water octopuses lack fins and instead crawl about the seafloor using their arms for locomotion. These cephalopods are remarkably intelligent—particularly octopuses. One common feature among all of these animals is a very brief lifespan. The reef squid (*Sepioteuthis lessoniana*), which Georgia Aquarium has successfully reared and displayed, completes its life cycle in less than one year. Most cuttlefish species live less than two years. And the giant octopus, despite its great size, lives only 3–4 years. They die shortly after mating and laying eggs.

The giant Pacific octopus, (*Enteroctopus dofleini*), is the largest of all octopus species and fully-grown it may measure 16' (4.9 m) from arm tip to arm tip, and weigh 50–90 lbs (22.7–40.8 kg)—or more. Ordinarily, this octopus is nocturnal and feeds on shrimp, crabs, other octopus, and a variety of fishes, including an occasional small shark. All shallow-water octopuses have the ability to rapidly change their color pattern to match their surroundings, or their mood.

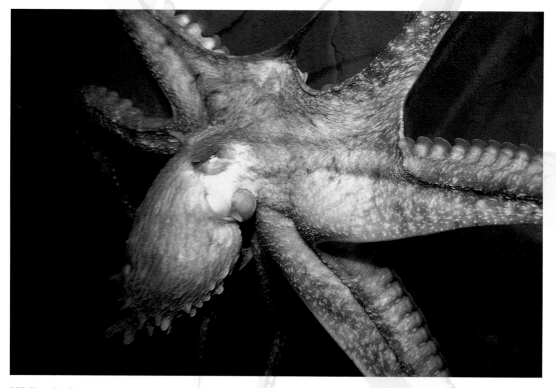

287. Giant Pacific octopus, *Enteroctopus dofleini* (Northern California to Japan)

144

The pharaoh cuttlefish (*Sepia pharaonis*) is found in the tropical Pacific and Indian Oceans. It is large for a cuttlefish reaching a length of nearly 16″ (40 cm). Males display a prominent zebra pattern on their arms during mating and when fending off competing males. Occasionally, the Georgia Aquarium will also display the common cuttlefish (*Sepia officinalis*) from European waters.

Reef squid are not often displayed in aquariums due to their demanding husbandry requirements and brief lifespan, but the Georgia Aquarium has successfully maintained the Pacific bigfin reef squid (*Sepioteuthis lessoniana*) and has reared them from eggs. Of the hundreds of species of squids, the reef squid is one of the few that is suitable for aquariums since it lives on reefs and is accustomed to maneuvering among rocks and other objects in the water. Like the octopus and cuttlefish, squid have the amazing ability to instantly change their coloration.

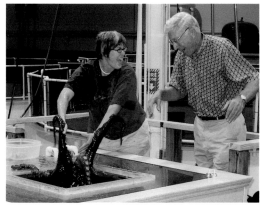

288. Kerry Gladish introduces Bernie to a giant Pacific octopus

290. A male pharaoh cuttlefish, *Sepia pharaonis*, caressing a female after mating. This is a tropical species that lives in the Indian Ocean east to Japan.

289. The bigfin reef squid, *Sepioteuthis lessoniana*, is a tropical Pacific species.

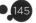

291. The day octopus, *Octopus cyanea* (Pacific), captivates a child on the Education Loop.

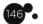

CHAPTER NINE:

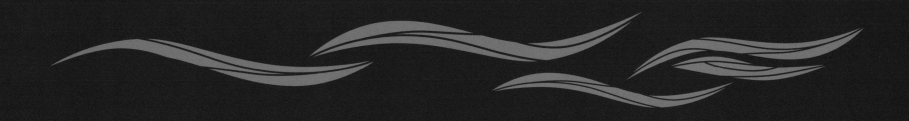

The Education Loop

Presented by:

Deepo's Undersea 3-D Wondershow

Presented by:

The Education Loop

Unknown to most Aquarium guests, circling above them in all of the galleries is a unique facility of the Georgia Aquarium known as the Education Loop. The Education Loop covers 25% of the public space inside the Aquarium, and was designed specifically for conducting education programs for school students. It is also a convenient pathway for behind-the-scenes tours. The Education Loop completely encircles the Aquarium on the second floor level (hence the name "loop"), with access to the top of most of the major exhibits, and the south end of the loop provides public access to the 4-D Theater. In most aquariums this space is usually reserved for life support systems, husbandry operations and storage. All of those functions take place here, but the space was carefully laid out to provide safe and unimpeded access for students and visitors too.

Classrooms above four of the galleries allow education staff the opportunity to present programs without the distractions they would encounter in the public galleries. Each classroom is themed to correspond with the gallery below it. For example, students in the Georgia Explorer classroom learn about Georgia's coastal animals,

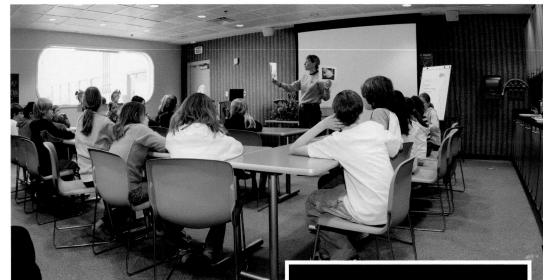

292. Robin Pressley-Keough in the Coral Classroom giving a lesson about coral reefs

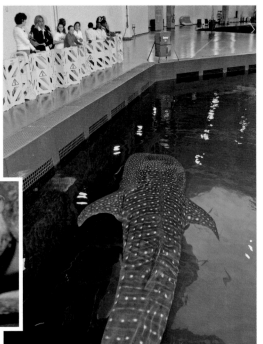

294. Special viewing of the whale sharks

293. Holiday darter, *Etheostoma brevirostrum*, from a Georgia stream

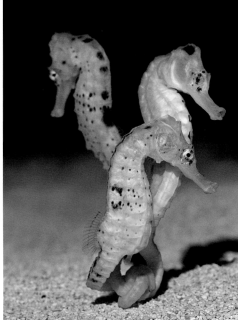

295. Longsnout seahorses, *Hippocampus reidi* (West Atlantic)

148

ecosystems and watersheds; in River Scout they learn about river ecosystems and the importance of reducing pollution; the Cold Water Quest classroom is devoted to learning about research and how scientists conduct their studies; in Tropical Diver students learn about corals and coral reef ecosystems. Outside each classroom are exhibits and touch pools. A complete coral reef ecosystem was created on the upper level of the Pacific Barrier Reef exhibit allowing students to see waves crashing on the outer reef, a calm lagoon environment, and a living mangrove forest.

In the first two school years, 83,857 students and teachers participated in Georgia Aquarium education programs. During their trip through the Education Loop, students participate in a variety of educational programs designed to enhance their understanding of aquatic animals and ecosystems, and also help them meet the Georgia Performance Standards for science education. When they are finished, the Kid's Cove lunchroom is theirs to eat a snack or have lunch and watch a video about ocean life.

Sponsored by

PUBLIX SUPER MARKETS
CHARITIES

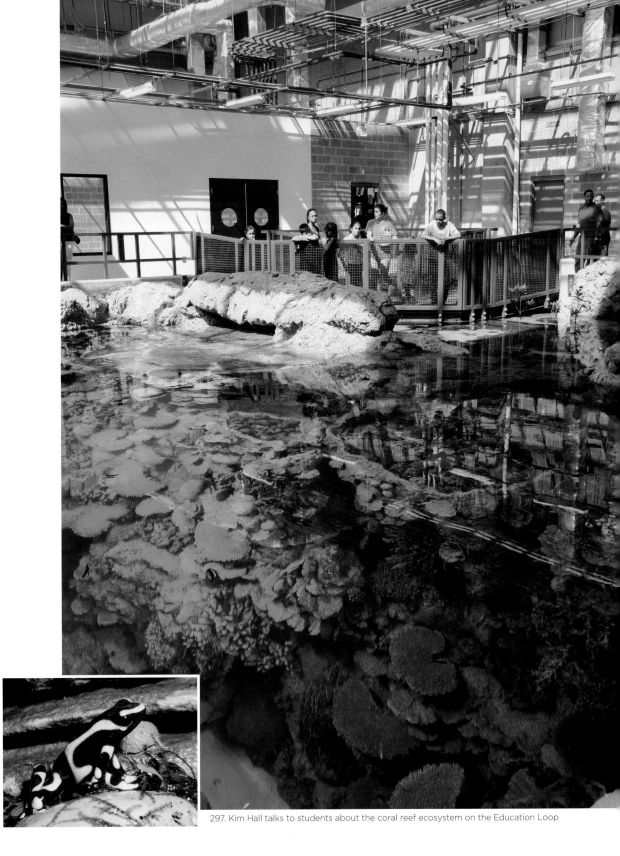

296. A tropical terrarium allows students to compare jungle ecosystems and coral reefs. This is a poison arrow frog, *Dendrobates auratus*, from South America.

297. Kim Hall talks to students about the coral reef ecosystem on the Education Loop

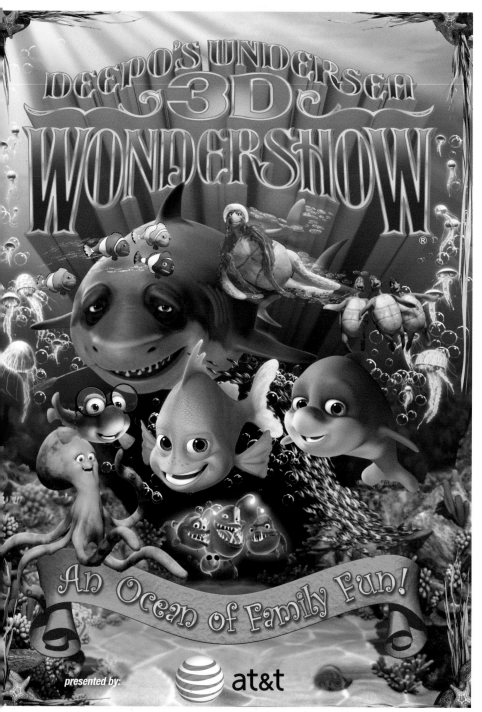

298.

Deepo's Undersea 3-D Wondershow

The Georgia Aquarium has been described as resembling a large ship, or more appropriately, an "Ark." The "bow" of this ship is a spacious area that is well suited for a special theater that now features *Deepo's 3-D Undersea Wondershow*. It is located on the second floor along the Education Loop. The theater and its animated 3-D program, and all the special effects, were the creation of Gary Goddard Enterprises in consultation with the Georgia Aquarium planning team.

The resulting program is a musical underwater adventure featuring the Aquarium's mascot, Deepo. The theater and the film employ special effects creating a set of "4D" experiences that are synchronized to the film production, adding another layer of immersive fun for audiences. For instance, you not only see jellies as they move by in 3D, you also feel tingling (artificial) tentacles as they brush by your face. The movie also provides some important conservation messages in the manner of the Ocean Project, which stresses the need "to embrace entertainment as a means to provide guests with engaging experiences that teach the heart as well as the mind." The theater holds up to 250 guests per show, with multiple shows every hour.

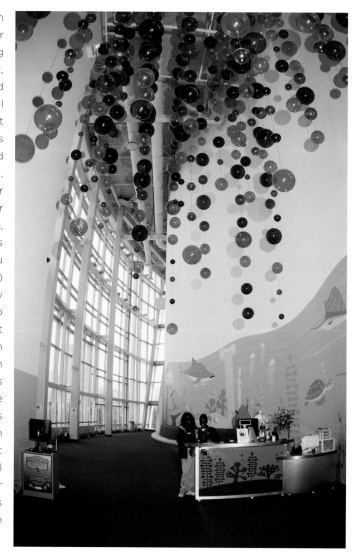

299. The spectacular entrance to the 4-D Theater

Behind the Scenes Tours

Visitors in the galleries see only a fraction of the Georgia Aquarium facilities. To see the rest, you must go on a Behind the Scenes Tour. The Georgia Aquarium is open everyday to visitors for special, pre-paid Behind the Scenes Tours. Along the way, guests have a topside view of many of the Aquarium's exhibits while walking along the Education Loop.

The journey includes a visit to the top of the Tropical Diver Gallery to see how this intricate exhibit operates, and also learn more about coral reef ecology. The tour continues with a visit to the commissary where over 375 lbs (170.4 kg) of food are prepared daily for the animals. This room is maintained to the highest standards of cleanliness and probably exceeds what you would find in the kitchens of some high-class restaurants!

Windows are provided for guests to view into the Correll Center for Aquatic Animal Health, operated in conjunction with the University of Georgia College of Veterinary Medicine. If a procedure is underway, visitors can watch it all happen. This lab is one of the Aquarium's unique design features incorporating all veterinary and laboratory facilities in one area.

The tours also include visits to the top of Ocean Voyager, the Beluga Whale habitat, and the Aquaculture facilities—all located along the Education Loop.

300.

301. Guests observing medical procedure during a tour behind the scenes

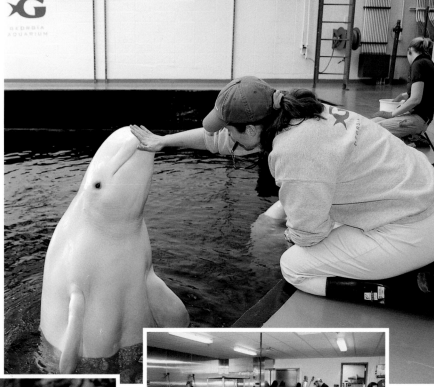

302. Guests can observe beluga whale training during certain hours.

303. A copperband butterflyfish, *Chelmon rostratus*, can be seen on the tour

304. The Husbandry commissary is where all the fish food is prepared.

151

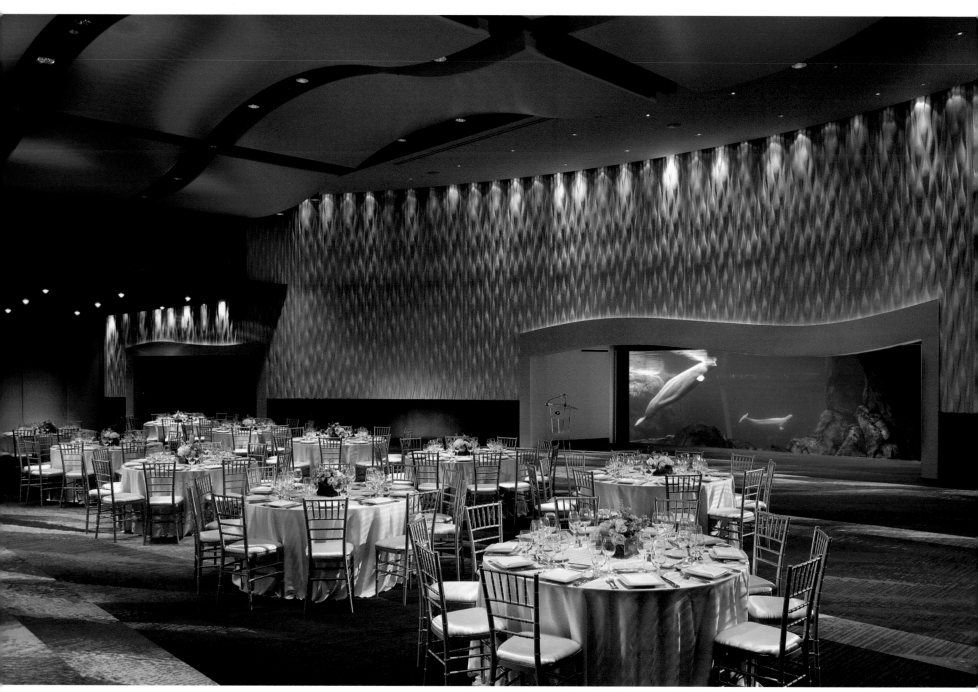

305.

CHAPTER TEN:

Food, Gifts and Special Events

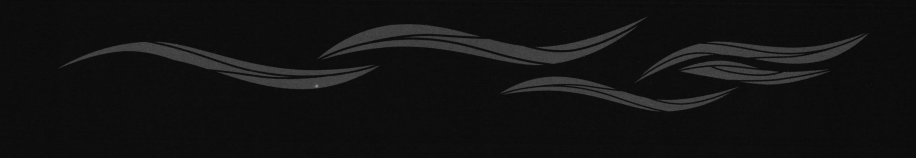

306.

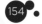

The Oceans Ballroom

The planning team for the Georgia Aquarium envisioned an aquarium that could only be described in superlatives. When the Aquarium finally opened, that is exactly how the public and the media responded when they described their experiences. Among the special experiences and venues at the Georgia Aquarium, is the spectacular Oceans Ballroom. There is nothing like it at any other aquarium. This 16,400 square foot ballroom features two large viewing windows providing private views of the whale sharks on one side, and beluga whales on the other. Wolfgang Puck Catering was enlisted to provide an innovative menu, including a kosher menu prepared in the Aquarium's kosher kitchen.

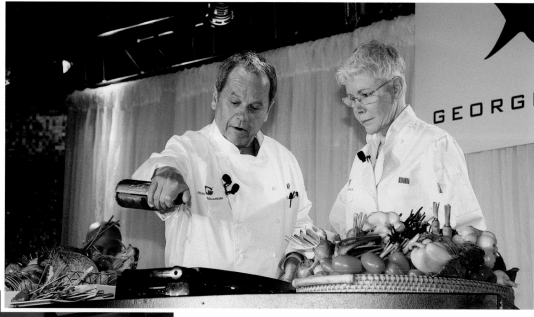

307. Wolfgang Puck gives a cooking demonstration to Billi Marcus (July 25, 2005)

The Oceans Ballroom is huge by any standard with a capacity to comfortably seat 1,100 people for an elegant dinner or up to 1,500 for a reception. Even more can be accommodated when the entire aquarium is booked for a special event. And, on days when no events are taking place in the ballroom, the doors are opened allowing the general public to visit the spacious room, bring their lunch from Café Aquaria, and enjoy the views into the exhibits.

308.

Café Aquaria

Café Aquaria is conveniently located mid-way between the west side and east side exhibits and galleries. Guests can choose from a wide selection of food items from pizza to hot sandwiches to salads and more. A favorite spot for most guests is a visit to the pastry table!

Seafood Savvy

Café Aquaria and Wolfgang Puck Catering in the Oceans Ballroom have signed on to the Aquarium's Seafood Savvy program. Seafood Savvy is an initiative to educate the public about sustainable fisheries and how to make informed decisions when buying seafood. Wallet-size cards are available at Café Aquaria and the Information Booth in the atrium. The Aquarium encourages guests to pick one up and refer to it when eating at a restaurant or buying seafood.

309.

310.

BEST

Catfish (US farmed)	Mahi mahi (US Atlantic troll / pole)
Clams, Mussels, Oysters (farmed)	Salmon (Alaska wild)
Crab: Dungeness, Stone	Scallops: Bay (farmed)
Crayfish (US farmed)	Striped Bass (farmed or wild*)
Croaker: Atlantic *	Sturgeon, Caviar (farmed)
Halibut: Pacific	Tilapia (US farmed)
Herring: Atlantic / Sardines	Trout: Rainbow (farmed)
Lobster: Spiny (US)	Tuna: Albacore (BC, US troll / pole)
Mackerel: King *, Spanish *	

GOOD

Basa / Tra (farmed)	Snapper: Gray, Lane, Mutton *, Yellowtail (US)
Clams, Oysters * (wild)	
Cod: Pacific (trawled)	Squid
Crab: Blue *, King (Alaska), Snow, Imitation / Surimi	Swordfish (US longline) *
	Tilefish (Mid-Atlantic)
Lobster: American / Maine	Tuna: Bigeye, Yellowfin (troll / pole)
Mahi mahi / Dolphinfish (US)	Tuna: Canned light, canned white / Albacore *
Scallops: Sea (Canada and Northeast)	
Shrimp (US farmed or wild)	Wahoo*

AVOID

Chilean seabass / Toothfish *	Orange roughy *
Cod: Atlantic	Pompano: Florida
Crab: King (imported)	Salmon (farmed, including Atlantic) *
Crayfish (imported farmed)	Scallops: Sea (Mid-Atlantic)
Flounders / Soles (Atlantic)	Shrimp (imported farmed or wild)
Groupers *	Snapper: Red *, Vermillion (US)
Halibut: Atlantic	Snapper (imported)
Lobster: Spiny (Caribbean imported)	Swordfish (imported) *
Mahi mahi / Dolphinfish (imported)	Tuna: Bluefin * (longline)

The fish scale is an easy way for consumers to determine how their favorite seafood rates. The animals are rated on a scale of "Best" for consumption through "Good" and ending with "Avoid" consumption. Use this card to make savvy choices when you make your seafood purchase at the market or in a restaurant.

BEST The area shaded green are fish that are well-managed in a fishery or farm, not-overfished, and do not have a negative impact on the environment.

GOOD There are concerns about status, fishing methods, and / or management to the animals located in the yellow area.

AVOID Problems are abundant with the fish in the red area. Poor management, overfishing, and environmental impacts place the animals here.

* Contaminant levels are often elevated in species with high fat content or large species.

Seafood Recommendations from the Monterey Bay Aquarium Foundation ©2007. All Rights Reserved.

Beyond the Reef Gift Shop

The gift shop is the termination point for visitors and leads to the exit. This is a great opportunity for guests to purchase a gift or souvenir, a t-shirt, a DVD about the oceans, or to buy a copy of this book!

311. The Sand Dollar Gift Shop located next to Café Aquaria

312. Beyond the Reef Gift Shop located at the Aquarium exit

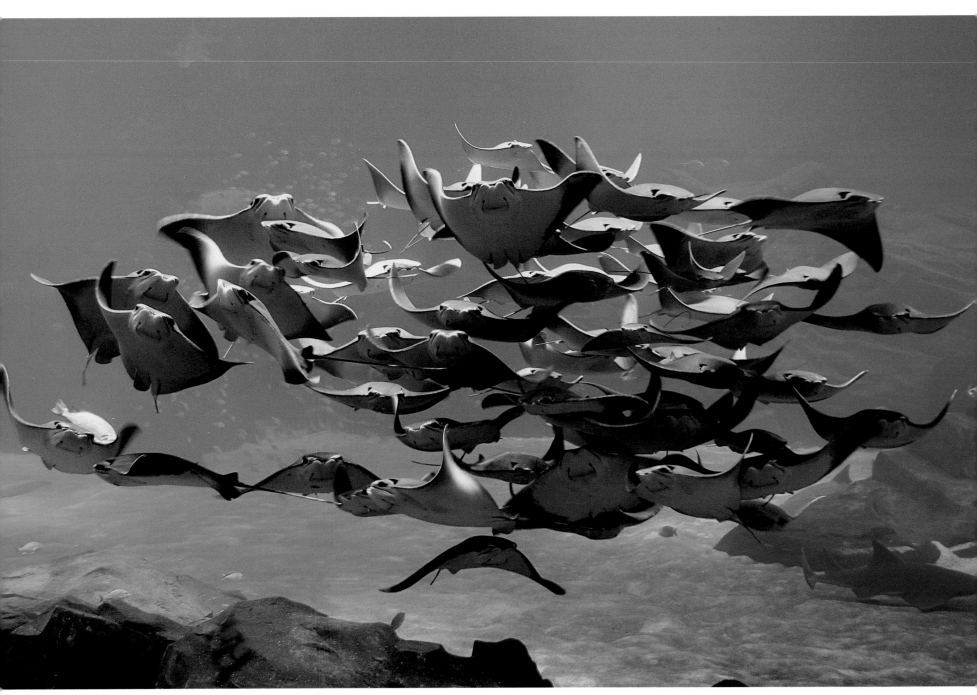

313. Cownose rays, *Rhinoptera bonasus*, in Ocean Voyager

158

The Next Wave
By Jeff Swanagan

One of Bernie Marcus' goals for the Georgia Aquarium was to set in motion an economic wave for the community by creating a world-class destination - a "must see" venue. Already, the impact of the Georgia Aquarium on the economy of Atlanta and the State of Georgia has been estimated at $1.2 billion over five years, creating hospitality jobs and enhancing Georgia's second largest industry. The influence of the Georgia Aquarium is also evident in the amount of construction taking place on every city block surrounding the Aquarium. New hotels, condominiums, restaurants and retail shops are currently under construction or have opened for business. Experts have estimated that construction valued at more than $3 billion has begun in the area surrounding the Aquarium. The new World of Coca-Cola attraction opened in 2007 next door to the Aquarium at Pemberton Place. With the tremendous success of the Georgia Aquarium, we are looking to the future and what might be in store on the "next wave."

Future plans for the Georgia Aquarium will continue to embrace our vision "to be the world's most engaging aquarium experience." So far, this has been achieved by embracing entertainment strategies using theater, lighting, drama, music and humor to deliver cognitive messages to teach the heart as well as the mind. In the future, these experiences may include immersion opportunities for those with varying skills from SCUBA to snorkeling, or even for those who choose to observe from dry land. At the Aquarium we can guarantee calm seas and close encounters of the "animal kind." The future may also see divers and trekkers embarking on ecotours arranged by the Georgia Aquarium using the world's busiest airport to travel to destinations around the globe.

Conservation and education will also drive the future of the Georgia Aquarium. Even before the Aquarium opened, conservation and research programs on sharks, sea turtles, coral reefs and veterinary science were underway. The future growth of these programs, along with collaborations with other conservation organizations, will contribute greatly to science and public awareness of the oceans. Students of all ages and abilities will be able to use this incredible aquatic facility.

From the beginning it was envisioned that the Aquarium would expand, and the design team has already begun contemplating concepts for future expansion. You can be sure that we will be "listening" again as we prepare to grow this amazing gift from Bernie and Billi Marcus!

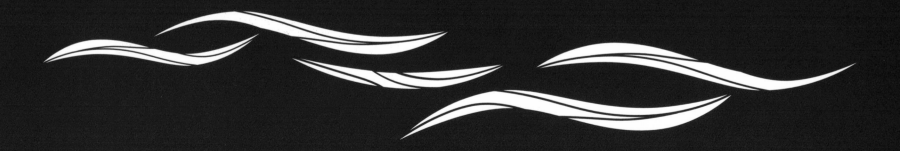

314. Richelle Weinstock feeds seahorses on the Education Loop

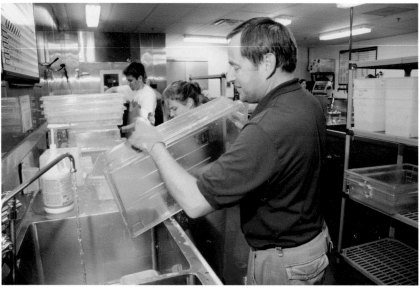

315. Steve Shindell assists in the Husbandry commissary

316. Tony Dwornitski cleaning gravel in Ocean Voyager

Georgia Aquarium Board of Directors

Bernie Marcus
Chairman
The Marcus Foundation

Billi Marcus
Board Member
The Marcus Foundation

Dennis Cooper
Chairman
Cooper-Atlanta, Inc.

A.D. "Pete" Correll
Chairman
Atlanta Equity Investors, LLC

John Costello
CEO, President & Director
Zounds, Inc.

Robert L. Fornaro
President & COO
AirTran Airways

James S. Grien
Managing Director & Partner
TM Capital Corp.

G. Edison Holland, Jr.
EVP, General Counsel & Corporate Secretary
Southern Company

Paul M. Houghton
Regional VP-East Region Enterprise &
 Partner Group
Microsoft Corporation

M. Christine Jacobs
Chairman, President & CEO
Theragenics Corporation

Phil Jacobs
AT&T

Jim Jacoby
Chairman
Jacoby Development, Inc.

Steven Richard Koonin
President
Turner Entertainment Networks

Julian LeCraw, Jr.
CEO
Julian LeCraw & Co.

Michael A. Leven
Vice Chairman
The Marcus Foundation

John K. Morgan
President & CEO
Acuity Specialty Products Group, Inc.

Michael Morris
President
SRI Travel/Travelgirl, Inc.

Michelle Nunn
President & CEO
Hands On Atlanta

Timothy J. Pakenham
Partner
Alston & Bird LLP

Dr. Carl Patton
President
Georgia State University

Gary Peacock, Jr.
President & CEO
SunTrust Bank

Ray M. Robinson
Chairman
Citizens Trust Bank

Frederick Slagle
Executive Director
The Marcus Foundation

Derek V. Smith
Chairman & CEO
Choicepoint, Inc.

Jeffery S. Swanagan
President & Executive Director
Georgia Aquarium

J. Scott Wilfong
President & CEO
SunTrust Bank - Greater Washington

Georgia Aquarium Program Manager, Architects, Engineers, And Contractors

Heery International, Inc.
Program Manager

Thompson, Ventulett, Stainback & Associates
Building Architect

Estes Shields Engineering
Civil Engineer

Syska Hennessy Group
Mechanical/Electrical/Plumbing/LSS/Fire
 Protection Engineer

Peckham Guyton Albers & Viets, Inc.
Exhibit Architect

Uzun & Case Engineers
Structural Engineer

Brasfield & Gorrie, LLC
General Contractors

Georgia Aquarium Founding Members

The following individuals gave generously to support conservation, the environment and are leaders in the revitalization of the downtown community through their support of the Georgia Aquarium's mission. Their early commitment to the future success of the Aquarium gives them their designation as Founding Members.

Anonymous Friends of the Aquarium (3)
The Family of Stacey F. & John R. Adams
Chris & Olga Addison
David Aitken
Steven L. Aldridge
Diane & Kent Alexander
Elaine & Miles Alexander
Pinney Allen & Charles Miller
Harold & Kayrita Anderson

Lee & Tinley Anderson
The Andresen Family
Alyza & Michael Antar & Family
Chris & Patti Arapoglou
Wayne, Joan, Nicole & Lindsey Aronson
Richard & Muffet Arroll
Thomas & Vanessa Arvid
Rick & Lyn Asbill
Kathy & Lawrence Ashe
Barbara B. & Ronald David Balser
Paul F. Baranco
David & Mary Betsill
Charles Bobo
Dan & Merrie Boone
Drs. Lisa & Brad Bootstaylor
Jon, Christine, Max & Zoe Bos
Bossick & Maene Families
Caryn & Michael Boxer
Mr. & Mrs. Charles W. Brady
Ginny & Charles Brewer
Ron & Lisa Brill & Family
Mr. & Mrs. William S. Bumgarner III
Mr. & Mrs. David J. Burke
Gene & Jan Burleson
Joel & Sissy Butler
CAB Incorporated
The Caldwell Foundation
James & Jean Callier
Leslie A. Camp
Bruce & Gabriela Carroll
The Carufe Family
Peter, Helen, Fionnbarr, Ryan, Neala, Ailisha &
 Siofra Casey
Barbara & Steve Chaddick
The Chilom Family
Dr. David S. H. Chu
Kevin, Maria, Philip, Daniel & Sophia Chung
Erik & Rachel Ciccarone
John & Lynn Cogan & Family
The Honorable & Mrs. Ezra Cohen
Cameron, Caroline & Catherine Anne Colavito
The Colberg Family
Dennis & Jeannie Cooper
Dr. & Mrs. Lawrence E. Cooper
Pete & Ada Lee Correll
John & Janet Costello
Doug, Trisha, Charlie, Jonathan & Sarah Craft
Guy & Dotty Crain
Doug & Kathleen Crosby
Mr. & Mrs. David A. Crow
Curran Designer Fabrics & Furniture
The Dahl Family
Bill & Jill Dahlberg
David Jay Daitch
Philip & Rebecca Davis
Ray Davis & Vivian McCoy & Families
The DeAntonio Family, Harry, Nicolas, Isabell,
 Michael & Shannon Hester
Deep Blue Insight Group
Samuel & Cynthia DeKinder
Robert & Kim Dennis
The Dhom's—Doug, Susan, Alex & Sarah Kate
Cheryl E. Dixon & David M. Dixon
Jim & Becky Dockter
Doucette Family—John, Mabel, Alfonso, Alejandra
 & Alan
The Dudley Family
Brian A. Eckman & David M. Sondergeld
Tracy & Terri Eden
Karen Lansky Edlin & Andrew Edlin—
 In memory of Lola & Rubin Lansky
Educational Enterprises, Inc.—Glenna Tyler
Greg & Peggy Eisenhauer
Timothy & Susan Ellington
Kathy Elliott-Parr—Bretton, Davis & Stephen Elliott

Empire Tickets—Robbi Raitt
In Loving Memory of Alison Leigh Etheridge—
 Anne & Tommy Etheridge & Kim & David
 Sandor
Frank & Maureen Fernandez
The Fialkow Family—Emanuel, Stacy, Ethan,
 Samuel, Sydney Ray & Isaac
Bryan & Barbara Fields
FirstPro, Inc.
Tim, Sissy, Sadie, & Maggie Fitzgerald
Mr. & Mrs. Martin Flanagan & Family
The Fried Family—
 Joe, Terry, Sophia, Noah, Nicole & Jonah
The Garmon Family—
 Henry, Virginia, Christopher, Kevin & Patrick
The James A. Gernatt Family—Jim, Julie, Jennifer,
 Jim, Jr., Laura, Steven & Michael
Geoffrey Gish
Lauren & Jim Grien
Dusty & Nancy Griffith
Susan & Leon Gross
Dr. Norys Guerra, MD, MPH.
Nancy & Lawrence Gutstein
Howard & Lynne Halpern
Kurt & Sharon Hartman & Family
Richard A. Herter, Jr.
Doug & Lila Hertz
Kristi & Robert Highsmith & Family
Christopher A. Hill
Ben & Corey Hirokawa
Mr. & Mrs. Jonathan C. Hoel
Wayne & Kate Hood
Paul & Marianne Houghton
Chris & Helen Hoverman
Lane & Clark Howard—
 Rebecca, Stephanie & Grant
Matthew & Suzanne Howard
Mr. & Mrs. Hilton Howell, Jr.
HR Works
HunterDouglas, Inc.
InterContinental Buckhead Atlanta
Pamela & Neville Isdell
M. Christine Jacobs
Phil & Jenny Jacobs
Dr. David J. Jacobson & Family
Jim & Jan Jacoby
Mr. & Mrs. Evan D. Jennings III
The Joel Family
Carol A. Johnson
The Cathleen & Edward F. Johnson Family
Edwina & Tom Johnson
David & Jennifer Kahn & Family
Larry & Laura Kelly
Michele & Bob Kelly & Family
Donald & Marilyn Keough
The Michael & Andrea Leven Family
Dr. & Mrs. David & Nori Levine
Ehud & Terry Levy
Dr. Maria Arias, Dr. Jerrold Levy & Gillian Levy
The Linzer Family—Jeff, Claudine, Jeffrey II,
 Jacquelyn-Jennifer & Aaron
Charles & Eva Lipman
Mr. & Mrs. Dan Lipson
The Lowthers Family
J. Patrick Luke
Elvin Johann Magee & Family
Magnum Communications, Limited
Sam & JoAnn Maguire
Dr Hugh, Jill & Zechariah Mainzer
Mr. Peter J. Mallen
Dr. & Mrs. Brian P. Maloney & Family
Fred & Nancy Marcus
David & Dorothy Markert Family
Trip & Ginnie Martin
David & Kerrie Marvin

Tom & Cynthia Massey
Shirley & Walter Massey
Pat & Jim Maucere
Mike & Anne McGlamry—Caroline, Kate &
 Elizabeth
McNichols Company
Arthur, Sally, Art, Bill, Bonita, Sarah, Beth David,
 Brooke, Billy, Maggie, & Brazos Merrill
Tinsley Grace & Michelle Christy Merrill
Janie & Randy Merrill
The Merrill Family—Harrison, Nancie, Brittany
 Harrison Jr., Lindsay, Daniel & Tinsley
The Middelthon Family
John & Robyn Morgan
Morris Family Foundation—Michael & Morris
Tim, Toni & John Morrison
Gordon & Andi Morse
Wayne & Jennifer Mosley
The Edwin R. Neel Family
Ann Starr & Oz Nelson
Michelle Nunn & Ron Martin
Michael, Tracy & Carys Obertone
John D. Oetgen & John Lineweaver
Matt & Linda Ornstein
Osborn Family Foundation
Eric, Mari, Neil & Dain Owen
In memory of David Ozner
The Pakenham Family, Tim, Cathi, Sarah, Cassie
 & Philip
John & Helen Parker
The Parsonnet Family
Kristi & Bill Patterson
David, Iris, Meryom & Mathew Pattillo
Carl & Gretchen Patton
Brooke & Bill Pendleton
Susanne R. Pesterfield
George & Libba Pickett
Ben G. Porter Foundation
Don & Deborah Printz
Pull-A-Part
The Robert Rakusin Family
Craig & Mary Ramsey & Family
Ray's Restaurants
Mr. & Mrs. Toby Regal
Chris, Jean, Sarah, Hannah & Katie Riley
The Rink Family—David, Penny, Rachel, Thomas,
 James & Davis
Miranda Roberson & Peter Brual
Ray & Arlane Robinson
Mr. & Mrs. Kenny Rogers
Danielle & Glen Rollins
Ellen Rollins
Ruthie & Gary Rollins
Emanuel & Peggy Roth
Dr. Arnold & Judy Rubenstein
Dr. Randy, Jennifer, & Pierce Rudderman & Family
Robert Russell & Family
Mr. Bert Russo & Dr. Deborah A. Levy
Carine A. Jelinek & Joseph S. Sagona III
Dr. Elizabeth Lynett Salley
The Saperstein Family
Sarah's School of Fish
Drs. Arthur & Patty Schiff—Julia & Daniel Schiff
Frank A. Schuler IV
The Selig Family
In honor of the Selig Lewis Shoulberg grandchildren
Bridget & Andrew Seng
Marco & Lesli Seta Francesca, Nola, & Joseph
The Shallat Family—Chuck, Renee, Kaden, Stone
 & Cole
Robert & Hope Sheft
Steve & Margi Shindell
Sara & John Shlesinger
Gayle Hartness & Joella Hartness Shrader—
 Alex, Houston & Julian Shrader
Mark, Eve & Sage Shumate
Ellen S. Frauenthal, M.D. & Leonard A. Silverstein
Tammy Simpson

Rick Slagle & Family
Dr. Reuben & Mrs. Deborah Sloan
Mr. & Mrs. John Smart
Derek V. Smith & Family
Randy, Hadley, Emmaline & Wyatt Smith
Nick & Betty Snider
The Spangler Family—
 John, Lita, Jennifer, John & Eric
Wallace & Janet Speed
Paul Victor Spiegl, Sr.
The Stans Foundation—
 Stephanie & Patrick Warren
Neal & Judy Starkey
Sara & Paul Steinfeld
Stuart & Candy Sutliff
Jeffery S. Swanagan Family
Brett & Joanne Taylor
Kenneth, Michele, Zachary & Zöe Taylor
Ms. Myli Taylor
Scott, Carrie, Julia & Owen Taylor
Linda & Mel Teetz
June & Michael Tompkins
John & Marie Towers
The Ramie A. Tritt Family Foundation
Debra London & Russ Umphenour
William, Susan & Michael Usdan
Velossent, LLC—Joshua McAfee
Felicia & Joe Weber
Mr. & Mrs. A. Ray Weeks, Jr.
Brooke & Winston Weinmann & Family
Keehln, Maggie, Lydia & Madeline Wheeler
B. Rodney White & Michael P. Williams
Mr. & Mrs. Benjamin T. White
Susan & Tony White
John & Lisa Wicks
Mike & Nancy Wilkinson
David Nicol Williams, Jr. & Jennifer
O'Brien Williams
Chuck & Missy Wolf
Graham, Diana & Kelly Wood
Honey & Howard Workman & Family
Robert & Rae Wright
David & Diane Yelich
Judy & Erwin Zaban
Robert, Connie, Jason & Eliot Zerden

Georgia Aquarium Major Donors

The people and corporations listed below made
gifts of ten thousand dollars or more to the
Georgia Aquarium facilities or programs as of
August 2007

Accenture
Lithonia Lighting & Zep, Acuity Brands Companies
ADP
AGL Resources
AirTran Airways
Alston & Bird, LLP
American Heart Association
American Honda Motor Company, Inc.
American Standard Foundation
Harold & Kayrita Anderson
The Arby's Foundation, Inc.
Thomas & Vanessa Arvid
Rich & Muffet Arroll
Asahi International
AT&T Foundation
Atlanta Mariott Downtown
Avnet
Barbara B. & Ronald Davis Balser
Jon, Christine, Max & Zoe Bos
Brasfield & Gorrie, LLC
Caterpillar
Chevron
Choicepoint
Clear Channel
CMS Foundation
The Coca-Cola Company
The Coca-Cola Foundation
The Honorable & Mrs. Ezra Cohen
The Colberg Family
Comcast
Dennis & Jeannie Cooper
Cooper-Atlanta Transportation Services
Correll Family Foundation, Inc.
Cousins Properties Incorporated
James M. Cox Foundation
Cypress Care
Dornbracht
Embassy Suites
Empire Distributors
Environmental Protection Agency
FF&E
Federated Insurance
Geographics, Inc.
Georgia Hospital Association
Georgia Institute of Technology
Georgia-Pacific Corporation
The Glenn Hotel
Goodman Decorating Company, Inc.
Lauren & Jim Grien
Gwinnett Sprinkler Company
Hampton Inn, Georgia Tech
Hard Rock Café – Atlanta
Heery International
Hilton Atlanta
Holiday Inn Downtown
The Home Depot, Inc.
Hyatt Regency Atlanta
IBM
ING Foundation
David B. Kahn Foundation, Inc.
Kenwood
Kodak
Lanier Parking System
Susan & Julian LeCraw, Jr.
Dr. & Mrs. David & Nori Levine
Debra London & Russ Umphenour
The Lovett School
The Marcus Foundation
Marriott Marquis, Atlanta
Trip & Ginnie Martin
McKenney's

McNichols Company
Met-Pro Corporation, Fybroc Division
Metro Waterproofing
Microsoft
ModularArts Designs
Morgens West Foundation
Morris Family Foundation
Mountain View Group / Lab 601
Mohawk Industries
National Marine Sanctuary Foundation
Neptune Benson
Newell Rubbermaid
Omni Hotel at CNN Center
Eric, Mari, Neil & Dain Owne
Paradies-Georgia Aquarium, LLC
PBD Worldwide Fulfillment Services
Peckham Guyton Albers & Viets, Inc.
The Laura & Isaac Perlmutter Foundation, Inc.
PGA Tour Superstore
Piedmont Hospital
Pratt Industries USA
Publix Super Markets Charities, Inc.
Radiant Systems
Renaissance Atlanta Hotel
Ritz Carlton Atlanta
Ritz Carlton Buckhead
Ray & Arlane Robinson
Ruthie & Gary Rollins
Romanoff Floor Covering
RPM
Ruth's Chris Steakhouse
Shaw Industries
Sheraton Atlanta Hotel
Silverpop Systems, Inc.
Sinacola Group
Mr. & Mrs. John Smart
Ralph L. Smith Family Foundation
Southern Company
Spunlogic
Ann Starr & Oz Nelson
SunTrust Bank
Sutherland, Asbill & Brennan, LLP
Thompson, Ventulett, Stainback & Associates, Inc.
Turner Broadcasting Systems
Turner Foundation
Twelve Hotels & Residences, LLC
Unisys
United Distributors
The University of Georgia
The University of Georgia Marine Extension
 Service
UPS
US Fish & Wildlife Services
The Varsity
Weber Family Foundation
Westin Peachtree Plaza
Whole Foods Market
Wolfgang Puck Catering at Georgia Aquarium
WXIA-TV, 11 Alive
Wyndham Atlanta

We have done our best to recognize all those who
have been instrumental in our success. Our
apologies if we have inadvertently missed anyone.

Full Time Employees as of August 2007

Accime, Gaelle
Adams, Charles G
Allen, Camille M
Allpere, E. Mihkel
Anderson, Audrey S
Anderson, William H
Askin, Sequathia N.
Atkinson, Charlotte A
Awai, Marjorie L
Barnes, Katie
Barnett, Rick E
Barney, Mary Alexandra
Becker, Katherine
Bell Jr, Gilbert
Bell, Mauritius
Bell, Melvin
Berliner, Aimee L
Billak, Lauren N
Binder, Timothy M
Blash, Travis
Blythers, Evonne
Blyton, Gary
Boedeker, Jessica P
Boucha, Nicole
Brewer, LeRita
Brosius, Cory
Busse, Erica L
Carlson, Bruce A
Cavin, Julie M
Chapman, John E
Chinberg, Amanda J
Christen, Dennis R
Clark, Beach M
Clark, Janet
Clarkson, Paul A
Clauss, Tonya M
Clem, Blake
Cloudt, Lisa E
Cobb, Kristie L
Coburn-Allen, Carolyn
Coco, Christopher S
Cordero, Luis
Curlee, R Kevin
Curry, Mary L
Daniel, Coronda L
Daniel, Michael W
Danley, Kathryn C
Davis, Carlene
Davis, Herbert A
Davis, Melissa
Davis, Raymond L
Davis, Zelie
Dawson, Nicole L
Deaton, Dennis
Deaton, Karen A
Dennard, Conchetta E
Denney, Charles Ray
Denney, Timothy
Densmore, Sally A
Desiderio, Alex S
Dhakal, Birendra
Diem, Jason
Dodson, Brett W
Dongerdive, Amit S
Doubrava Jr, Gary
Dove, Alistair
Dove, Patricia
Durand, William
Dzeidzic, Heather
Edwards, Jamie
Ellis, Helen W
Fairbanks, Brenda C
Farnau, Nathan
Fields, Kenneth

Fine, Andrew
Fisher, Gina
Floyd, Allison K
Friday, Toni
Gaglione, Eric
Gaither, Jennifer D
George II, Albert A
Gibbons, K. Meghann
Gladish, Kerry L
Godfrey, E. Anthony
Gordon, Bruce B
Gramley, Michael
Grant, Virginia
Green, Ewan A
Hacke, Keith
Hall, Eric A
Hall, Kimberly A
Handy, Joseph
Hannans, Jahmar
Harrington, Michael
Harris, Jerry
Haws, Jeremiah J
Henry, Gwendolyn
Herbert, Beth
Herrarte, Irene E
Herrera, Lissette M
Hewitt, Thomas
Hogrefe, Matthew
Hollis, Scott
Holloway, Susann K
Horton, Eric D
Howard, Aretha
Hurst, Michael J
Hutchinson, Deborah A
Ihlo, Christy
Irvin, Jacob
Jackson, Chris E
Janssen, Jennifer D
Jefferson, Tekilya N
Jeskie, Aaron
Johnson, Janelle A
Jones, John Mitchell
Jorden, Serge F
Kanezaki, Akira
Karnik, Amanda
Kawahara, Naoaki
King, Tia
Koyagialo, Yahonziala
Krenner, Jeff J
Labove, Nicole
Lett, Cathy
Lewis, Salomie
Lewis, Sha
Lewis, Shaquanna
Light, Christine
Lopez, Ruth D
Magyar, John
Maples, Kelly H
Maples, Robert C
Marquez, Arlene C
Marrero, Cynthia M
Maslanka, Michael
Masson, John
McElhannon, Jessyca
McWhorter II, Bradford
Meeks, Stephen
Methvin, Katherine
Miller, Mark L
Monday, Janet
Moore, Eugene
Morlang, Erin
Morris-Zarneke, Kimberly L
Moser, Bevlynn E
Mullins, Kayoung
Napierala, Sarah A
Nash, David
Nietfeld, Theresa E
Nimz, James C

Noland, Stacy Y
Nord, Jessica
Nugent, Richard S
O'Dell, Jennifer H
Olsen, Mark S
Parker, David
Parsons, Deborah A
Payne, Sarah Ashley
Peace, Dawn M
Perry, Andrew M
Peterson, Angela R
Phillips, Calvin L
Phillips, Carla
Phung, Tuananh P
Poniatowski, Joseph A
Powell, Marendeia T
Ramsey, William S
Rankin, Robert E
Reddick, Regina
Reid, Jeffery S
Repotski, Christopher
Richardson, Velma
Rogers, David
Rollinson, Amy M
Rountree, Carey
Rutherford, William
Santucci, David C
Saona, Stephanie N
Saunders, Gregory N
Schreiber, Christian M
Seaman, Heather L
Selby, Paul
Sheorn, Ryan
Simmons, Timothy E
Smith, John C
Spratling, Jacquelyn
Stephens, Andrea
Stovall, Roderick
Stuebing, Erika
Swanagan, Jeffery S
Tai, Jany
Taylor, Roosevelt
Thompson, Derrick T
Vailes, Jomal W
Varner, Andrea
Vincent, Marc T
Vinson, Ashlie
Walker, Benjamin
Walker, John
Walker, Pattaya
Warnock, Amy L
Washington, Katia
White, Anthony C
Wiederhold, Tiffany
Wilkins, Deborah
Williams, Andre
Williams, Elizabeth C
Williams, James C
Williams, Vanroy
Wilson, Kevin D
Wingo, Damen P
Wood, Emmanda
Young, Donald
Zellars, Edna V

Part time employees as of August 2007

Adams, Nicole L
Andrews, Charles
Arsenault, Jennifer
Axson, Santoria L
Aziz, Amina
Barampama, Remy
Barnett, Yashica A
Bell, Chasity R
Belt, Myrna
Benedict, James D
Benjamin, Jason
Benson, Ruth
Berger, Susan
Berry, Henrietta D
Boddie, Stephanie T
Bolton, Shawnkia
Bowens, Volna
Bowers, Cochiese
Bradley, Amanda Larkin
Brawley, Jeremy Shane
Brayboy, Jamar N
Brifnek, Heather
Britton, Lakeshia N
Broughton, Angela M
Brown, Kimberly M
Brown, Melanie J
Brown, Stephanie
Bullay, Natasha
Burbano, Victor H
Burnup, Kevin C
Byrd, Veronica
Campbell, Lauren K
Canty, Joseph L
Choice, Angel
Clark, Kimberly
Clark, Zachary T
Clayton, Carl A
Clement, Andrew
Coons, Terita
Cotton, Vandreena
Curry, LeRonda J
Daffron, Viktor
Daniels, Kristi
Davis, Rebecca
DeHay, Stacey
Dixon, Laquinta D
Dongerdive, Janipher J
Donlan, Paula A
Dudley, Victoria
Dutton, Adam
Eaddy, Johnny
Egerdahl, Ethan
Eleazer, Paul M
Epps, Jacqueline E
Evans, Tara
Falkner, Alyx
Farah, Abdinasir
Farmer, Pamela L
Ford, Josh
Freeman, Jetter
French, Jeanie
Frichter, Arnold
Frieson, Simone
Gaither, Vanessa
Geise, Wendy
Giattina, Christine
Gibbs, Koreen
Gibson, Andrew
Grant, Ernestine
Griffin, Nicole R
Gulley, Benjamin
Hall, Areba
Hampton, Michelle D
Hathaway, Elizabeth L

Headley, Donald
Henry, Janan C
Hill, Latrecia
Hogue, Alishea
Holcomb, James M
Holland, Marcie
Holmes Jr, Ernest L
Houlder, Jacqueline K
Houston, Christopher
Huff, Shirkia
Hull, Stephanie
Hutchins, Randy
Itkoff, Cynthia
Ivey, Leola P
Jackson, Brandy
Jackson, Leomar
Jama, Amal
James, Patricia
Jean-Baptiste, Cianovlie B
Jefferson, Shanterria D
Jenkinson, John W
Jensen, Kenneth E
Johnson, Alton
Johnson, Elnora K
Johnson, Michael
Jones, Dominique
Jones, Isaac
Jones, Rachel
Jones, Tyeshah
Keaton, Dequilla S
Kemper, Jennifer
King, George R
Kirkland, Natasha
Lancaster, Diana
Lanier, Mike
Latners, Gloria W
Latners, James
Long, James Charles
Manning, Ivonne I
Maxey, Shannon
McCoy, Sada
McDowell, Yvonne
McKitrick, Seth Ronald
Meeks, Joel T
Mills, Bradford T
Minter, Nicholas
Mohamed, Joseph A
Montouth, Patrick A
Morel, Michael E
Morris, Ada
Moses, Reginald T
Moulton, Clifton A
Nisenson, David
Njoku, Kenneth
Norbeck, Brenda
Page, Helen
Parker, Michael
Parvis, Daniel P
Pate, Pamela M
Patrick, Dameus M
Payne, George
Peterson, Dawn C
Peterson, Haley M
Picquet, Ebony
Polewski, Bridgette
Pressley, Robin
Rambler, Katherine
Reynolds, Sherika S
Richards, Conchata S
Robinson, Michael T
Rodriguez, Diana L
Ruiz, Eva
Saffell, Samantha
Sallette, Tyrone
Saxton, Sophia
Scott, Dawnita

Sellers, Anntrees
Sexton-Maddox, Ritaria
Shealey, Dionna
Shealey, Quinnecia
Sheffield, Wendell T
Shepherd, Camille
Shiver, Brittany J
Sibley, Ingrid
Smiedendorf, Jeremy
Smith, Melvin
Smith, Suzanne M
Snow, Charles L
Stevens, Sandy
Stills, Kevia
Taratine, Bianca
Taylor, C. Emile
Taylor, Isabella
Thomas, Michael
Thomas, Patrick
Thompson, Shiovanna V
Towner, Joyce
Turco, Alan
Turner, Antoine
Umar, Waseem
Varnedoe, Elise B
Varner, Lakeisha R
Vaughan, Victoria
Walker, Jocelyn R
Walker, Monica C
Wallace, Lavour
Walls, Sonya
Ware, Kiimberly
Waterstone, Joshua
Webb, Eric
Weems, Walter J
Westhafer, Krystle M
Wheeler, Sherman
White, Porcia L
Whitfield, Arthur
Wiggins, Tiffany M
Wilcox, Beverly
Wilcox, Joyce
Williams, Ansley A
Williams, Micheal
Wilridge, Roslyn
Wimberly, Iya D
Xuereb, Jonathan
Zellner, Termond
Zvonar, David
Zvonar, Linda L
Zvonar, Noel

163

Over 500 hours of service
Avena, Craig
Balsley, Pamela
Baswell, Jody
Bernhard, Douglas
Black, Michael
Chequer, Alex
DiGangi, Vincent
Dwornitski, Anthony
Eagens, James
Edelberg, Roz
Emanuel, Adrian
Eslinger, Andrea
Evick, Charles
Frey, Holly
Fuerst, Julian
Gomez, Lily
Guzdial, Gene
Kalbach, Hank
Lemley, Christopher
McAllister, Leslie-Anne
McNamara, Thomas
Mercer, Edward
Mercer, Patricia 'Pat'
Michels, Christina
Morel, Michael
Nielsen, Scott
Price, Debbie
Rodriguez, Wanda
Shealy, Judy
Stafford, Rick
Strommen, Diana
Talbott Jr, Doug
Tribble, Katherine
Weinstock, Richelle
Wener, Steve
Zvonar, David

400-499 hours of service
Aitken, David
Allison, Gregory
Berman, Gary
Commins, Drew
Demmers, Jim
Drummond, Wayne
Ellis, Jeremy
Groom, Heidi
Jacobson, David
Joe, Herbert
Luke, Eunice
Mason, Mary Ann
Mason, Walter
McKitrick, Ron
Powell, Julie
Rosa, Harry
Roy, Daniel 'Dan'
Shindell, Steve
Tripp, Andrew
Valente, Mary Ann
Vedejs, Art
Walter, Donald

300-399 hours of service
Adams, Philip
Allen, Mindy
Bennett, Harold 'Hal'
Biggs, Lynn
Byers, Bryn
Cielinski, Susan
Cobiella, Angel
Corey, Benjamin
Davidson, Alexander
Davidson, Laura

Delatourdupin, Louis
Devlin, David
Doiron, John
Droms, Fred
Du, Mila
Evick, Lea
Frady, Erin
Galon, Ron
Gay, Harvey
Gotling, Greg
Grant, Virginia
Hammond, Lynn
Hentschel, Ingo
Herrington, Mary
Homlar, Robert
Ienna, Rocky
Jersin, Katharine
Jimenez, Carlos
Kauffman, Ursula
Levine, Stacey
Llewallyn, Joy
Maene, Theresa
Mallicote, Richard
Matthew, Risa
McConnell, Cindy
Noll, Susan
Pape, Elizabeth
Pierce, Jim
Reardon, Barbara
Richards, Chuck
Rohn, Cheryl
Sampson, Elaine
Sandlin, Cathryn
Schultz, Robert
Spasser, Jill
Strommen, Douglas
Tlapa, George
Tomlinson, George
Walter, Perry
Watters, Julian
Westergard, Susan
Zaharopoulos, Liz
Zvonar, Linda

200-299 hours of service
Agustin, Andrew
Agustin, Diedre
Banks, Tim
Bardack, Richard
Baumgartner, Marianne
Baxter, Linda
Beattie, Jennifer
Bierbaum, Benjamin
Blackwell, Ruth Ann
Blum, Matt
Bradford, Hal
Brody, Robyn
Camp, Lee
Childers, Cherry
Consuegra, Jim
Darnell, Susan
De Santis, Joe
Deano, David
Dickens, Jean
Dike, Charis
Dutton, Lois
Fradkin, Maury
Fry, Babs
Gay, Janice
Gayton, Edie
Gilchrist, James
Greenberg, Bonita
Greeson, Thomas
Hagerty, Brian
Harness, Jeff

Hayden, Ellen
Henry, Jim
Henry, Merle
Highsmith, Robert
Hobbs, Jonathan
Houlditch, George
Houlditch, Regina 'Gina'
Jeffrey, Helene
Kersey, Michele
Ketchum, Dorothy
Ketchum, Joe
Kiessling, Beverly
King, Brian
Klein, Garry 'Wade'
Krasny, Skip
Ledman, Robert 'Bob'
Lenczowski, Timothy
Louthan, Katherine
Luckey, Elizabeth
McClain Jr, Buford 'Mac'
McLure, Ashley
McMorran, Gregg
Meeks, Leon
Moore, Joyce
Morrison, Wendy
Norris, Amy
Ore, Mary
Owen, Mari
Parks, Samantha
Petsis, Linda
Poole, Sandra
Porter-Fink, Vicki
Price, Marvin
Richardson, Marie
Roemer, Sidney
Rogers, Ronald 'Ron'
Rozier, Carol
Sarver, Barbara
Scher, Steven
Schmeltzer, Thomas
Schwartz, Barbara
Schwartz, Robert
Shumpert, Gretchen
Simister, David
Smith, Jan
Smith, Milton 'M.A.'
Smith, Wanda
Stearns, Charles
Stone, Marvin
Takada, Tomomi
Teel, Oliver
Van Treuren, Kathy
Wallace, Matthew
Walton, Bridgette
Washowich, Todd
Wheeler, Ellen
Workman, Sandra
Wright, Demia
Zwiren, Mary

100-199 hours of service
Albers, Tom
Alberty, Toni
Alonso, Carlos
Arsenault, Jennifer
Artz, Donna
Bakas, Yoel
Barfuss, Judy
Bartkus, John
Batson, Diana
Baumgartner, Joe
Beasley, Rhonda
Berahzer, Stacey
Berkowitz, Norm
Berly, Mary

Billingsley, Malinda
Boston, Therese
Bradley, Amanda 'Larkin'
Brett, Gayle
Brinson, David
Brooks, Kathryn
Brown, Chester
Brown, Robert 'Bob'
Bucher, Carl 'Chris'
Burst, Mignon
Bush, Arlene
Bush, Kevin
Bynum, Julia
Calhoun, Carol
Carpenter, Colleen
Cauthen, Ashley
Coakley, Ken
Cobiella, David
Cochran, Jennifer
Cohn, Sheryl
Coley, Carolisa
Cook, Betsy
Cook, Simerly
Cooley, Jerry
Cooper, Andrea
Cotter, Patricia
Cousins, Elisa
Curtiss, Bruce S
Davenport, Adria
Day, Stacey
Delameter, Christina
Dennis-Blake, Beverly
DesRosiers, Noah
Dix, Thomas
Drobny, James
Dudley, Diane
Eaton, Sonyja
Edgerton, Mike
Ehlers, Bethany
Elkins, Bill
Engeman, Kathleen
Fink, Aaron
Fisher, Cheryl
Fisher, Jeffrey
Flinn, Linda
Francisco, Anthony
Franklin, Susan
Frye, Christopher
Frye, Kytle
Furrow, Kris
Gaber, Paula
Gaona, Juanita
Garner, C Kent
Gerblick, Natalie
Gonzalez, Valicia
Gowder, Deborah
Graham, Pamela
Grant, Glen
Greenhood, Karen
Greenwood, Andrew
Griggs, Janice
Groom, Corey
Groom, Kasie
Gunturi, Rahul
Gunturi, Ratika
Halpern, Robin
Harris, Gerinda
Harrod, Susan
Henry, Eather
Higgins, Jennifer
Hinkle, Jeff
Holley, Harriett
House, Jesse
Hudson, Susan
Humes, Philip

Hunt, Helena
Israel, Don
Israel, Hadassah
Jackson, Laurette
Jensen, Kenneth
Jessop, Katrina
Jessop, Kevin
Johnson, Debra
Jones, Anne
Jones, Larry
Keeble, Renee
Klein, June
Klump, David
Kohli, Elise
Kuhne, Thomas
LaFlam, Michael
Lang, William 'Bill'
Larson, Judith
Latham, Teresa 'Terri'
LaVallee, Lynne
Leisch, Karen
Leone, Anthony
Levine, Dana
Levine, Linda
Lewis, June
Lilly, Dana
Long, Mattie
Macsotai, Christine
Managh, Leslie
Marokko, Rita
Martin, Lee
Martindale, Franklin 'Bart'
Martindale, Nancy 'Diana'
McAlister, James
McKelvey, Megan
McKitrick, Teresa
Miller, Heather
Mohamed, Joseph
Moore, Molly
Morgenbesser, Barbara
Morton, Heidi
Munoz, Livier
Murrain, William
Mussig, Ronald 'Ron'
Pack, Michael
Panhorst, Frederick
Patterson, Phimar
Pelphrey, Bats
Pelphrey, Joyce
Perry, Edward
Pfitzenmaier, Erich
Poggi, Scott
Pound, Bill
Pyburn, Paula
Reff, Michael
Reis, Debbie
Robbins, Lillie
Robinson, Doug
Robinson, Michael
Roby, Teresa
Rogin, Gail
Romero-Rallis, MaryAnn
Rosario, Tina
Rosen, Muriel
Rowan, Wanda
Ruiz, Bryan
Runyans, John
Rush, Sylvia
Russell, Marilyn A
Schaben, Terry
Schmeltzer, Terry
Schoeke, Klaus
Scroggy, Ron
Shaw, Aloyce
Shearer, Tonya

Sheffield, Robert
Shindell, Margi
Silvers, Mitchell
Siroky, Theresa
Slovick, Patrick
Smith, Chiyo
Smith, Susan
Snypp, Suzanne
Stanat, David
Stephenson, Jacqueline
Strange, John
Su, Bianca
Sunderland, Brett
Sykes, Kirsten
Taff, John
Taylor, Lisa
Temske, Heather
Thompson, Pearline
Tolbert, Cindy
Uribe, Mirtha
Van Wassenhove, Nanette
Viera, Francisco
Walker, David
Walker, Janet
Walker, Leroy
Walters, Clark
Will, Patricia
Williams, Asa
Winchester, Sarah
Winieckie, Debra
Wisotzky, Myra
Wolfe, Cynthia
Yarbrough, Kim
Yeatman, Daniel
Yoder, Jack
Zollweg, Denny

Under 100 hours of service
Aab, Zachary
Abbas, Tami
Adair, Kay
Adams, Gena
Adams, Mar Tia
Akstein, Stephanie
Alexander, Henry 'Hank'
Amezaga, Rosamari
Anders, Lynn
Anderson, John
Anderson, Judith
Andrew, Bess
Armstrong, Mark
Aubertine, Anita
Baker, Tina
Baker-Richardson, Jennifer
Ball, Elizabeth
Bandhauer, Karen
Bangsboll, Michele
Barber, Lisa
Barron, Juli
Bates, Jamar
Batson, John
Bean, Elaine
Beasley, Brandon
Bedenbaugh, Lisa
Bender, Maureen
Bentz, Sandra
Berkman, Scott
Berman, Jason
Bilek, Jennifer
Bius, Gwyned
Bjerg, Colleen
Blackburn, Amanda
Blaikie, Dianne
Bland, Francina
Blessett, Charlyne

Blomert, Ainsley
Bloom, Jenny
Blount, April
Boalch, Stephen
Bodenstein, Lynn
Bodenstein, Steven
Bone, Emily
Bowden, Susan
Bower, Allison
Boyd, Kristen
Brantley, Debbie
Brock, Martha
Brodnik, Natalka
Brooks, Dianne
Brosius, Cory
Brown, John
Bruner, Debborah
Bryan, Leslie
Bryant, Beverly
Buchanan, Dott
Buchanan, Theresa
Bullock, Mary
Burgess, Robert
Butterfield, Debbie
Byrne, David
Campbell, Andrew
Campbell, Jennifer
Campbell, Lisa
Carlin, Sarah
Carlson, Lisa
Carlton, Brenda
Carter, Melissa
Carter, Thomas
Carter, William
Casler, Timothy
Casurella, Gina
Catledge-Hall, Barbara
Caven, Pat
Celmer, Nicole
Chancey, Natasha
Chandler, Michael
Charpiat, Frank
Charpiat, Janeine
Chegwidden, Jennifer
Chirina, Svetlana
Christian, Aimee
Church, Bonnie
Clayton, Brenna
Clayton, Elizabeth
Clements, David
Cleveland, Douglas
Coates, Phyllis
Cochran, Craig
Cohen, Sharon
Collazo, Nilsa
Colley, Gloria
Compton, Barbara
Connell, Mary 'Jan'
Conner, Seth
Cooner, Justin
Cooper, Angela
Cope, Adam
Copelan, Helen
Copeland, Brandi
Cormier, Tiffany
Corra, Linda
Cotton, Heather
Courval, Jeanne
Cowan, Tracy
Cox, Derek
Coyner, Jennifer
Craft, Rose
Crouch, Victor
Cupertino, Allison
Cusimano, David

Daley, Nancy
Dalloul, Ghassan
Danforth, Catherine
Danowitz, Ted
Davenport, Kimberly
Davis, Chris
Davis, Kasey
Davis, Stephanie
Dennis, Jason
Devine, Mary Ann
Diaz, Hector
Dickey, Gene
Dierckman, Christa
Dillon, Robert
Dinur, Suzanne
Dirscherl, Courtney 'Paige'
Dorsey, Phillip
Duff, Carol
Duff, Cynthia
Dunn, William
Dyce, Keith
Eason, Hillary
Eckerle, Josh
Ellingson, Michelle
Ellis, Patricia
Ellul, Victoria
Elz, Robert 'Bob'
Elzemeyer, Jeffrey
England, Ellen
Faires, Rachel
Fallin, Veronica
Fallon, Nancy
Feinberg, Marcia
Feldman, Sharon
Fenwick, Greg
Ferrer (Glick), Louisa
Fields, Malachi
Fisher, Melanie
Florio, Melinda
Florio Jr., Philip 'Rick'
Ford, Jason
Ford, John
Ford, Kieshawn
Foster, Jim
Fowler, Curtis
Fox, Mary
Frame, Theresa
Franklin, Minerva
Fraser, Gareth
Frazier, Terri
Froment, Karen
Fuller, Rushia
Gallagher, Jana
Geise, Wendy
Gentry, Kathleen
Gloppen, Kari
Goggins, Reginald
Golson, Monique
Goodson, Christopher
Goosby, Patsy
Gorman, Jaya
Greenbaum, David
Grubbs, Judith
Gurin, Lisa
Gurvey, Leslie
Haag, David
Hall, Karen
Halpern-Dunowitz, Ingrid
Hamilton, Joyce
Hamilton, William 'Bill'
Harless, Carol
Hartsfield, Kathryn
Hartwick, Terry
Hasson, Deirdre
Hasty, Frank

Hasty, Laura
Hathaway, Elizabeth
Hayden, Christopher
Hayman, Larry
Henderson, Gerald
Henderson, Seth
Hendrich, Elizabeth 'Beth'
Henning, Kurt
Herndon, Lauren
Herron, Jeri
Hicks, Kimberly
Hildreth, William 'Paul'
Hill, Cindy
Hohman, Jennifer
Holbrook, Elizabeth 'Betsy'
Holbrook, Jeremy
Hoover, Christine
Horner, Jacquelyn
Houlihan, Susan
Hubler, Elizabeth
Huch, Natalie
Hughes, Ashley
Hull, Stephanie
Hull, Susan
Huszar, Ryan
Imler, Diana
Iqbal, Shareen
Ison, Judi
Itkoff, Cynthia
Jablonski, Kaleigh
Jackson, Joel
Jenkins, Myra
Johnson, Carolyn
Johnston, Angela
Jones, Nathaniel 'Nathan'
Kahn, Phyllis
Karnik, Amanda
Kassens, Jane
Katnik, Sondra
Keene, Peggy
Kelly, Elizabeth 'Beth'
Kelly, Frank
Kemper, Jennifer
Kennedy, Leslie
Kenney, Harold
Kenny, Lorraine
Kiepper, Michelle
Kim, Yeo
King, Labrisha
King, Shalawn
Kirkman, Leo
Kirkpatrick, Alicia
Kluttz, Sandra 'Sandy'
Knight, Jerry
Knight, Nance
Koconis, Catherine
Korn, Randi-Lynn
Kosinda, Antonius
Kraft, Connie
Kujala, Carolyn
Kwiatkowsky, Denise
Kyser, Lara 'Danielle'
La Tour, Kathryn
Lainhart, George
Lancaster, Diana
Landau, Robert
Lanford, Julia
Leatherwood, Donita
Lee, Audrey
Lee, Judy C.
Lee, Matthew
Lee, Tracy
Lekas, Thomas
Levy, Jose
Lewis, Diaha

317.

318.

Salley, Katherine
Sams, Karen
Santucci, David
Schilling, Kristin
Schoeller, Dorothy 'Dot'
Schoenberg, Josh
Schoonover, Kevin
Schumacher, Ann
Schwerzel, Amy
Scott, Dennis
Searcy, Josh
Sell, Holly
Sexton, Leah
Shealey, Quinnecia
Shectman, Sheryl
Sheehan, Candace
Shein, Jered
Sheridan, Megan
Shiver, Brittany
Shorr, Ada
Simmons, Karen
Simmons, William
Slade, James 'Westby'
Slaughter, Carolyn
Smith, Christopher
Smith, Sakeena
Smith, Timothy
Speed, Jeannie
Spiegel, Jennifer
Stack, James
Stevens, Sandy
Stewart, Megan
Stiggers, Karen
Stockinger, John
Stone, Katherine
Storne, Charles
Stringer, Kay
Strong, Kimberly
Stuart, Leslie
Stuchinski, David
Suarez, Christina
Sulsona, Jim
Summers, Kathy
Sustaita, Sarah
Sutton, Mark
Sutton, Sally
Sweatt, Mark
Tant, Alek
Tatum, Meredith
Tavel, Javier
Taylor, Robin
Teague, Lynn
Tharle, Millie
Thazhath, Rupal
Thompson, Adam
Thompson, Eric
Thompson, Hillary
Tis, Laurie
Todd, David
Toney, Kathryn
Toomer, Mary
Travis, Samuel
Troesch, David
Troutman, Grant
Trussell, John
Turner, Walter
Underwood, Phillip
Vaughan, Jesse
Vaughn, Kayley
Vence, Heather
Voccio, Laura
Voss, Amy
Wages, Sarah
Wahoske, Randall 'Randy'
Ward, Alicia

Ward, Andy
Waters, Torrey
Watts, Jodi
Watts, Stacy
Webb, Krystal
Weitzel, Jennifer
Whalen, Mackenzie
White, Christine
White, Gwendolyn
White, Stephanie
White, William
Wichmann, John
Wike, Laurel
Wilburn, Valaida
Wilder, Nathan
Wilhelm, Keri
Wilkins, Matt
Williams, Elizabeth
Williams, Muriel
Williams, Philip
Willis, Mary
Willis, Robert
Wilson, Kelly
Winckler, Morten
Winston, Carol
Wisdom Smyth, Jennifer
Wise, Nicole
Wissler, Janell
Wright, Jonnie
Wright, Lauren
Yahres, Jim
Yamashita, Laura
Yancey, Elleen
Yeargin, Kimberly
Zamboni, Christina
Zaragoza, Zandro
Zidar, Laura
Zimmerman, Katrina
Zuckerman, Terri

Linge, Aisha
Loree, Leonor
Loree, Melissa
Ludd (Bolden), Bettye
Lye, Jason
Lyons, Roxanne
Macleish, Frederick 'Rick'
Macleish, Stacy
Makepeace, Amy
Mankin, Danielle
Marchitto, Bonnie
Markwell, Shea
Martin, Arthur
Martin, Jamie
Martin, Jerry
Martinez, David
Martinez, Weston
Mason, Carolyn
Mason, Mark
Massey, Suzanne
Mast, Tyler
Matabane, Paula
May, Tolen
May, Warner 'Jeff'
McCollum, Crystal
McCullers, Brittany
McGrath, Dustin
McGriff, Crystal

McLemore, Canditra
McMillan, Elizabeth 'Lili'
Meeks, Burrelle
Middleton, Amy
Mileshko, Sharon
Minor, Barbara
Miranda, Javier
Mitchell, Amy
Mohl, Robert 'Bob'
Monasterio, Laura 'Elizabeth'
Moon, Thomas
Mooney, Nancy
Moore, Darlene
Moore, Shelly
Morin, Adrianne
Morris, Darian
Morrow, Wendy
Morse, Brian
Moss, Lauren
Napierala, Sarah
Nash, Margaret 'Grace'
Nause, Catherine
Nichols, Lisa
Nix, Alexander
Nix, Letha
Nixon, Lea
Norton, Catherine
Nunn, Joseph

Nygaard, Lynn
O'Connor, Rory
O'Donnell, Dianne
Oglesby, Susan
Okoh, Izebhokun
Ou, Jeff (Shaochieh)
Pannell, Charles
Parks, Jennifer
Parr, Christina
Parsons, Sheryl
Pate, Velera
Payne, Diane
Perez, Danay
Pernia, Benjamin
Perry, Faith
Peters, 'Darwin' Lane
Pfeninger, Scott
Phelps, Christy
Philpot, Lucille
Pickering, Melanie
Pickett-Woodland, Karen
Plunkett, Elizabeth 'Ashley'
Polinchak, William
Pourmehr, Kathy
Prusas, Paul
Ramatally, Naeem
Ramsey, Kimberly
Ratcliffe, Peggy

Reed, Karen
Renard, Daryl
Reyes, Imelda
Reyes, Maribel
Ricci, John
Richardson, Kristal
Rigger, Mary
Riggins, Courtenay
Riviere, Susan
Roan, Florence
Roberts, Stefanie
Rogers, Ashley
Rogers, Faryka
Rollins II, Paul
Roloff, Robert
Romashko, Tim
Ronick, Mindy
Rosen, Sy
Rosenthal, Rick
Rosovsky, Barbara
Rosovsky, Jay
Royal, Gerry
Ruff, Kyle
Rutherford, Lois
Sabol, Ashley
Sadler, Jennifer
Saleem, Edward
Salikof, Katherine

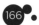

Only FSC-certified Printers Can Provide the Label

FSC certification ensures the paper used in this book contains fiber from well-managed and responsibly harvested forests that meet strict environmental and socioeconomic standards.

The only way to obtain the FSC label on your printed material is through an FSC-certified printer. Each printer has earned a unique certification number that appears in the FSC label.

Geographics

Geographics completed an extensive evaluation to become FSC-certified, demonstrating that there are processes in place to ensure FSC-certified materials are not mixed with non-certified products and a special handling process is in place for all FSC jobs.

Geographics also takes extra steps that the FSC doesn't require to be environmentally responsible, such as using water or vegetable-based inks and ensuring proper recycling methods are in place for paper waste.

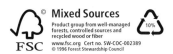

© **Mixed Sources**
Product group from well-managed forests, controlled sources and recycled wood or fiber
www.fsc.org Cert no. SW-COC-002389
© 1996 Forest Stewardship Council
FSC 10%

A Little Goes a Long Way

Just look at the environmental savings calculator below. A little investment goes a long way.

Savings derived from using post-consumer recycled fiber in lieu of virgin fiber in the printing of this book:

28.57	1,343 lbs.
trees preserved for the future	solid waste not generated
82.51 lbs.	2,644 lbs.
waterborne waste not created	net greenhouse gases prevented
12,137 gallons	20,238,925
wastewater flow saved	BTUs energy not consumed

319. Amicalola Falls State Park, Georgia